Fantasy⁺

② Best Artworks of CG Artists

Vincent Zhao

 CYPI PRESS

Contents

Preface

Memento and Pledge

Vincent Zhao

I never thought the production of the *"Fantasy+"* series would take 2 years. But the time passed before we knew it.

When the first book of *Fantasy+-Best Artworks of Chinese CG Artists* was introduced, I filled a faraway address in the postal delivery order, to send a book to one of my friends who had worked with me for *Fantasy* magazine. I wrote on the head page: "this is our memento for the past, as well as a pledge for the future."

This is my definition of the first book. When I informed everyone of the publication and they expressed their congratulations and excitement, I said again and again: "the significance of the book is far more than its contents." Yes, the 20 Chinese illustrators are familiar to us, and most of the several hundreds of their works are not strange to the insiders of this field. But we are willing to buy this thick book, mostly because we want to say "hello" to our sweet memory.

After I read the hot praise and comments on the web, I began the publishing with more motivation, confidence and sense of mission. The second and third books were postponed for a long time due to difficulties I could not explain in detail. I knew that I must do my best, or the "pledge for the future" would seem only bravado.

Between the second book *Fantasy+-Best Artworks of CG Artists* and the third one *Fantasy+-Best Hand-painted Illustrations*, I wish to try a holistic architecture – the antinomy between the emergent digital art and the traditional hand-painted illustration.

In an age when artistic creation has become industrialized, the design and work is required to be finished in a short time. How do the artists who create digitally regard the traditional hand-painted illustration? Do they dispense with their sketchbooks and pencils? Are their works just products, not pains-taking creations?

On the other hand, do the traditional illustrators feel the pressure when digital arts dominate the industry? How do they regard the digital arts, and what do the traditional

techniques mean to them? How much time does it take for them to create a work? Does the artistic value of their works enable them to live an easy and agreeable life?

In this book about digital art, I try to present works of various styles. Some of the artists draw original paintings, some design concepts, some produce games, some produce animations, some draw interesting 2D illustrations, and some render vivid 3D characters. Of course, the 20 artists here are not enough to represent the large industry. But they are not just producing one character after another with the convenient drawing technique. The personalized design and establishment of their styles reflect their continuous exploration of digital art.

I incorporate more feeling in this book about hand-paintedart. Maybe because I entered this industry out of my love for traditional arts, you can capture the sense of propylene and watercolor in the interview from my early years. During the production of this book, the annual San Diego Cartoon Festival was held, and many artists postponed their meeting with us. But they showed much interest after they came back. And there were more candidates than we had expected, so we had to say sorry to some of them. During the interviews, what moved me most were their beliefs and tenets. They take pride in traditional hand-painted art. And gallery art provides them with much support. The respectable artist has passionate feelings towards the real works, even if one of them would take half a month to create.

In this book, I bring you 20 great artists, although just by interviews and presentations. I hope you can get the most out of the content, and remember my tenets of "fantasy and progress".

All of the 3 books of the *Fantasy*[+] series are now completed. But we do not mean to say "good-bye".

I would thank Ning Ning, Guo Yue and Wang Songsong for their help and contribution to the editing of this book.

Steven Stalberg

Name: Steven Stalberg
Occupation: Freelance Artist
Homepage: www.androidblues.com

Steven Stalberg

A Preacher

An Interview with Swedish Digital Artist Steven Stalberg

From 2000 on, everyone who entered the CG industry was likely to have seen a work like this: a nude girl reaching out for a ferocious-looking face. It brings about a shock arising from the contrast of reality and illusion as well as extreme beauty and extreme ugliness, so that the work by Maya was considered "divine" at a time when the technology was underdeveloped. It even became the sign of the birth or even maturity of CG creation.

Stalberg is now 47. And he never stops his exploration in CG. To be accurate, he is more a preacher than a creator. He is dedicated to the promotion and application of CG technology, sharing his experience as a pioneer with practitioners worldwide, in form of video teaching.

He is no longer the symbol of CG, but we can never forget the initial surprise he gave us. He is the earliest legend in CG, although he has provided less works in recent years.

Interview

-- You are among those who were the first in CG creation. What do you think is your advantage now?
-- Several years back, I might believe I had outstanding technology; at least, few people had a standard like mine. But now, as an increasing number of people get into this industry and master Maya and other software, a number of excellent young men are catching up. It's not bad, and I am proud of them. Yet there is still some work in this industry that needs me, and training is my core business. I make DVDs and publish my course on the web, through which I hope to help more people who want to enter into this trade and to boost the industry.

-- What is your biggest change in recent years?
-- I became more mature, or older. So I don't try too many styles now. Although I sometimes create something new, it is not as tentative as what I did at art school when I was young. What's more, my move from Kuala Lumpur, Malaysia to Gainesville, Florida brought a big change to my work. I am not a freelancer working at home, but a participant in many projects. Hum, I cannot tell you too much about that, because the work is confidential. What I can say is a first-person shooter game will be available around 2010, when you will find a lot of cool trailers and innovative gaming, which is my work. For those who think "Steven is too old to make anything new," that will change their minds.

-- How long has it been since you began CG creation? You started quite early as I know. Do you remember the process clearly?
-- Sure, it's almost 20 years now, from 1990 when I bought my AutoCAD computer. Later, I found SGI in the dark and cramped office in Hong Kong. I used a 4D20 "Personal Iris" with no cache, just a 200MB hard drive and some free software. It was a brown box like a suitcase, and I think it was the most beautiful thing in the world so that I bought the lap top without bargaining, at $13,000, with which you can buy 2 high-end products now. I used the free BRML-CAD at the very start, a software used by the U.S. military to make solid models. Ha, that was an interesting time, an adventure. It was an experiment as well as magic. I recorded the process of production with a video camera. Alias Quickmodel and Wavefronts Personal Visualizer became my most frequently used softwares, and then Indigo and Power Animator. When PA stopped updating, I found Maya. Then I began my real CG creation.

❶ Abduction

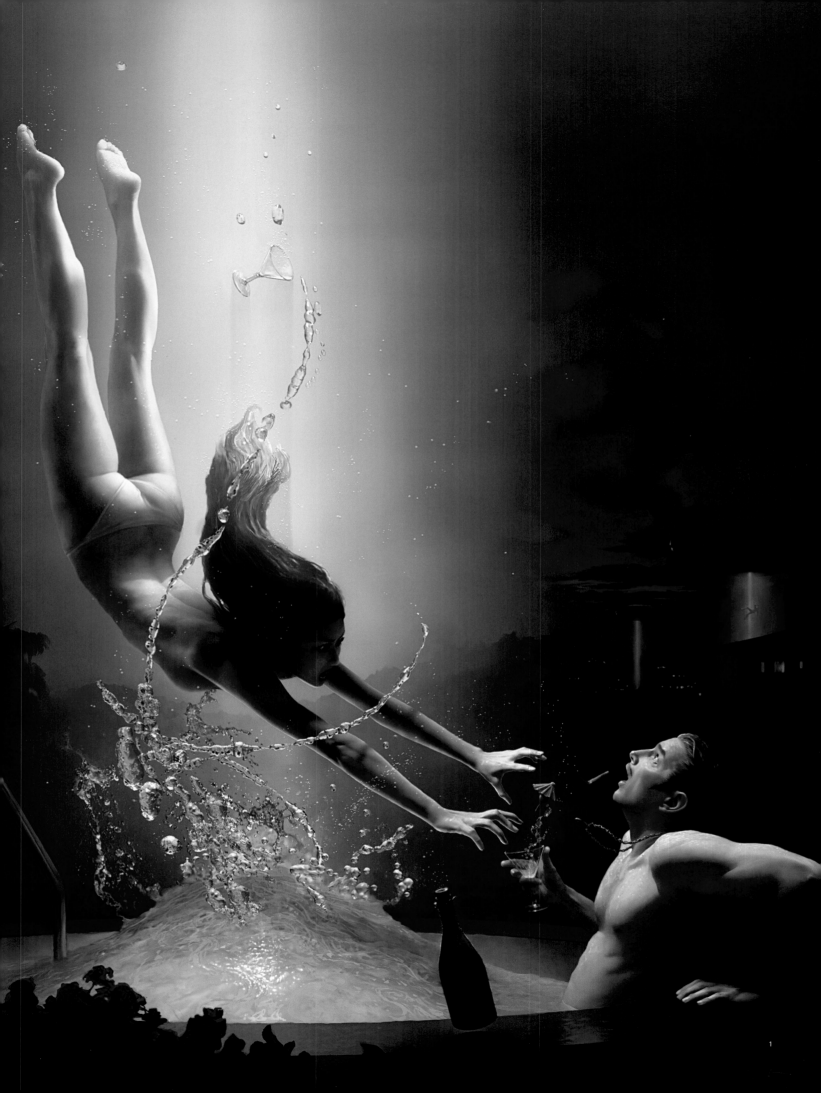

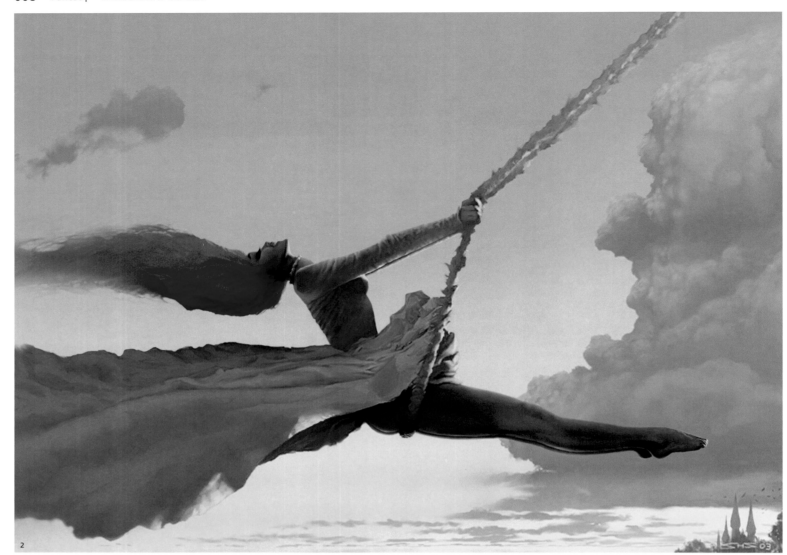

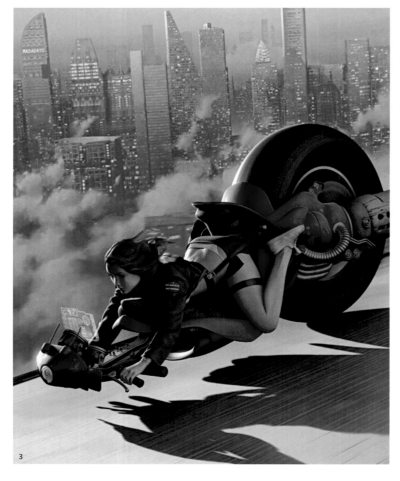

❷ Fairy Queen

❸ Mono Bike

❹ Price of Magic

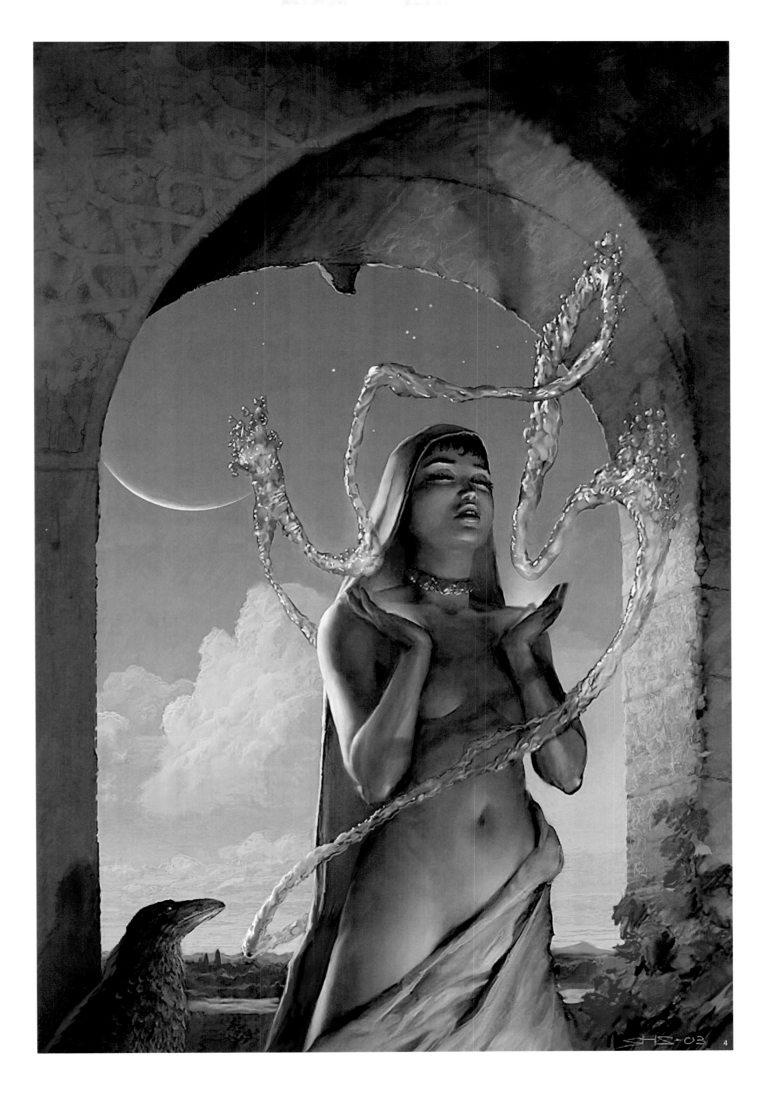

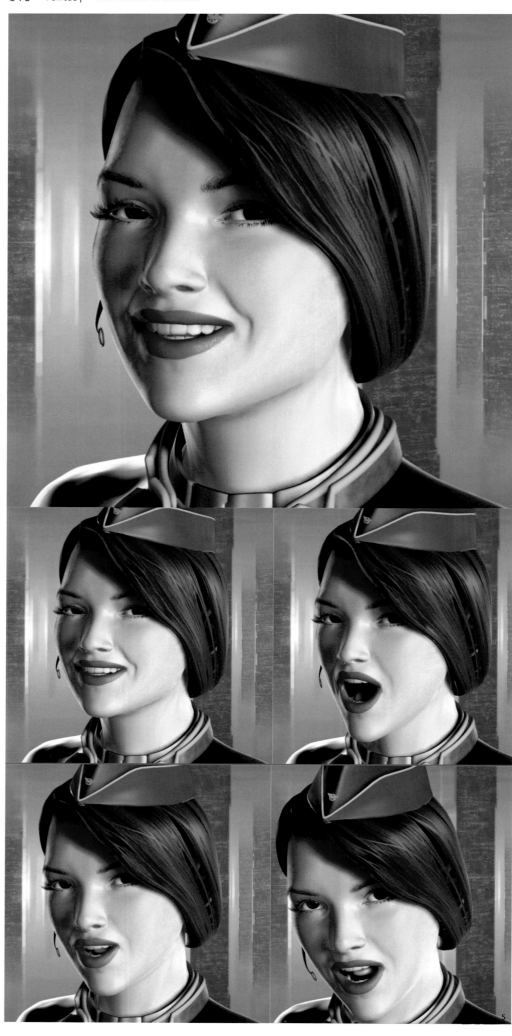

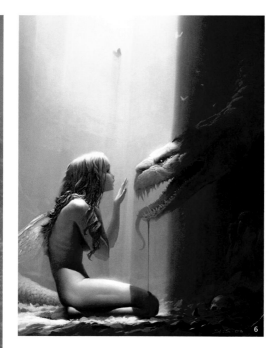

❺ Aida Film Strip

❻ One Last Time 2D

❼ One Last Time 3D

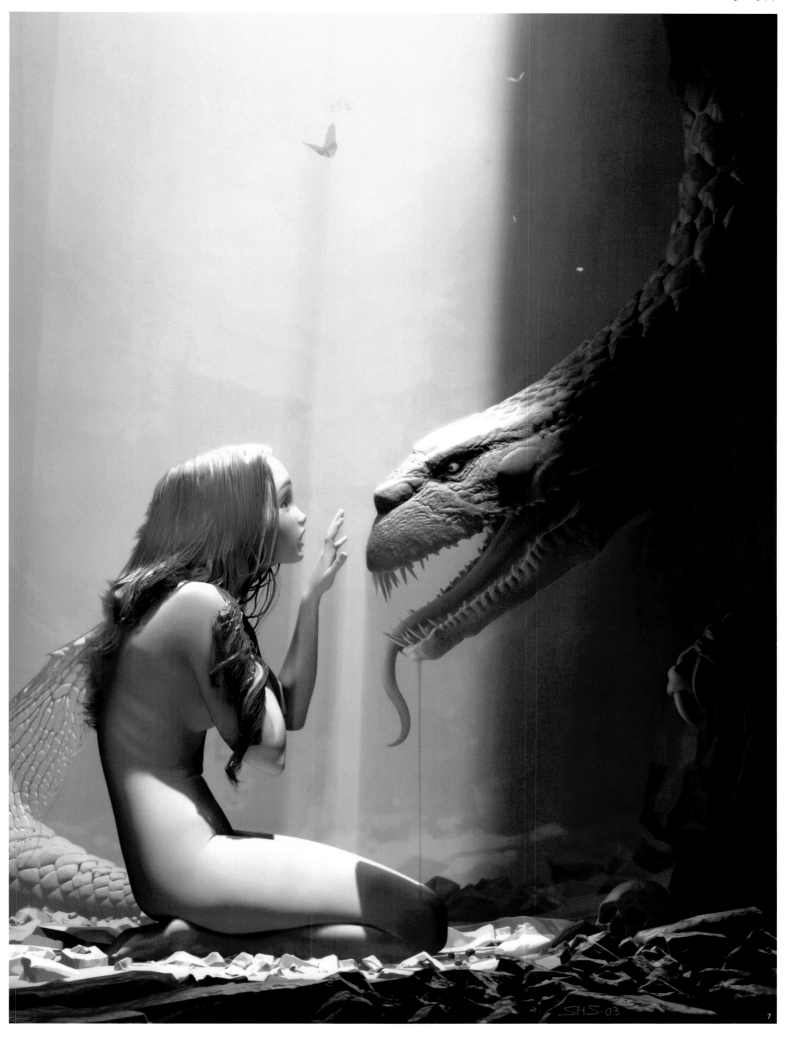

❽ Jealousy

❾ Sarah Morrison about to Shower

❿ Air Defense

⓫ Countess Dracula

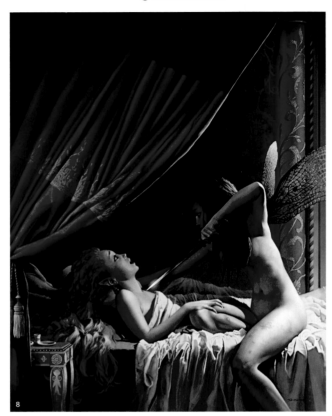

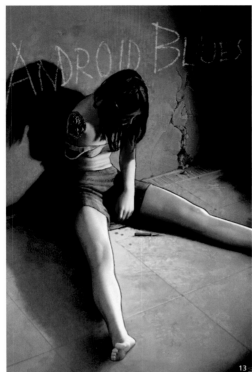

-- Have you decided to give up traditional illustration forever? After all, it has nothing to do with your job now.

-- First, I would say the traditional illustration is unique and provides a good platform. For me, the traditional illustration is now a way of relaxation, but it is not apart from my life. However, it has nothing to do with my job, because I have no time to do the inefficient work. The advancement in digital graphing and CG technology frees us from repeated work. The issue cannot be regarded in general. We must not consider the traditional skill as a "positive number" while the digital creation a "negative number". Or to put it another way, each has its advantages and disadvantages.

⓬ The King's Fairy Trap

⓭ Android Blues

⓮ 3D School Poster

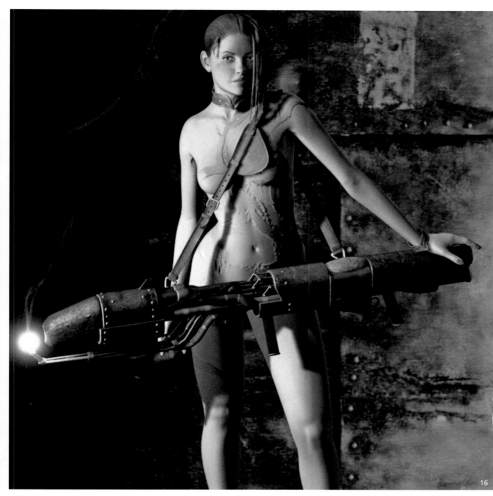

15 Road Trip

16 Flame Thrower

17 Coming Home

Jason Chan

Name: Jason Chan
Occupation: Freelance Artist
Homepage: www.jasonchanart.com

Jason Chan

Mature Women
An Interview with U.S. Illustrator Jason Chan

A girl becomes a mature woman through her thought.

Three years ago, I said there was always a girl at the center of the picture by Jason Chan, as a normal line around which other parts of the picture were arranged. 3 years later, we had a talk again. I know that he has made some change in his preference to suit the theme as he worked with Massive Black, Wizards and other clients. But his simple composition and somewhat thin and weak characters are still impressive.

"I want people to remember my works," Jason says.

So he is always thinking: how to give soul to his characters, what are the strengths of others' creation, what new means of creation can he get via Photoshop, and what shocks on thinking can traditional skills bring to him....

So, the girls in his works are not as blue and mysterious as before, and become more brave and heroic. The change is the result of his 3 years of deep thought, and has the profundity of traditional arts.

Jason says that digital arts are guns and traditional arts are swords. Then the girls in his works are gunners with swords.

Interview

-- We can always find continuous progress in your works during these years. What's the motivation behind it?
-- I think the most important aspect of my work is to create characters with vitality in my works. It's quite easy for us to find a print art work, but hard to find one that has its soul and moves us deeply. There are too many beautiful works in the world, but few unforgettable ones. My goal is those rare unforgettable ones. I do not often succeed. But if people remember one in 50 of my works, I consider it an achievement.

-- What is the most important development for you in the past 3 years?
-- I tried my best to improve my skill. But I don't know how much achievement I have made. I am now surrounded by a lot of genius artists, from whom I must learn. I can also know new artists through online chatting. They give me new insights into arts that I can incorporate into my work.

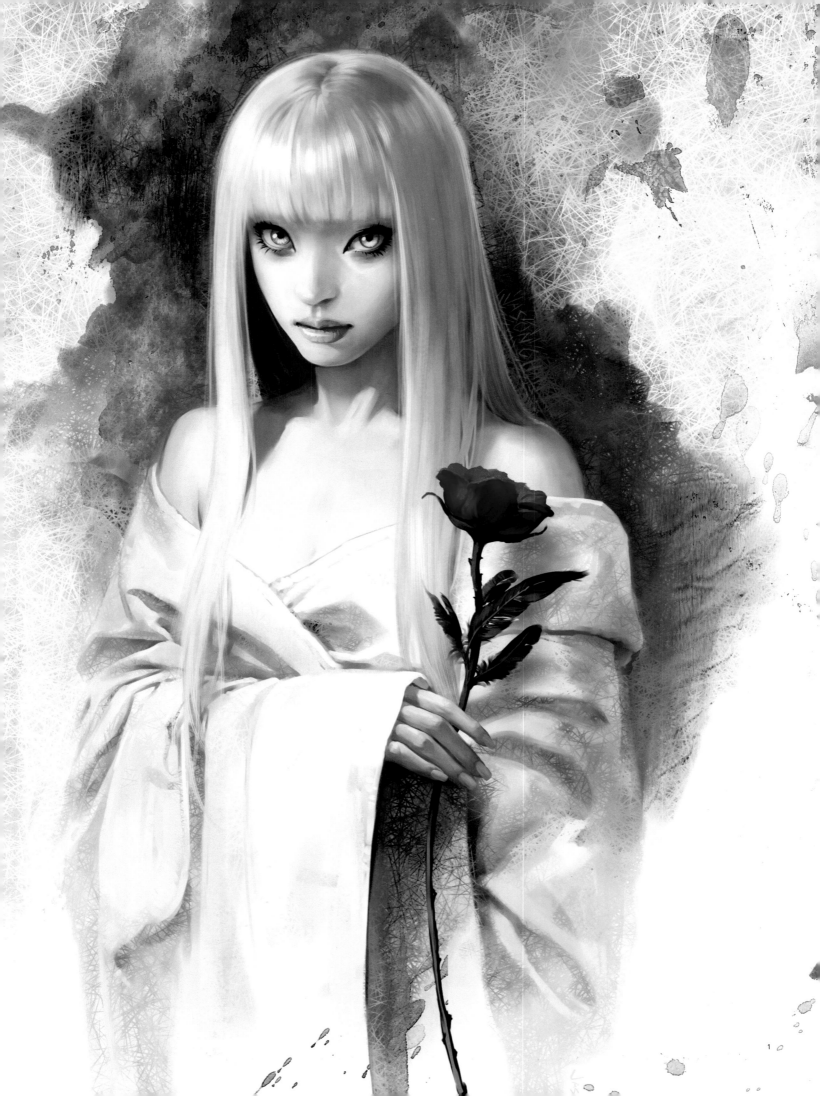

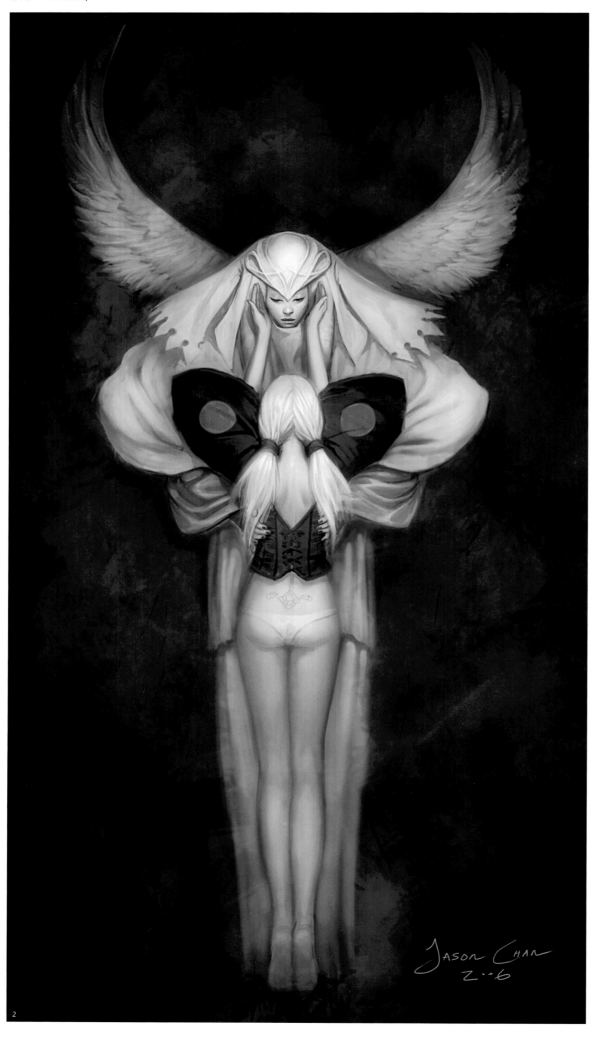

❷ Skull

❸ Waterfall

❹ White Angel

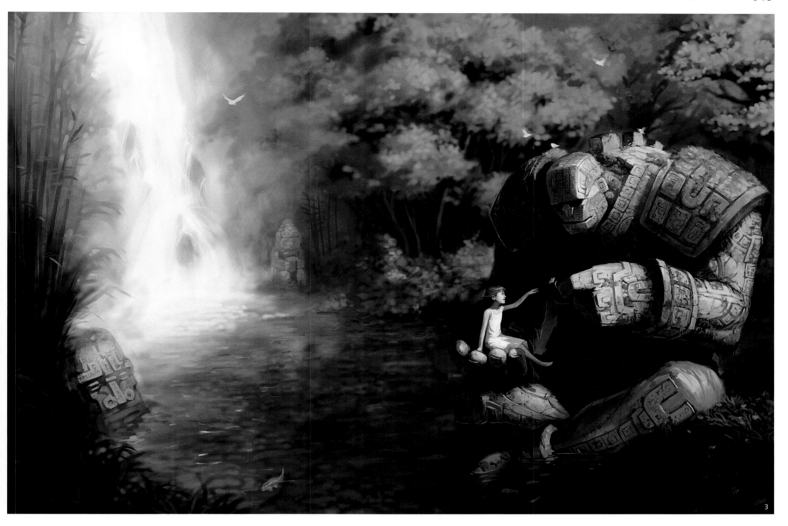

3

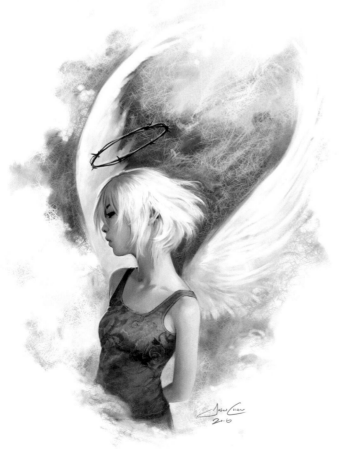

4

-- *What do you think is the next area to explore for digital artists?*
-- There are a lot of areas to explore. Some want to put true-life photos or three-dimensional graphs into their pictures and edit them with software to make them more realistic. The pictures are powerful tools in artistic creation, and the techniques are vital means for current entertainment media. And others try to make their digital works more like traditional drawings, for some sense of classic arts. Maybe someday people can break the boundary between traditional and digital arts.

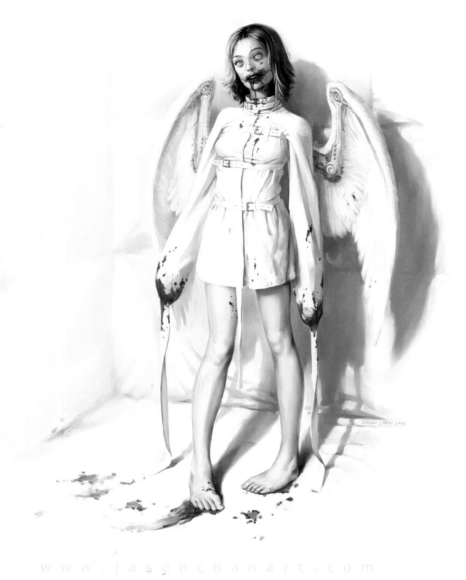

www.jasonchanart.com

5

-- *With so many years of experience in digital arts, what practical suggestions do you have to share?*

-- While it is important to know Photoshop and Printer, it is more important to know how to draw with pencils and paints. The best digital artists I know are good traditional artists at the same time. To draw with traditional techniques is time-consuming, but it forces you to be focused and patient. What's more, your mind can slow down and learn from your works. When drawing digitally, you work so fast that you do not use your mind. What you learn is about how to use Photoshop, not the art or anatomy. There are two kinds of knowledge you need to have: absolute knowledge and the knowledge to control your environment. The knowledge to control your environment means you know how to use Photoshop CS3 or watercolor and paints, which helps you use the software for creation. The absolute knowledge is to know lighting, anatomy, composition and color theories, which can help you create better art works whatever tools you use.

❺ Angel's Kiss
❻ Beginning-end
❼ Twins

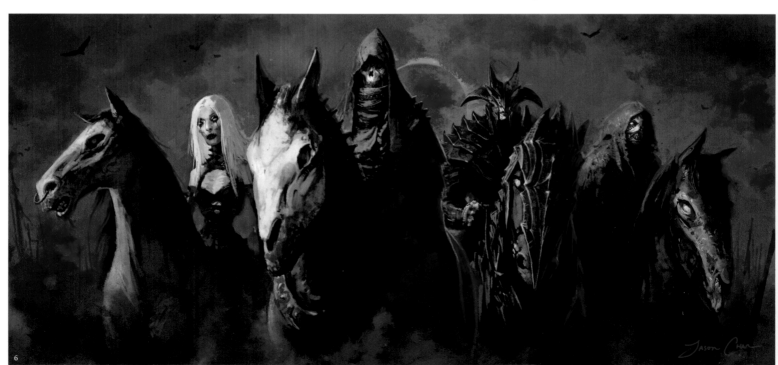

6

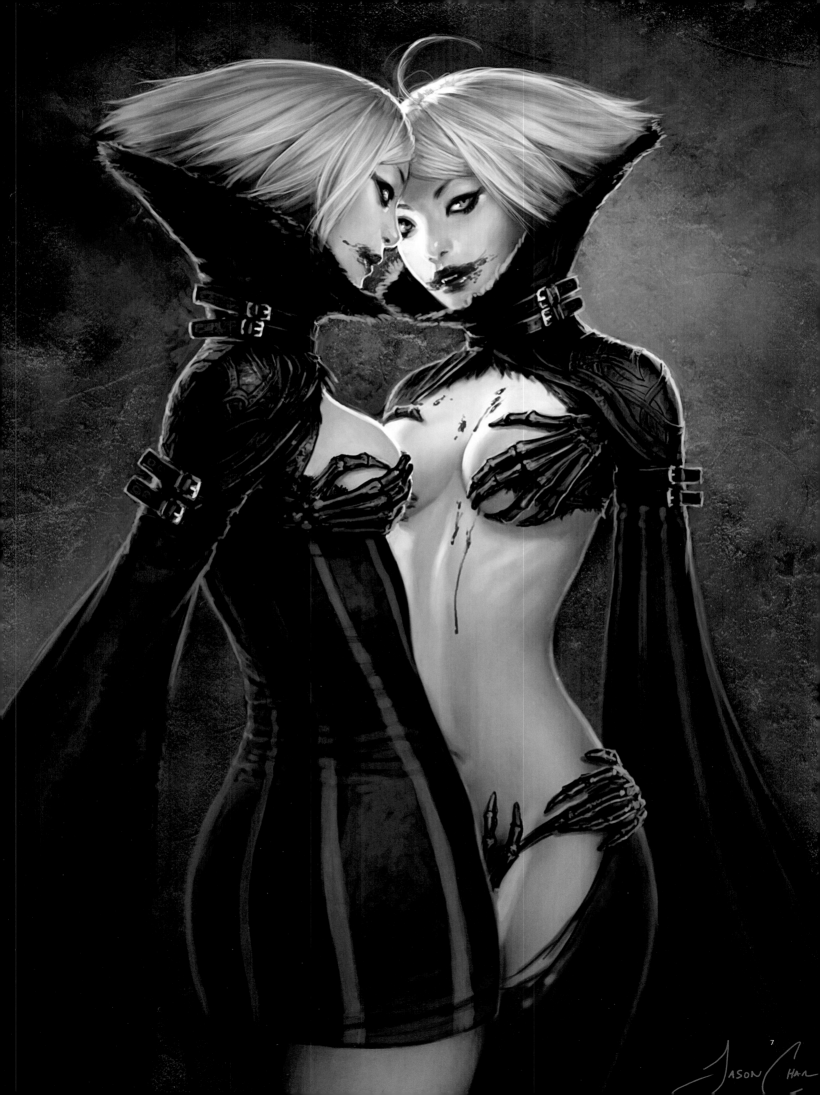

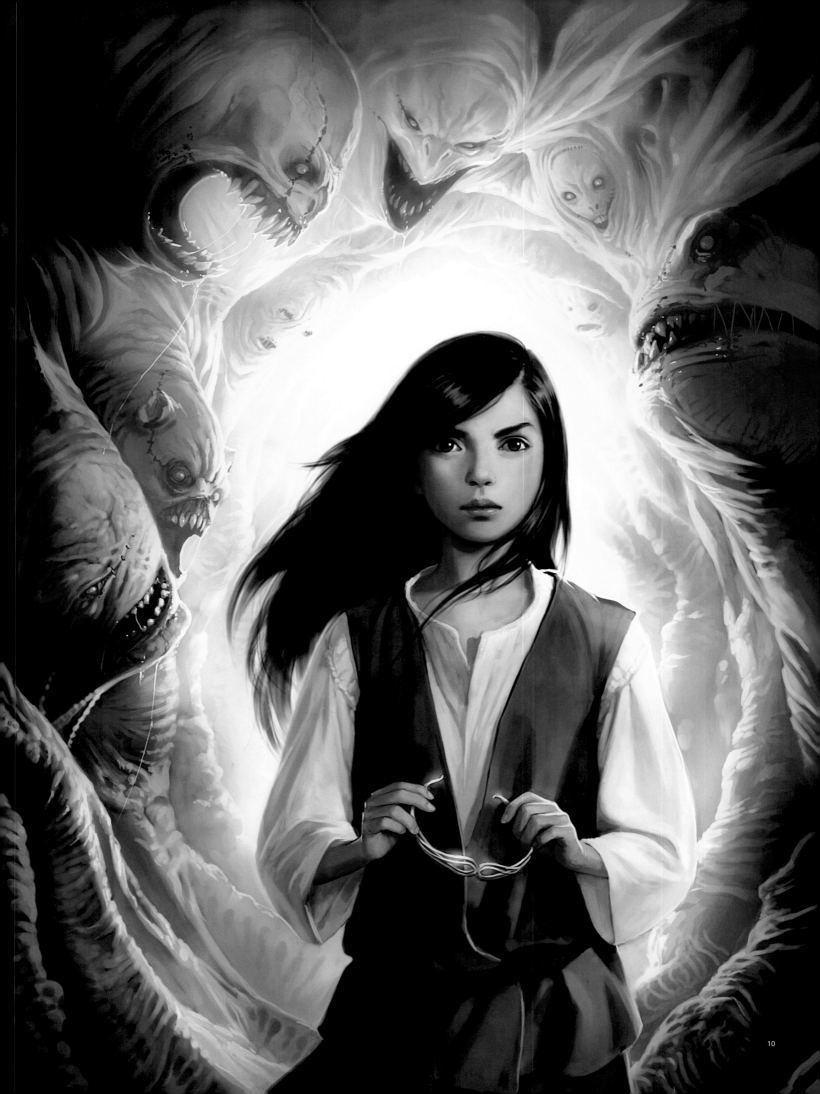

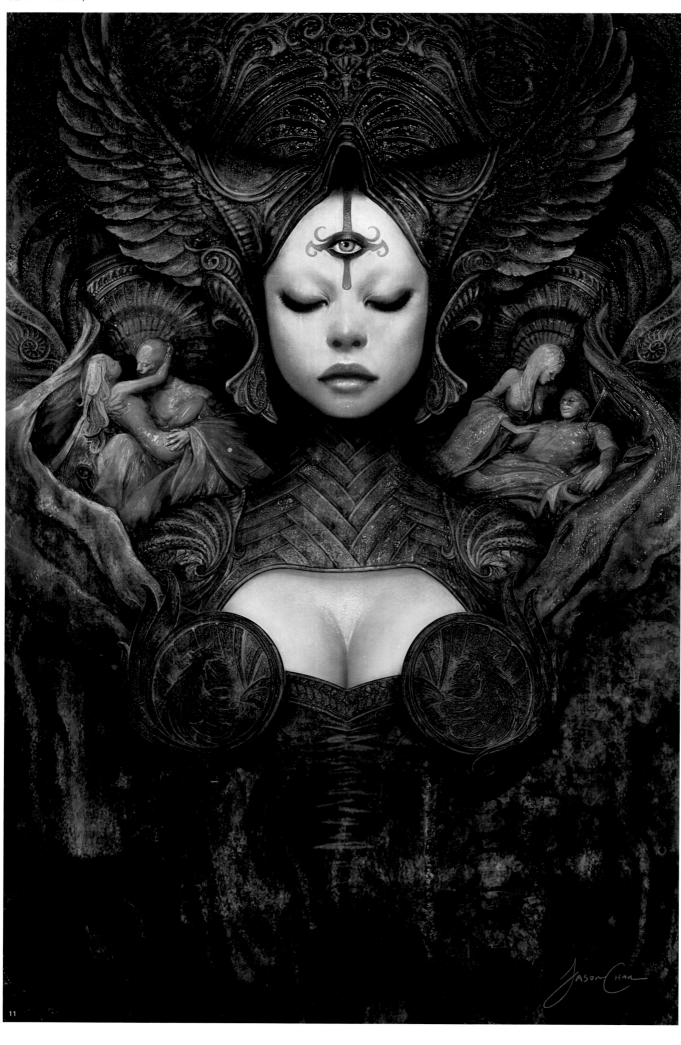

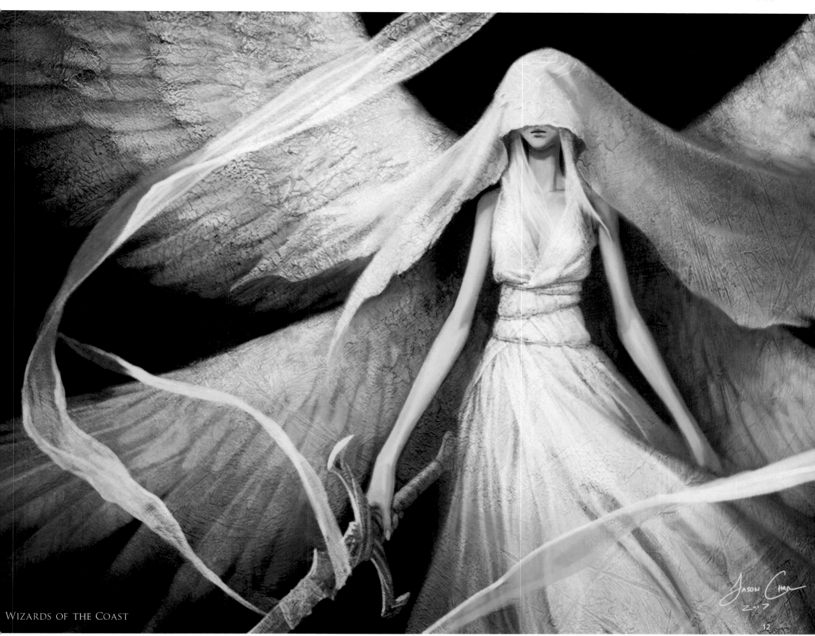

WIZARDS OF THE COAST

11 Third Eye

12 Twilight Shepherdess

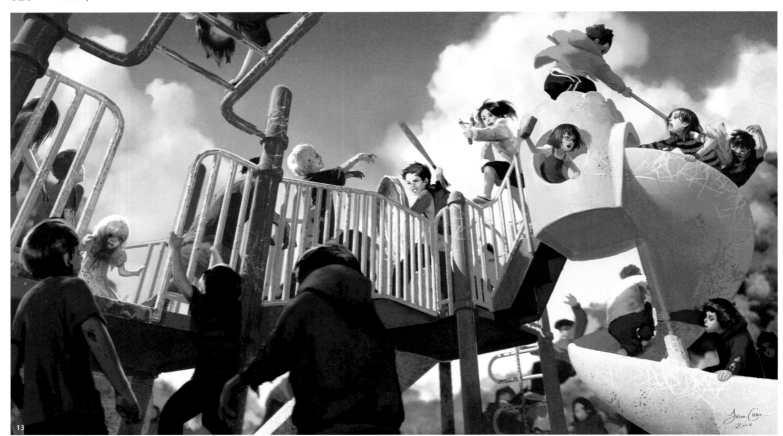

13

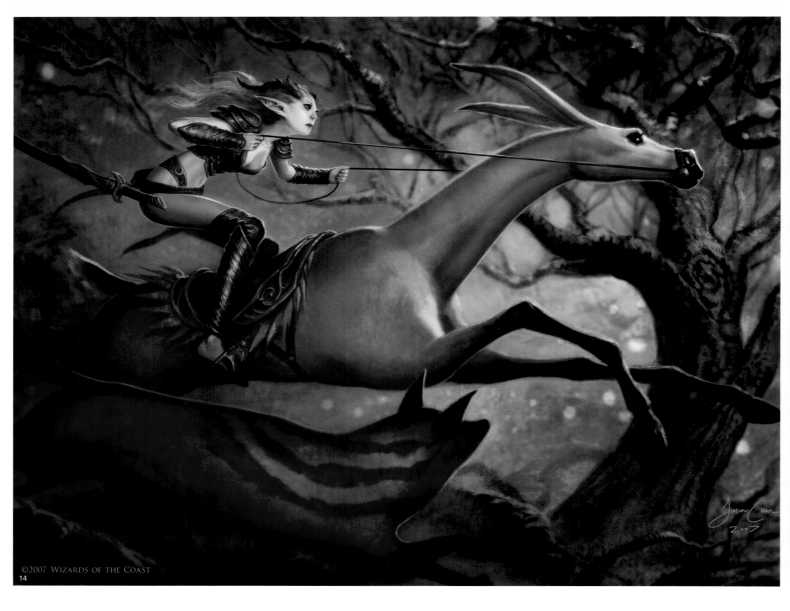

14

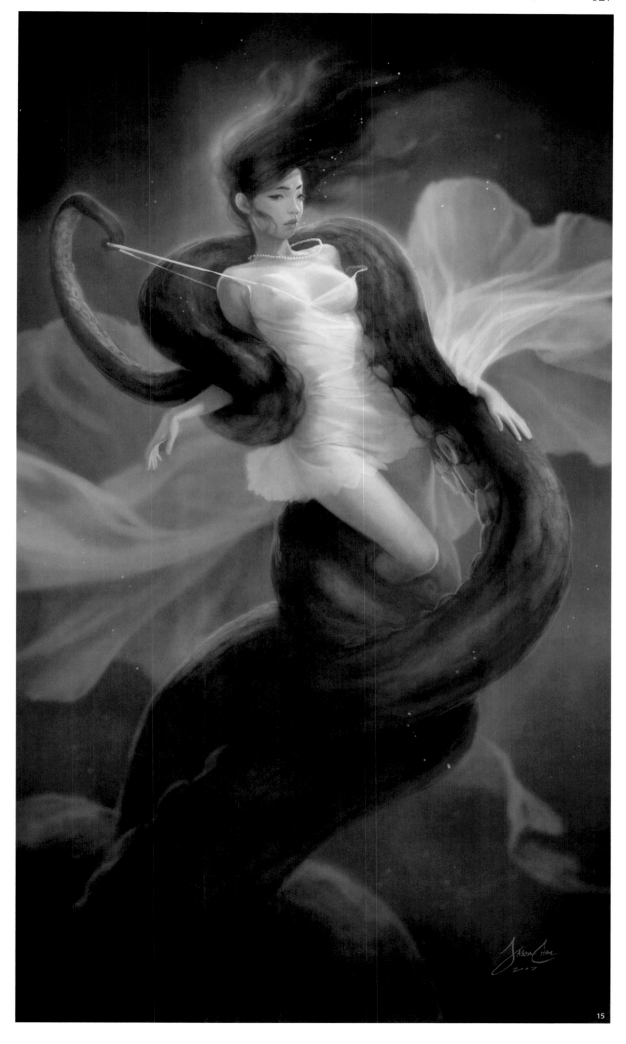

15

Name: Christian Alzmann
Occupation: Freelance Artist
Homepage: www.christianalzmann.com

Christian Alzmann

To Get away from the Common World
An Interview with U.S. Illustrator Christian Alzmann

At least part of a fantasy artist (the soul or spirit) should not belong to this world— just like Christian Alzmann.

Christian Alzmann walks a different road from most people all the time. In other words, having walked a road for too long, he will intuitively jump away from it. Just as he says, for the "Christian" who has been engaged in digital art creation all day long, the most impressive thing is nothing but a period working only with pen and paper, when he returns to the stage where he really touches the art with his own hands. As an art director, he feels this kind of pure creation is especially precious. To this end, he often puts down his brush and takes a cutter to carve out figures from the characters in his drawings.

For Christian Alzmann, the characters must be placed in a situation in his creation. It must be stereoscopic and he must become part of his works too. In such a status of creation, he left the common world and entered a space full of fantasy when he participated in the film productions of War of the Worlds, Harry Porter, The Incredible Hulk, Star Wars and Men in Black. For him, the theme of fantasy has never changed and his creation of fantasy has become a tool with which he gets away from the world when he needs to.

Interview

-- **Nowadays, digital arts are developing in such a vigorous way that a lot of people have thrown themselves into this industry. Thus, what is your trademark feature?**
-- I really like to make my images about storytelling. My favorite part of the process is to tell stories visually. That's why I have always liked looking at illustration and how it uses visuals to describe written stories. From a piece of clothes that a character wears to the type of leaves on the ground I like making every little detail add to the story.

-- **Digital arts have allowed artists to explore more styles and subjects. What do you think of that?**
-- I have played around a lot with different types of imagery, but I always come back to fantasy based images. My favorite images are ones that have a sense of oddity and adventure. I like to put in elements that are fun for me to paint and draw. If they aren't fun to draw then they probably won't be fun to look at for the viewer.

I do play around a lot with Photoshop and Painter just trying to find brushes that I like and interesting tricks I can use, but I found that whether digital or not it's mostly what you choose to draw or paint that matters. The subjects you choose and your ability to draw and compose them, that's the important stuff. I have also been playing with 3D a bit more, but I am more of a 2D purist and like to make my images about what I can draw and paint. If I can't draw and paint them then I study them over and over by doing multiple drawings until I can.

❶ Alliancer

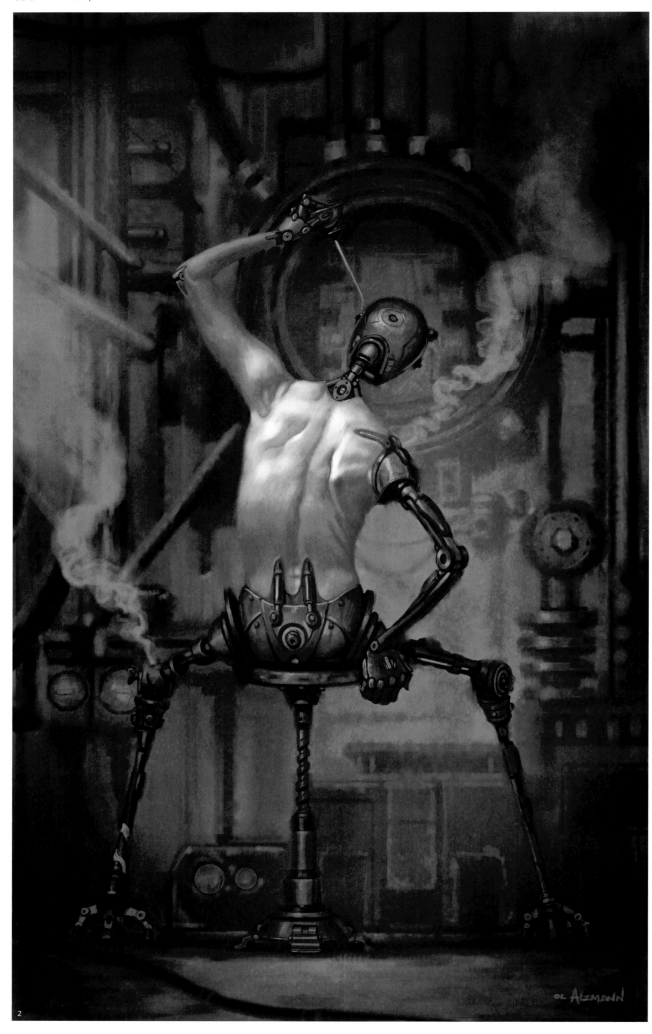

2

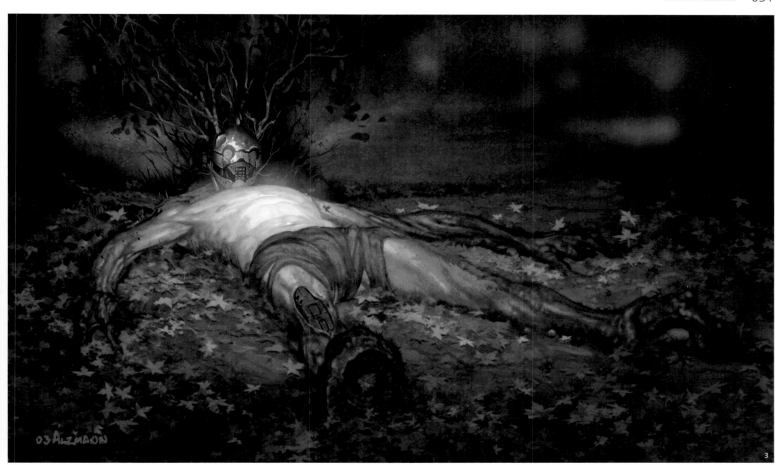

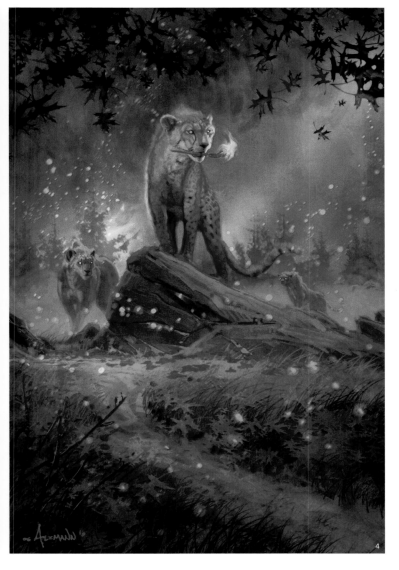

❷ Maintenance

❸ Stationed

❹ Rathas Creature

-- *For the past 3 years, what's the biggest change that has taken place in your work and life?*

-- Everything is pretty much the same. I have been at the same job for 9 years now and it's still interesting work. Stylistically though I am always working on simplifying my style. Making it read as realistic but without all of the little finicky details. I am also using a Cintiq now. It seems more tactile and more like traditional drawing to me than the older tablets.

-- *What's the most important project (or the most memorable project) in the past 3 years?*

-- Probably working on the film *War of the Worlds*. It was a lot of pressure with very quick deadlines, but a very fun project to work on. I am really glad I got to work on it.

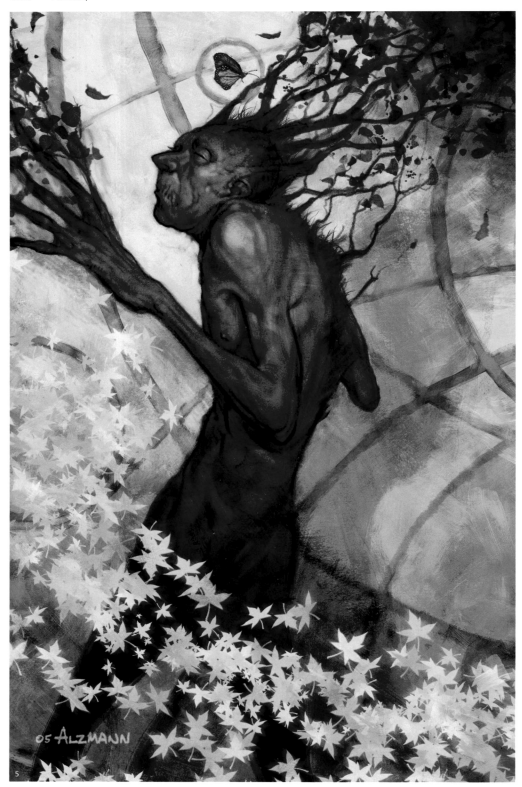

5

❺ Late Spring
❻ Gathering

-- What do you think is the next step in digital arts?
-- With the software getting more and more user friendly, easier and quicker to learn, I think that we will probably see artists that have many different skills. Maybe digital sculpting, painting, drawing, animation, everything. Like digital renaissance men. I am personally interested in all of the visual arts, but unfortunately I have only the time for

drawing and painting. I do try to squeeze in some sculpting now and again though. Maybe some day I will get to play with animation some more too.

-- You have been engaged in digital artistic creation for many years. Would you share with us some practical experiences?
-- Like everyone else I get used to the software doing a lot of work for me. About a year ago

I had to work away from my desk in a very different environment and with no computer. All I had was a pencil, paper and a marker to tone the drawing with.

I learned that software is great, but learning the basic skills of drawing is far more important. If you can't show your ideas clearly with pencil and paper then the digital part won't be that great. Your style is what you draw. so draw a lot and find your style.

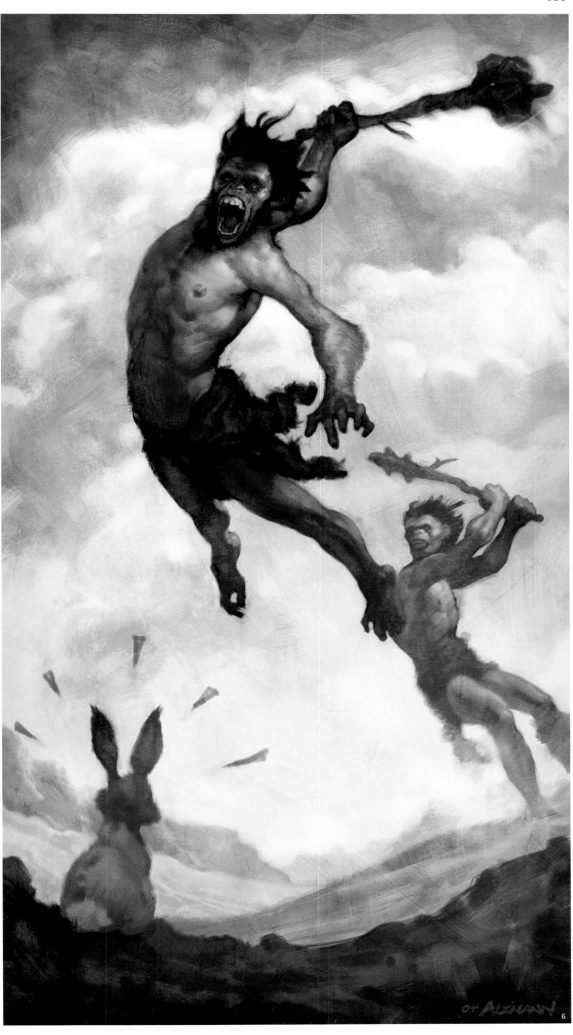

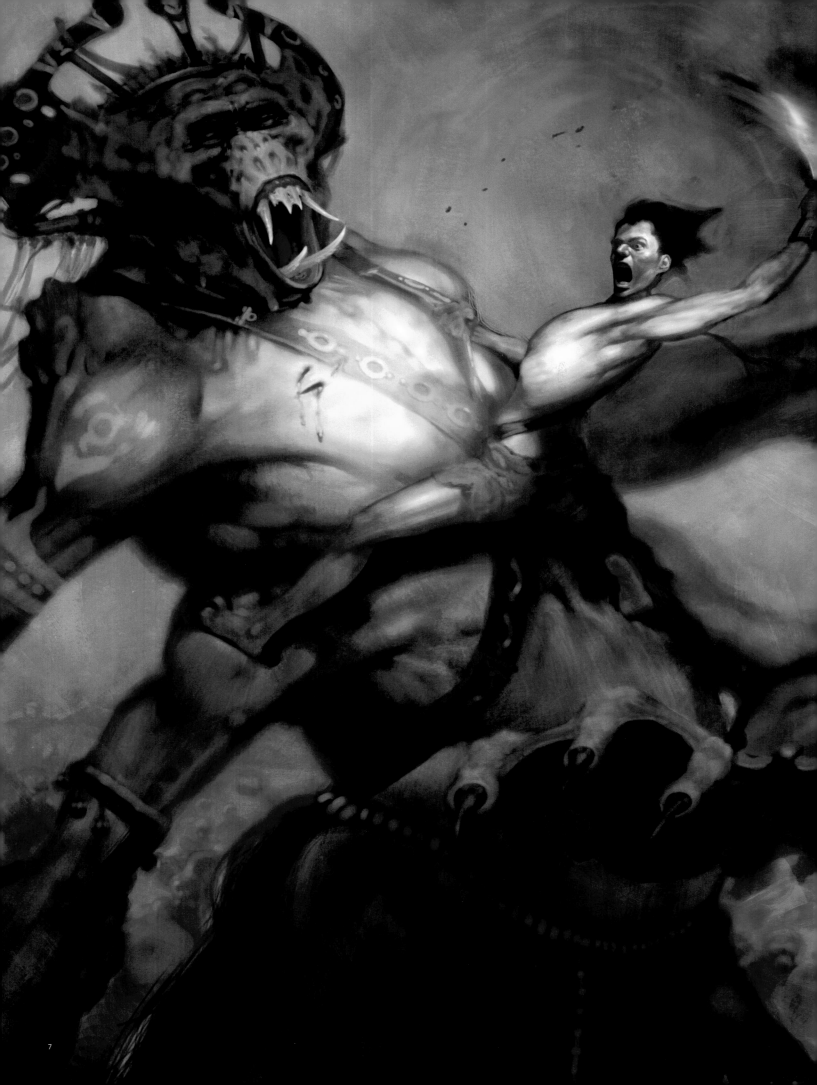

-- Now more and more people are engaged in this digital industry. Do you think the traditional hand-painted art is still needed in this era?

-- I do think that traditional art is needed. I love looking at traditional hand-painted art and I always say that I will go back to it someday. I think that there is no way to replace a physical dimensional painting or drawing, not even with the best of digital printers. I do think that it will be more for the purpose of fine arts and less for design. Digital art offers speed and full control of what you are doing to the image, but I think there will always be people interested in seeing the mistakes and accidents that go along with the traditional media. Most often it's the mistakes that give an artist his style, and with a traditional piece you get a physical record of the artwork. Like everything in design there will be shifts from the clean looking digital artwork to more tactile and messy traditional looking artwork.

 I do think that for film and video game design traditional media will never be able to offer the flexibility that digital media does. So in those fields it's probably irreplaceable with traditional media.

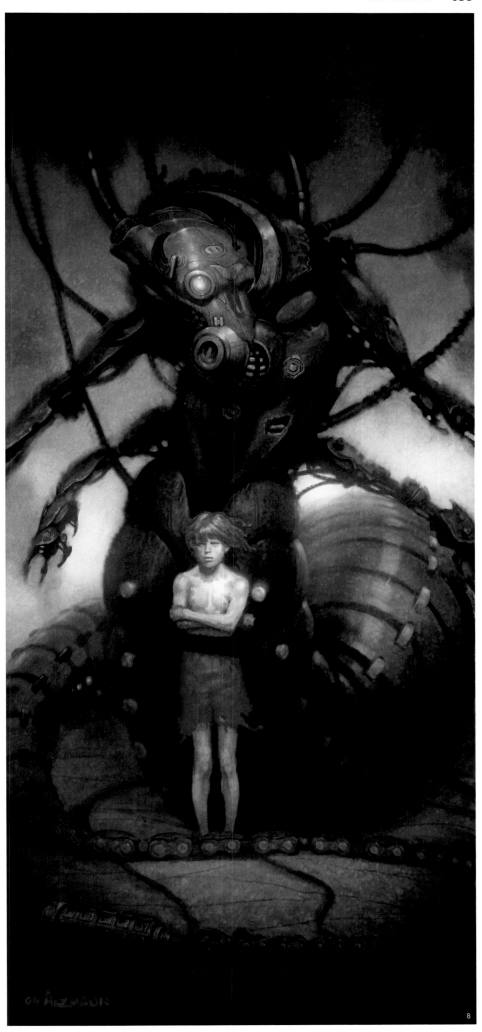

❼ Rage upon Him

❽ Bond

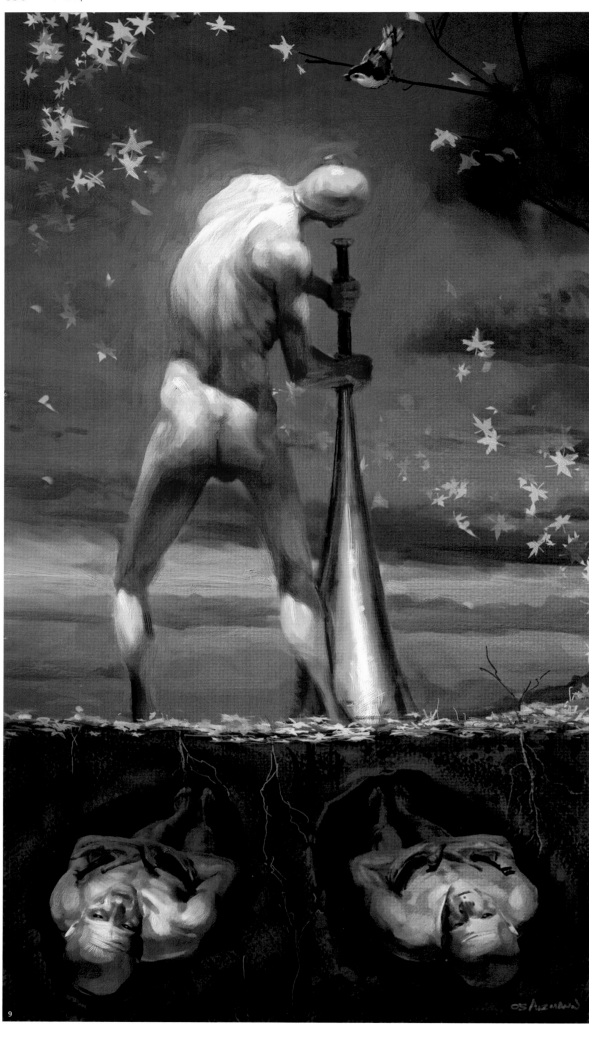

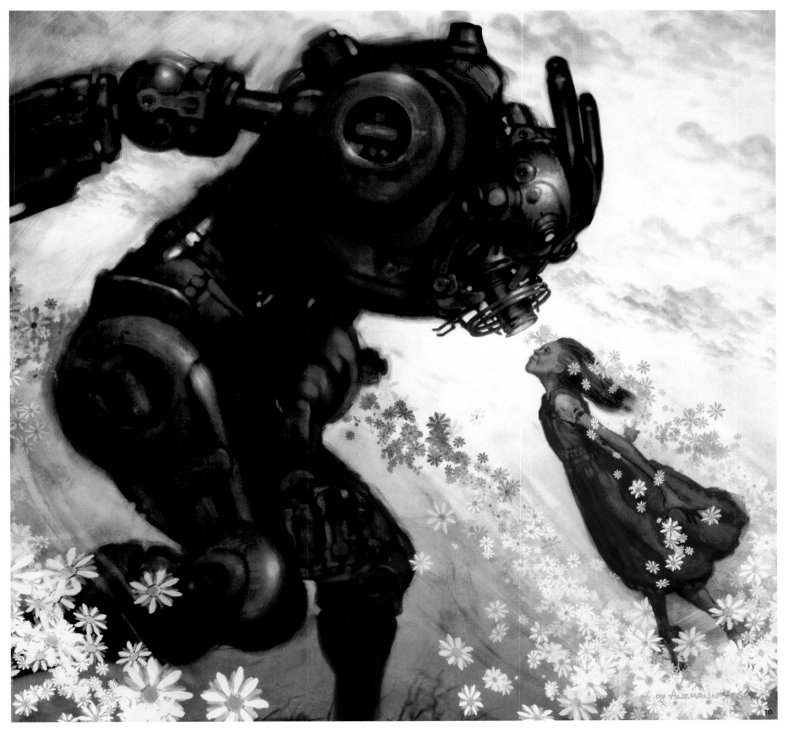

Andrew Jones

Name: Andrew Jones
Occupation: Freelance Artist
Homepage: www.androidjones.com

Andrew Jones

An Explorer
An Interview with U.S. Illustrator Andrew Jones

During the week we organized the art lectures with Andrew in China, we felt that he was more like a mixture of "nomadic explorer and pure artist." He talked relatively less in our team; but when he was on the rostrum, there was much acclamation and exclamation. Some of the audiences were dissatisfied, because they did not see the so called "one of the four gurus of conceptual design" showing his works during the period when he had been with Industrial Light & Magic (ILM) or the works published at the CA forum. Instead, he tends to complete an illustration – or, more accurately, an artwork – with graphs and splicing. Of course, you know the difference between an artwork and a commercial illustration.

Perhaps even now I do not know the difference between the Andrew in Seattle and the one in China, although I do know something about him. He has difficulty seeing things without his glasses; he does not want anyone to share his bedroom; he refuses to eat pork; he is infatuated with souvenirs from his friends. So many small things make me believe that he is at least different from other artists I know. While he is exploring the world of art all the time, he is worth exploring, too.

Interview

-- What is the biggest change you have experienced in recent years?
-- I draw fewer monsters. Yes, it isn't that I am tired of it or I will never draw them. After all, I am likely to provide Massive Black some support they need for their game production or some conceptual design for TV and movies. But for my individual creation, or if someone invites me to draw and tells me "Hey, just do it in your own style," I will give up the idea of creating monsters or of conceptual design. I want to be a purer artist, who can make use of newer and more diverse means to let others appreciate more forms of graphic arts. If you can hear the sound, smell the aroma and feel the temperature and mood from my work, you will find something from the work beyond the story and fantasy. I try to become a pure artist, and you can see I am exploring different areas: body painting, tattooing, sculpture and fashion design.

-- But you are now also passionate about drawing by virtue of music?
-- Ha ha, yes. If I don't explain, I don't know if anyone can see the "note" from the picture. Although we call it music, the fact is that I make graphs with the sound software and then use the graphs as the elements that the picture needs. It's something like the traditional collage. You know, sometimes the inspiration of an artist can dry up. Even if it does not, it might be constrained by certain thinking, and you will create mechanically. So I need some new graphs to inspire me. My friend Karl invented the software; he is also an outstanding artist and has many fanciful ideas, just like me. I believe it is these ideas that make the world change gradually.

-- In your opinion, the more difficult part of drawing is not technique, but exploration and innovation. Right?
-- It is so when your technique reaches a certain level. I know many who do game design and become workers in the pipeline. You can only bring into play a limited part of your imagination within a style of games, but it is necessary. It is true that a job is a job. But beyond the job, you must have another way of creation – if you really love art. You know, without this exploration, what we see now might be the works of Rembrandt, Monet or Sir Tadoma, and many industries would stop progressing.

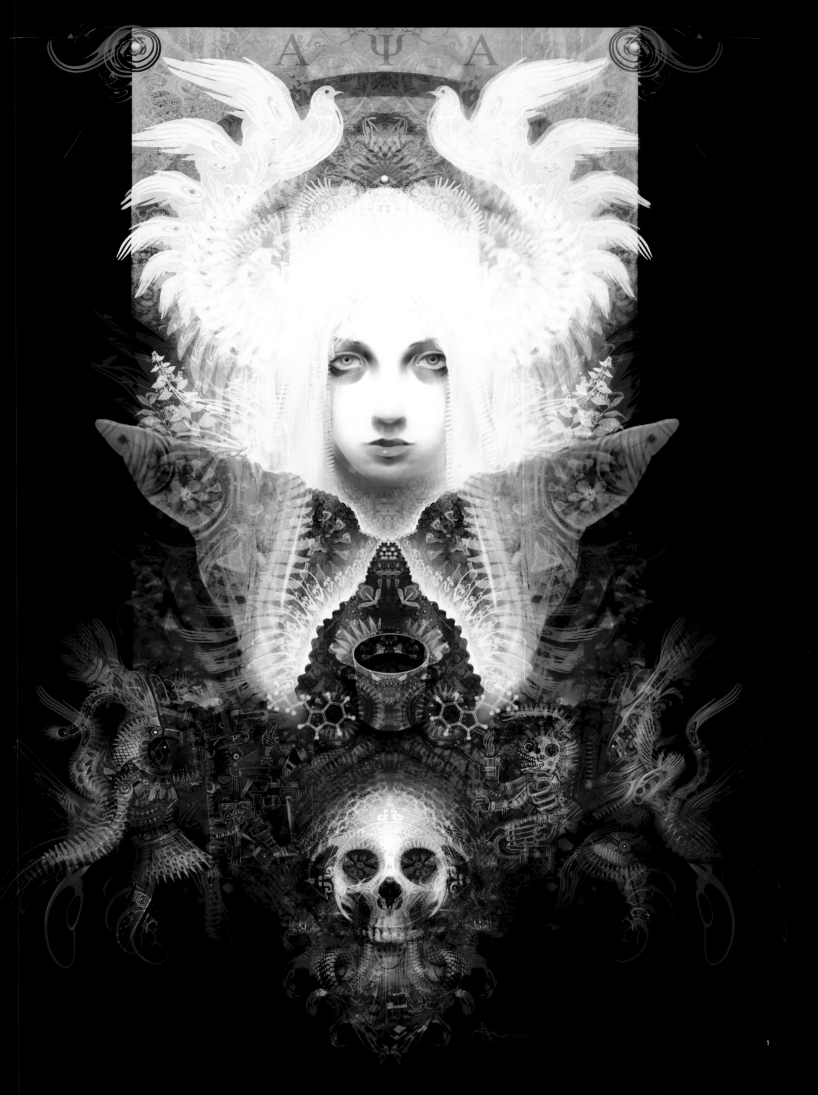

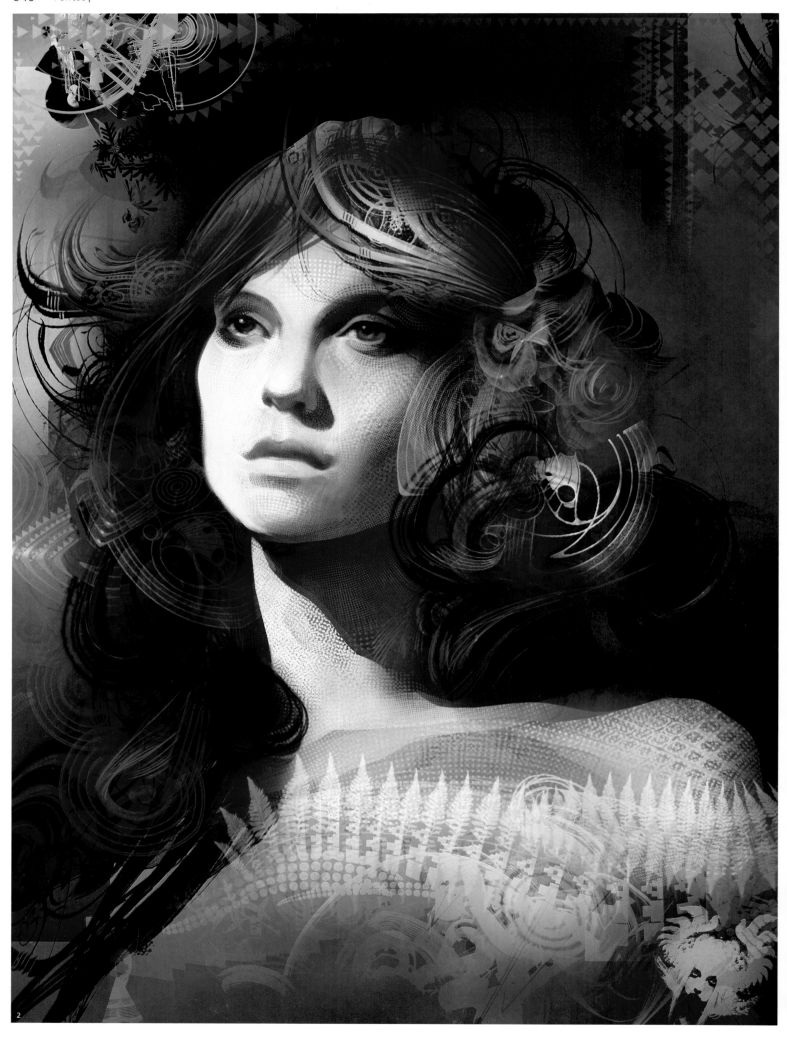

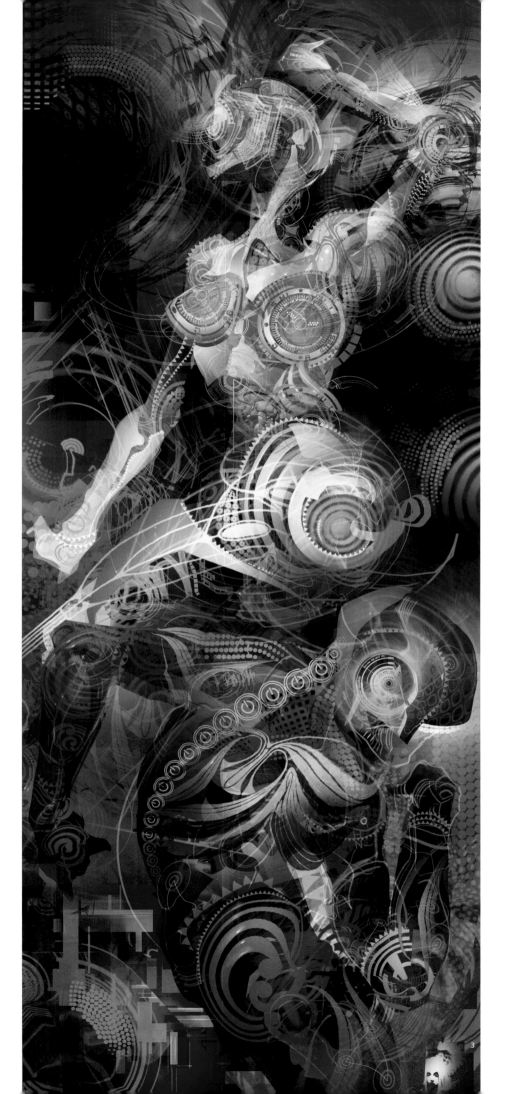

❷ Jess Love Red Final

❸ Adam and Eve Android

-- In your opinion, is exploration an attitude or a skill?
-- It is an attitude based on skill, absolutely. But on a number of occasions, the attitude might affect the skill you get later. You should first find out what you are best at, then what you love to do. Don't give in to others' opinion. They may say that you should do this and that, and you can make money if you do this. You are young when you begin to choose among the arts, so you can take some risky chances. Many masters in this field did not begin with professional training, so there is more than one road to success. The experiments in art are not like that in the economy; you will get your reward whether you succeed or not.

-- We have talked a lot about our understanding of the present. And as you said, we must go on with exploration and innovation. What do you think the future of CG technology will be like?
-- I hope the future might go beyond my imagination. What I imagine now is that we can draw with means other than hands – just like the game controlled by the mind, which has already been developed. Perhaps, there will be a form of art that really combines the computer and the body – the picture I imagine can directly appear on the computer. The technology must reach a high level for this to come true. The CG practitioners of our generation are growing together with the CG art. They will witness its combination with traditional arts. And the CG will become an ordinary trade when such a combination is achieved. We are now using the computer as a tool. If the technology is advanced enough to combine the computer with the human body, we will not create via such a tool, but on ourselves. But who knows what will take place in future?

❹ Lotusdrop Flat Plankton ❻ Punisher Android

❺ Mama Wisdom Cypher ❼ Mix Master Android

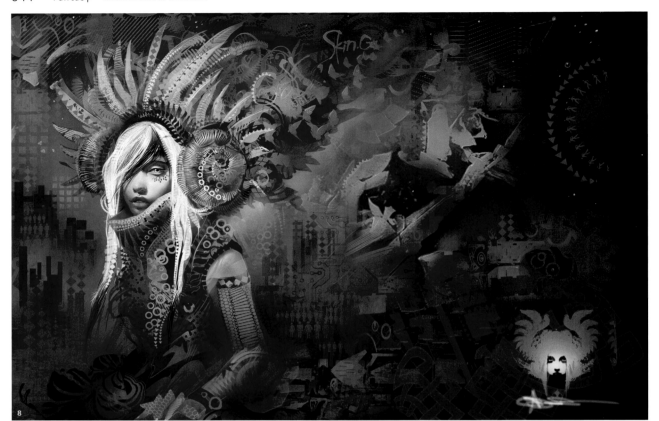

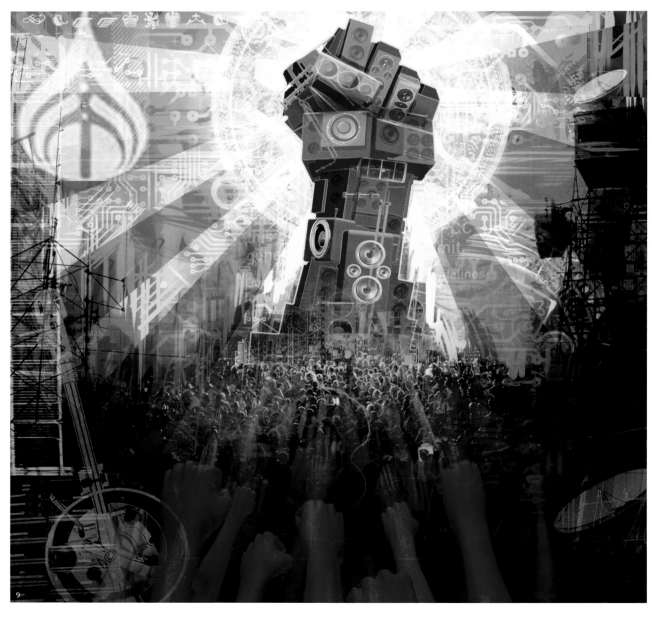

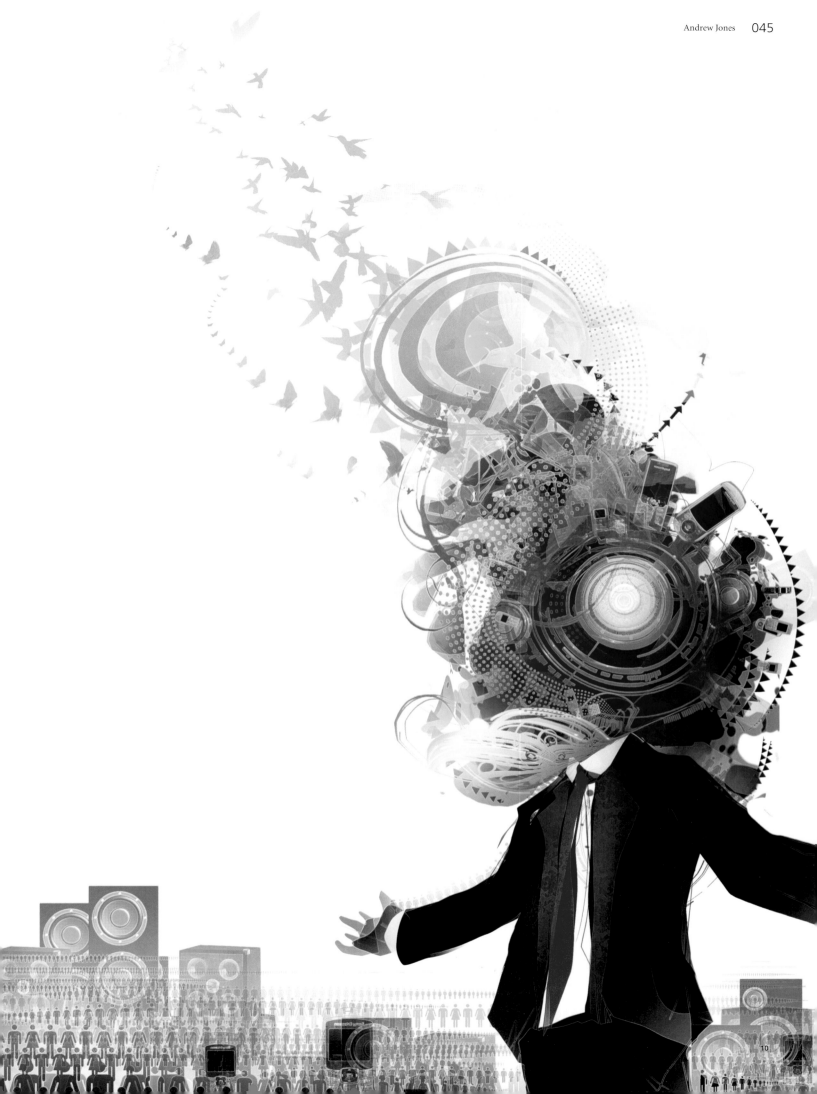

Andy Park

Name: Andy Park
Occupation: Concept Artist
Homepage: www.andyparkart.com

Andy Park

Working on Myths
An Interview with Andy Park, Concept Artist of Sony Santa Monica Studio

Andy Park has spent most of his time since 2000 with Sony's Santa Monica Studio, which is producing the best Greek Myth-themed games of our time – "*God of War*" series. They recreate a grand epic via a new hero "Kratos". Andy is responsible for the setting of characters, scenes and monsters. He is the most senior designer at the studio; we can hardly remember that the American-Korean came up in the community of cartoons in the early days. But Andy loves his identity as a "myth worker." From his story, you can see how a typical cartoonist enters into the mainstream market and begins to apply CG technology in the age of technical innovation. This is the third time I have talked with him. I know he has not changed much in almost 3 years. But as a man living in the world of myths, he can always arouse your curiosity.

Interview

-- Nowadays, digital arts are developing in such a vigorous way that a lot of people have thrown themselves into this industry. Thus, what is your trademark feature?
-- There are definitely more and more artists coming into the industry. And the use of digital art is pretty much standard in almost all entertainment fields. It's definitely a skill most artists need to know these days. So you ask what's the feature of my artwork? I definitely don't claim to do anything necessarily unique or special compared to any other artist. I learn from artists all around me every day. We all learn from each other and all borrow techniques and such from each other. I guess one thing that influences my art is my background. I started out my career as a comic book artist and an illustrator. Before I got into digital art / painting I drew almost exclusively with only a pencil for about 10 years. So in recent years when I approach my concept art and other digital art I think that background is always stamped into my work. So I definitely have a storytelling background, which I feel helps me be a better artist all around. I'm always trying to think of the story behind a character, environment, etc.

-- Digital arts have allowed the artists to explore more styles and subjects. What do you think of that?
-- When I discovered programs like Core I Painter and Adobe Photoshop I fell in love with them because they combined my two loves: drawing and painting. Working digitally really allows me to be flexible and go back and forth between drawing and painting. Traditionally when you use a pencil you are only drawing. You have to finish a drawing first and then go and paint over that drawing. But with digital you can go back and forth from drawing to painting throughout the art process so fluidly. It really opened up the possibilities of creating artwork. I also love creating artwork with a variety of subjects as well as styles from characters to environments, to photorealistic to cartoony. I just love creating, and working digitally definitely helps me work fluidly in whatever style or subject matter I choose to create in.

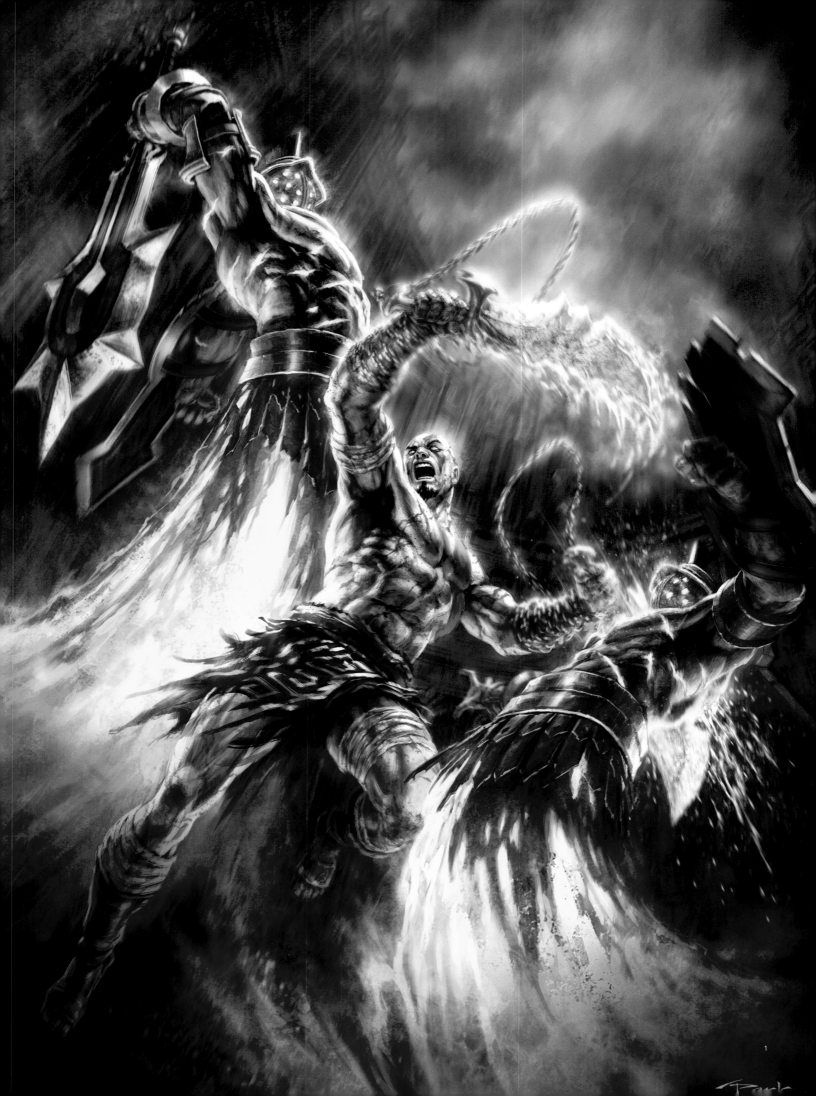

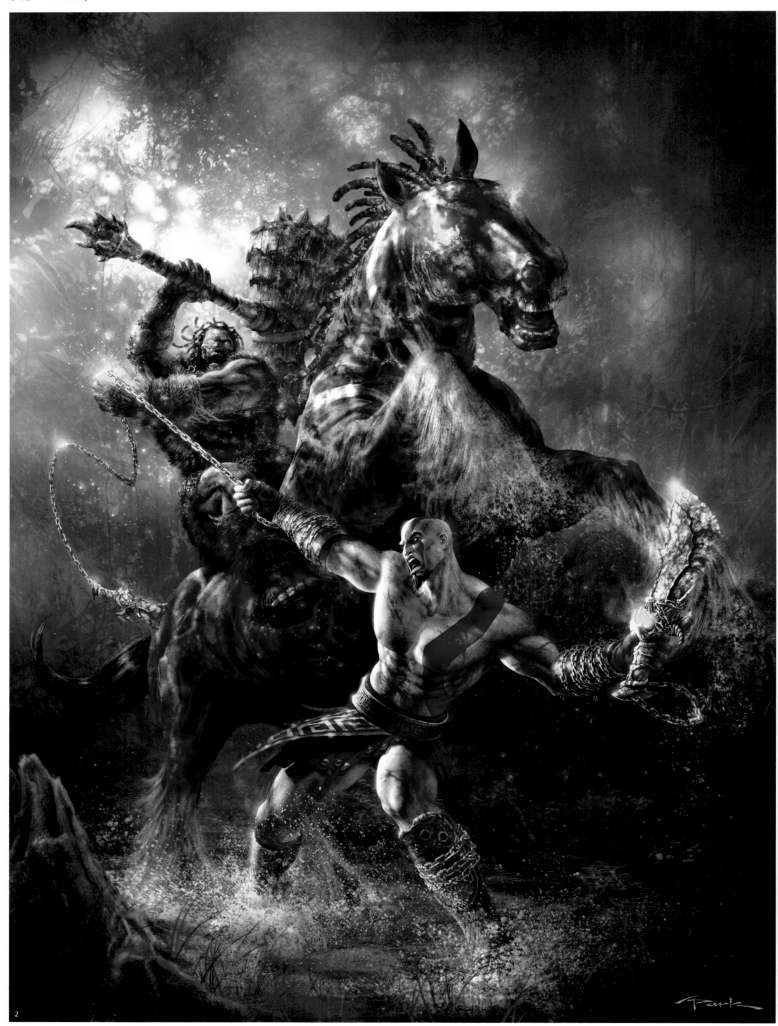

-- For the past three years, what's the biggest change in your work and life ?

-- For the past 3 years I've been working at Sony as a Senior Concept Artist. I've been concept-designing characters, weapons, creatures, environments, illustrations, and whatever else they throw at me for the *God of War* franchise (*God of War II*, *God of War PSP*, and now *God of War III*). I've also been doing a lot of freelance work on the side doing concept designs as well as storyboards for various television and film projects. But the biggest change is that my wife and I had our first baby earlier this year. So I'm a tired but happy man.

-- What has been the focus of your work over the past 3 years?

-- For the past 3 years I've been working on *God of War II*, *God of War: Chains of Olympus 20* and *God of War III*. On those games I've been focusing mainly on doing character/creature designs as well as doing marketing illustrations. I also do a lot of concept design and storyboarding for television and film projects throughout the entertainment industry. I really enjoy working on a variety of projects from commercials, to television shows, to video games, to movies.

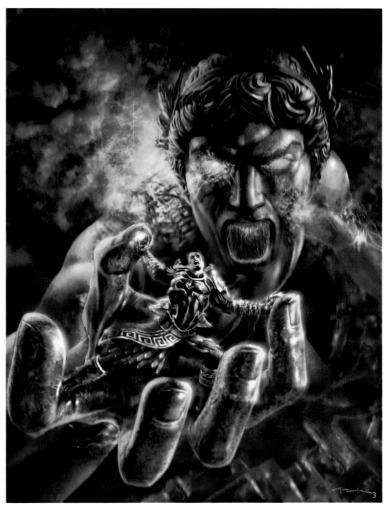

❷ Barbarian King Marketing

❸ Colossus Marketing

❹ *God of War* Sketch

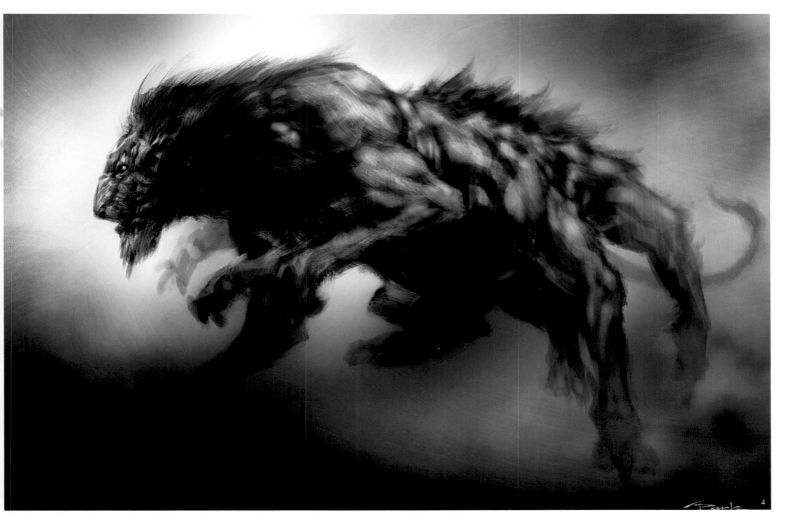

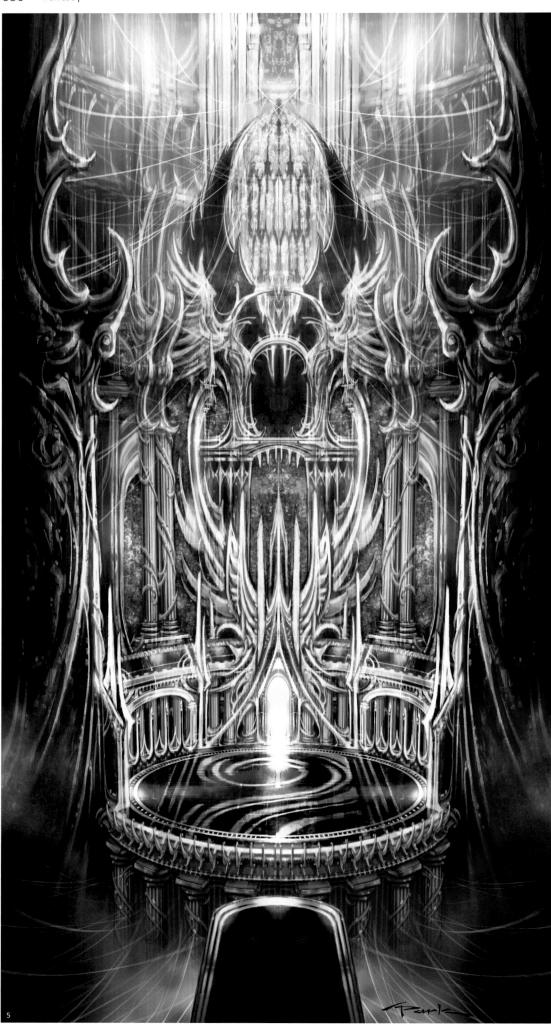

5

-- *You have been engaged in digital artistic creation for many years. Would you share with us some practical experiences?*

-- In my digital artwork the program that I almost exclusively use now is Adobe Photoshop CS2 or CS3. I used to use Corel Painter more but in a production situation working here at Sony, it is just easier and more practical to use Photoshop. This is because of the need to make changes on the fly and make adjustments throughout the design process. The layers in Painter are just more difficult to use than the layers in Photoshop. Although I do have to say that I like Painter's more traditional media feel. I wish we could just combine the two programs into one. So all my techniques really are in using Photoshop. I've learned the value of using layered effects, custom brushes, filters, the transform tool, and the liquefy filter. It really just comes down to experimenting and seeing what you like and don't like. I am in talks to do a DVD tutorial where I will be demonstrating my design process. When that is available I will be sure to announce it on my website and blog.

-- *Now more and more people are engaged in this digital industry. Do you think traditional hand-painted art is still needed in this era?*

-- Technically speaking, an artist doesn't necessarily need to know or have a background in traditional media such as oil, acrylic, or watercolor. Heck, they don't even have to ever pick up a pencil before starting directly in digital programs. But I'm definitely a firm believer that the best artists out there all have had some sort of traditional background. You learn things when working traditionally that you can't learn if you only work digitally. So I'd say that traditional art is still very necessary in making an artist. But in a professional setting, artists will rarely get to work traditionally since the advantages of working digitally are so great. So the importance of traditional skills is really in building an artist's strong foundation. But it's not necessarily needed in a professional environment.

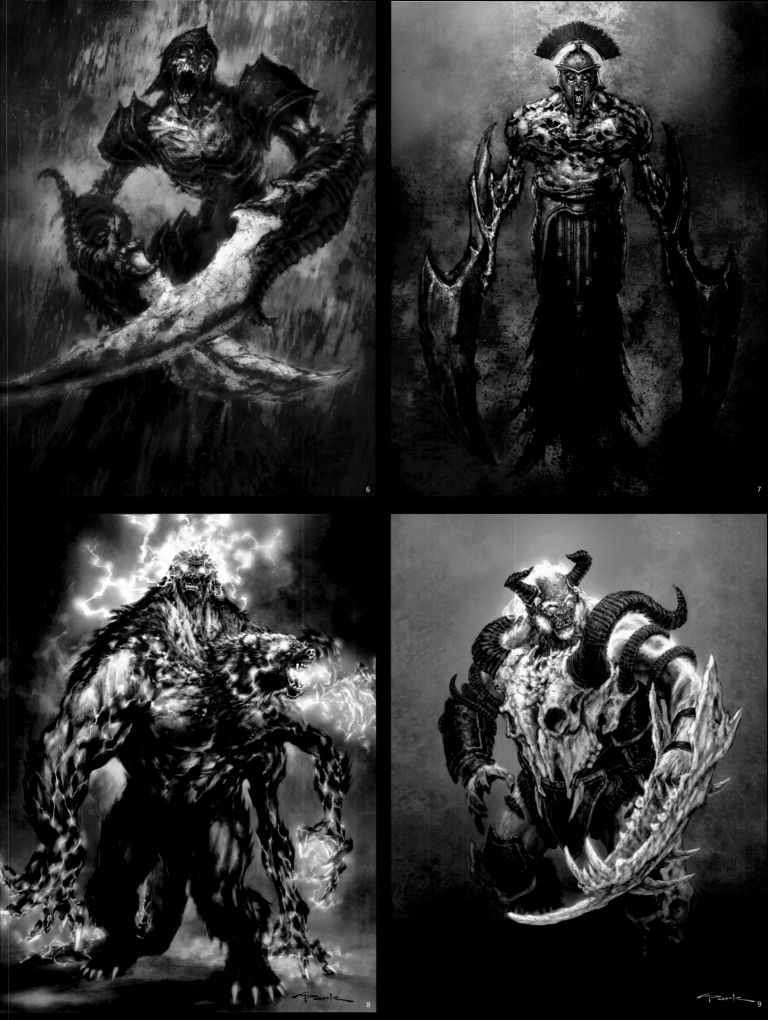

6

7

8

9

🔟 Zeus Throne Room

⓫ Mount Olympus

12 Chimera

Edu Martin

Name: Edu Martin
Occupation: Freelance Artist
Homepage: www.theposmaker.com

Edu Martin

A Strange Guest on the Planet

An Interview with Spanish Digital Artist Edu Martin

His full name is Eduardo Martin Julve, who also cut a figure at CGTALK very early. He once told me he hoped to work in the U.S. one day. But for the several years, he has been moving around several European countries. In fact, it doesn't matter where you go according to him; you can't go outside this planet anyway. As long as you can do your favorite work and tell others funny stories, you get the biggest return.

On this planet, Martin has created many strange images, all of which originate from his love for cartoons. He has loved cartoons since he was young (the first CG image he created was from *Adventures of Asterix*). He is also eager to make movies. But he failed to apply for admission into a cinema college in the end. However, this didn't hinder him from moving forward and he participated in a 3D study program. Although it seemed not very formal, he was so engrossed in it that he produced his own short animation in 1996. From then on, he became known in the industry and his stories won him many international awards. He brings lots of strange ideas to this planet. He never stops spoofing, even on himself.

Interview

-- The video industry is developing rapidly. Do you feel it in Spain? What changes have happened to you?
-- In the last three years, I have been to many places. For most of the time, I have been a freelancer. I participated in many different programs where I felt the industry awareness and the improvement in software. I'm mainly engaged in the production of TV advertisements. But I also did some image modeling in a TV program. Last summer, I worked for a Spanish company and helped them with the production of their first movie, which was a huge progress in my career because it was the work I always wanted to do -- the animated movie. Now I am still doing this job. Because of the job, I moved to a new city where both the people and scenery excite me.

-- Many people would participate in all kinds of selection contests with their own works each year. In your own opinion, how do you stand out from other competitors?
-- First, I don't think I am a creative artist. In fact, compared with pure art, all of my works pay more attention to storytelling. The image creation is based on the story I want to tell. But that means it needs for me to spend a lot of time and resources on it. It appears quite simple to create only static images. I don't pursue innovation in styles or techniques. I just want to tell interesting stories. The image style is decided by the story itself. I always seek to find suitable styles for stories, including my own style. So I think this is the reason why I've received some awards.

❶ Mexican Wrestler

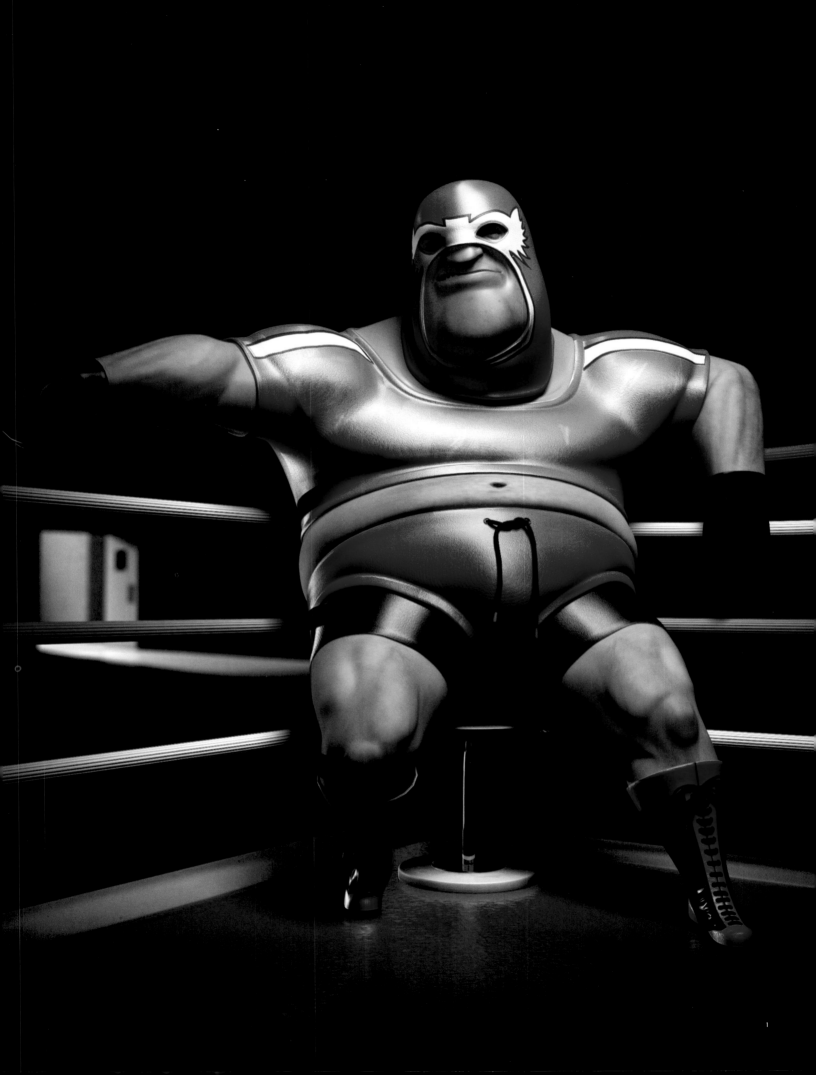

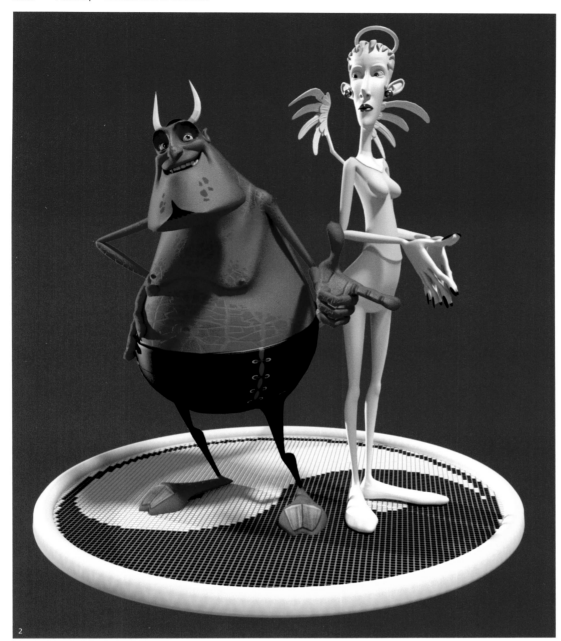

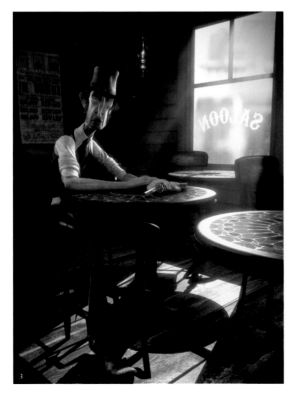

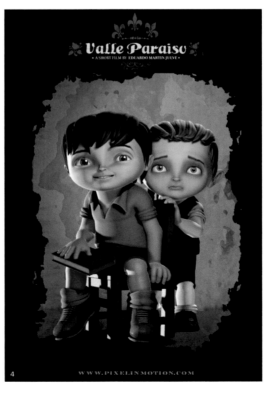

❷ Cross Roads

❸ Cowboy at Saloon

❹ Valle Paraiso

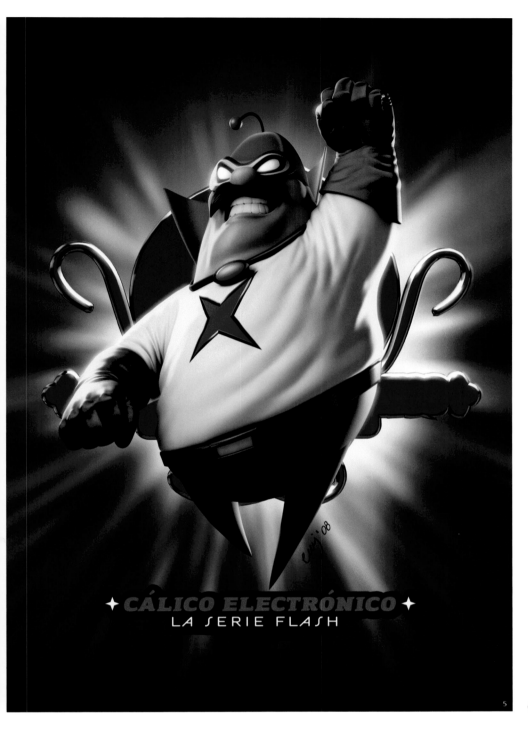

CÁLICO ELECTRÓNICO
LA SERIE FLASH

5

❺ Calico Electronico

-- For years, most of your works are cartoons. Is this because of your special positioning or your enthusiasm for cartoons?
-- Yes, I have intended to present their style. I have been a super cartoon fan since childhood. And I always think that for works produced with computers, the cartoon is a great source for character creation. Except for this kind of art, I can't find any inspiration in the real CG works. I mean that there are very wonderful and real artistic pieces in it. But if you try to tell a story, its content loses the meaning to express. Anyway, I believe there will be more 3D works to see next year, and many potential 3D cartoons will come out before us.

-- What role does hand-painting technique play in your life? Is the software technology more important for an animator?
-- Traditional hand-painting will not disappear. All the CG images begin from the bi-dimensional concept and it will also be so in the future. Compared with WACOM and displays, some people prefer the feeling of holding real brushes and white canvas. I am one of them. In the path of my artistic creation, it was those respectable artists such as Simon Bisley, Frank Frazzeta and Liberatore who first inspired me, and Sebastian Kruger's satirical cartoons also gave me inspiration, although I haven't attempted to present their style with computers. I think many people will choose new painting tools in this era, but traditional techniques will never be substituted.

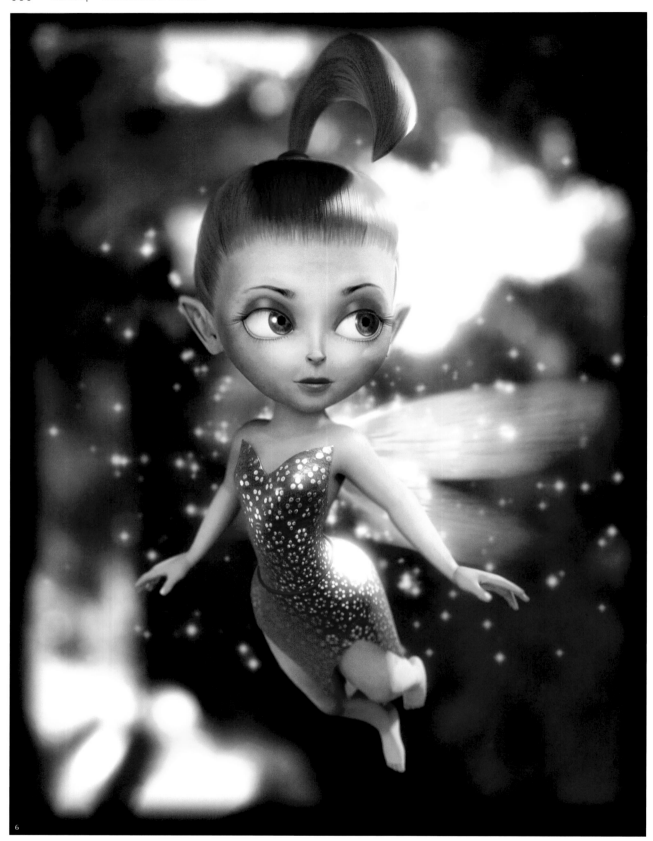

6

-- In the end, would you like to share with us your creation techniques?

-- My main principle is basically "keep it concise". I live in a small Spanish city where it is very difficult to acquire resources and achieve a big goal with a lot of money. So you need to train yourself to meet the requirements of clients in a flexible way. I believe there are no tips for it. The important thing is to realize your limitations and try to learn how to make works "perfect" under these kinds of restraints. I believe forever that it is more effective than the creation of a simple character. An excellent story or animation is the result you and your client expect. I try my best to do everything "consistently." I mean you also need to focus on models you create. It is necessary. When you have to do texture and character design, it will give you great convenience. If you apply the principle on each stage of your work, every thing will become excellent and convenient.

❻ Fairy

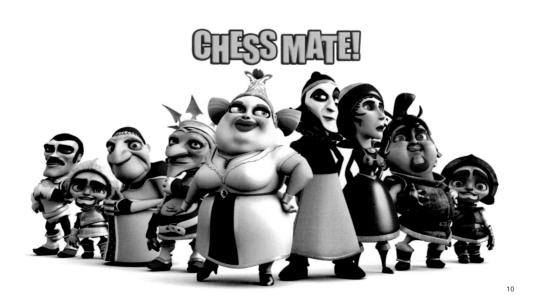

7 Bill

8 Pirata

9 Louise

10 Chess Mate

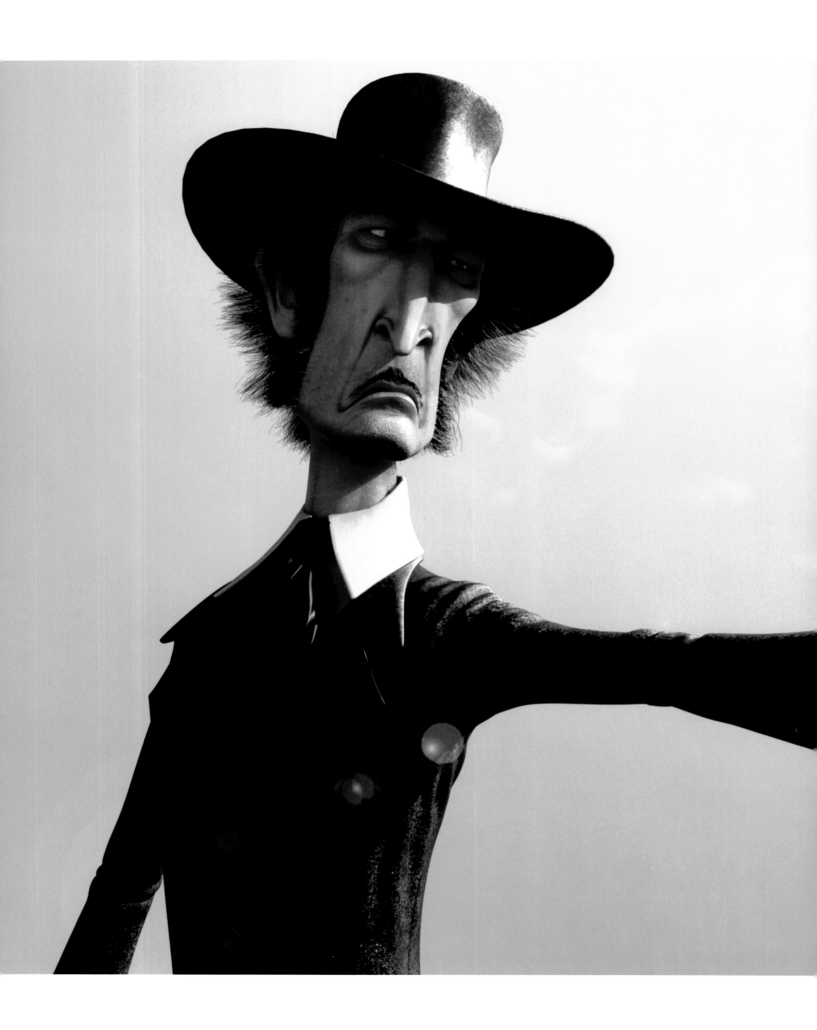

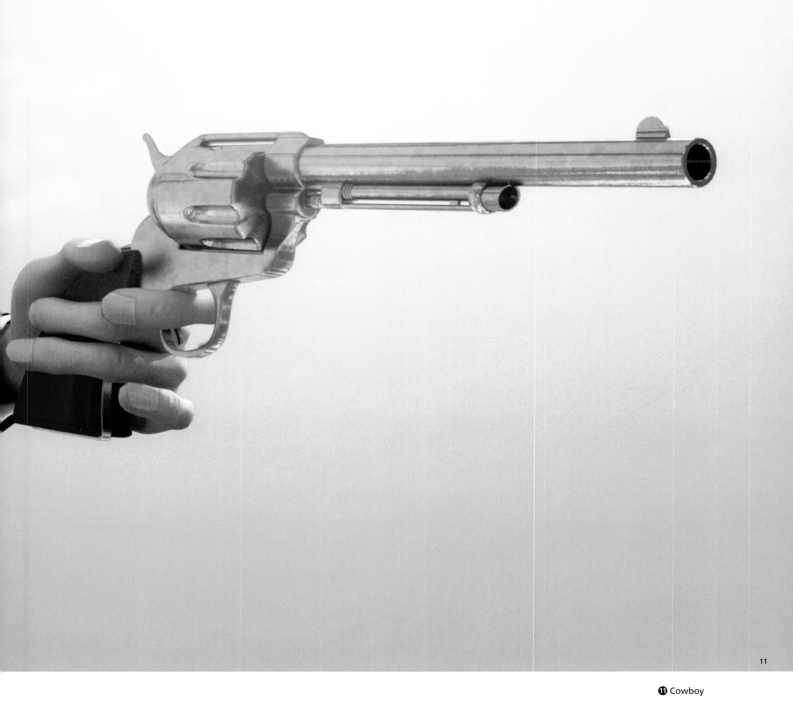

11

Name: Alex Taini
Occupation: Art Director of Ninja Theory
Homepage: www.talexiart.com

Alex Taini

..

His Hatred and Love There
An Interview with Italian Digital Artist Alex Taini

..

Alex Taini was born in Genoa, Italy, the 2nd largest port in Europe, where numerous vessels berth. It was a bit strange that an artist was born there, since most of the locals made their living on the sea. After studying illustration and communication at a local visual communication school, Alex worked for 3 years as a freelancer illustrator and found himself at odds with the country. He could not realize significant improvement in his work as a freelancer. To give his energy full play he needed to be in a country with a real digital art industry. He chose London.

In London, he participated in the production of LUMINAL (2005) as a concept artist and designer. After that, he published his first collection of thrilling drawings DARK DEMONIA. Later he worked on the project HEAVENLY SWORD for Ninja Theory as a concept artist. Now he is an art director of the company.

..

Interview

..

-- Nowadays, digital arts are developing in such a vigorous way that a lot of people have thrown themselves into this industry. Why did you throw your vigor in London and not your native Italy?
-- Yes. I went to London because in Italy there are not enough opportunities for game design or film making, which is a very unfortunate thing for the Italians who are known for their artistic talents. It is not possible for us to live only by our art, especially 8 years ago when I moved to London. Unfortunately, there has been no serious change still in Italy.

-- Which artists influenced you the most in your art career?
-- When I was younger I was really influenced by Giger, maybe because I was drawing with air brush. But at some point I decided to move in a different direction. Now I like to turn to master painters such as Caravaggio and Rembrandt for inspiration in light and mood, and many photographers such as Floria Sigismondi and Saudek for creativity and composition.

-- Would you please share with us your experiences in concept art?
-- The most difficult thing is creating beauti-ful pictures in a short time. Being creative all the time is not easy; especially if you don't have much time or you cannot find a direction you like. In this case you have to be very professional, putting all of yourself into it, showing how your style can actually make a change to the work you are assigned to do. A good concept artist is supposed to help the team to understand what has to be built in 3D with as many details as possible. Your contribution can be a mood image, a technical drawing, or anything that clearly represents what the team needs to do.

❶ Nariko Final

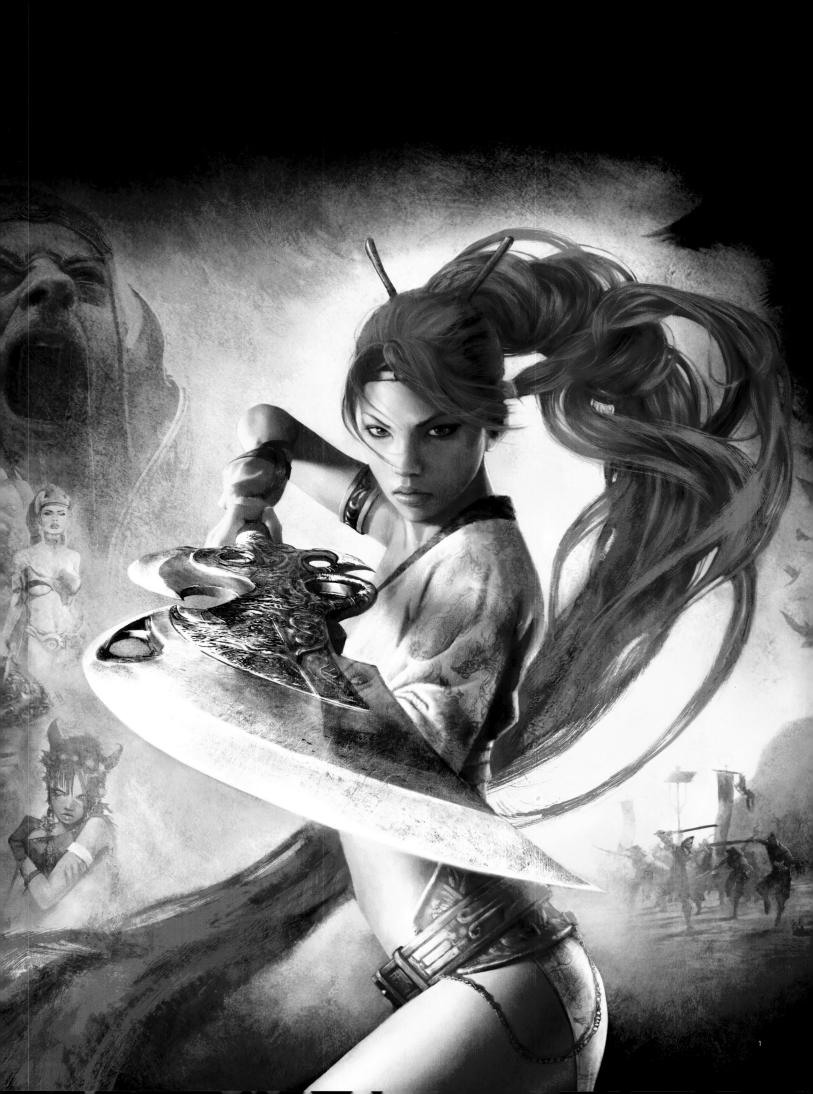

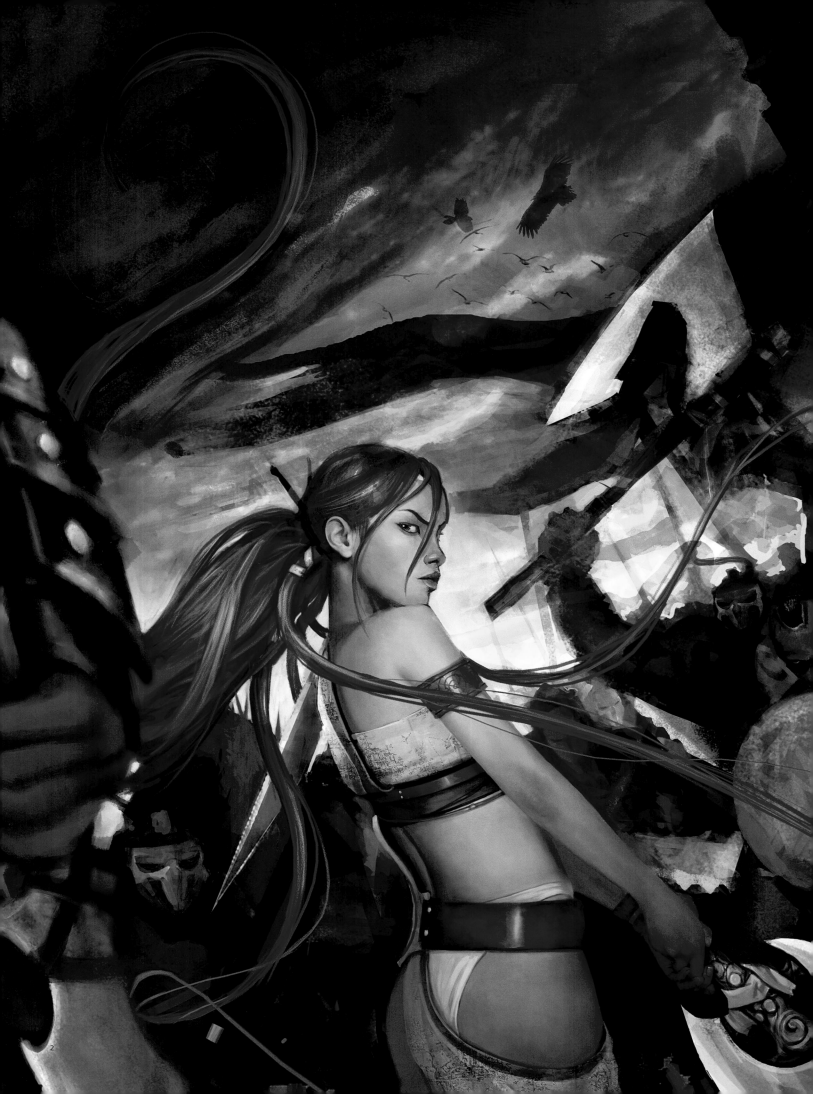

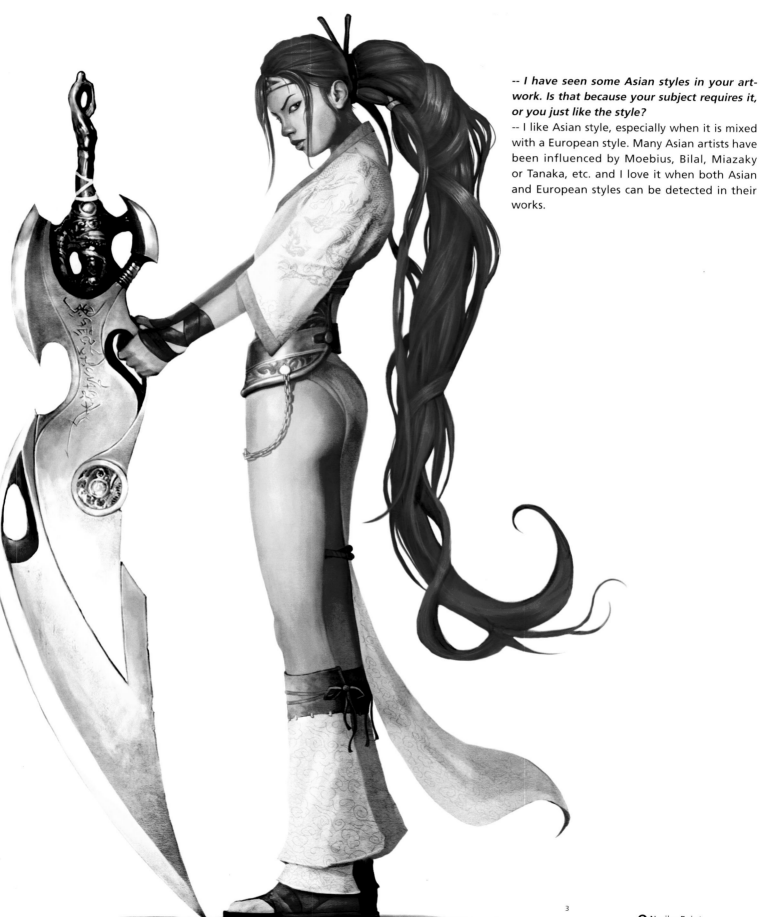

-- *I have seen some Asian styles in your art-work. Is that because your subject requires it, or you just like the style?*
-- I like Asian style, especially when it is mixed with a European style. Many Asian artists have been influenced by Moebius, Bilal, Miazaky or Tanaka, etc. and I love it when both Asian and European styles can be detected in their works.

3

❷ Nariko Paint

❸ Nariko

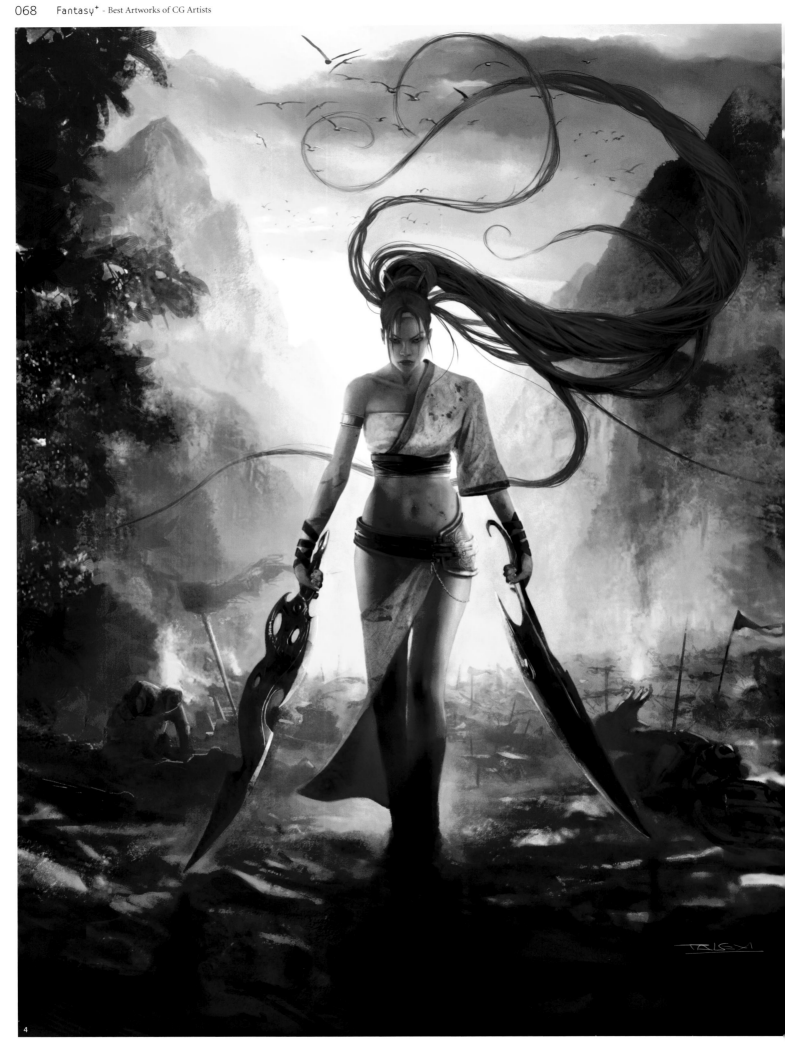

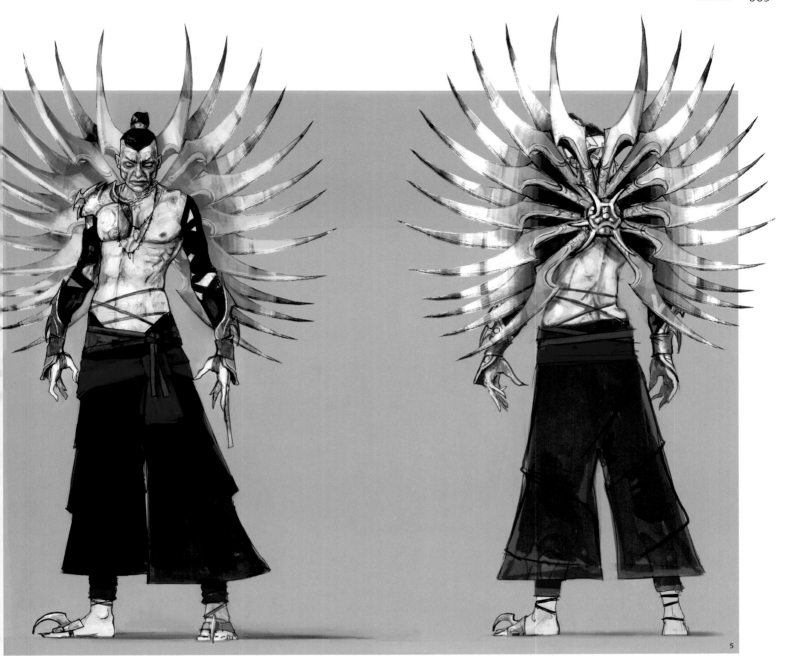

5

6

-- *Digital arts have allowed artists to try working in more styles and subjects. What do you think of that?*
-- I don't like artists doing the same thing all their life. Ceaseless exploration of new techniques is essential for an artist. Sometimes, even using different computers can enable me to change approaches in my painting.

❹ Nariko Speed Stance

❺ Areal

❻ Areal Face

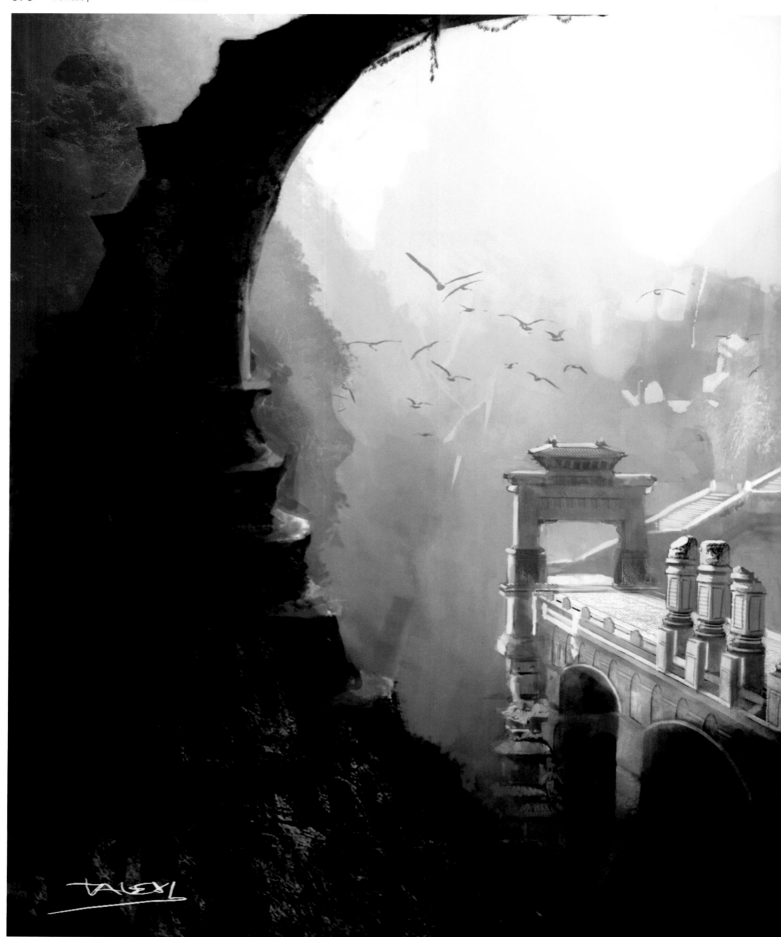

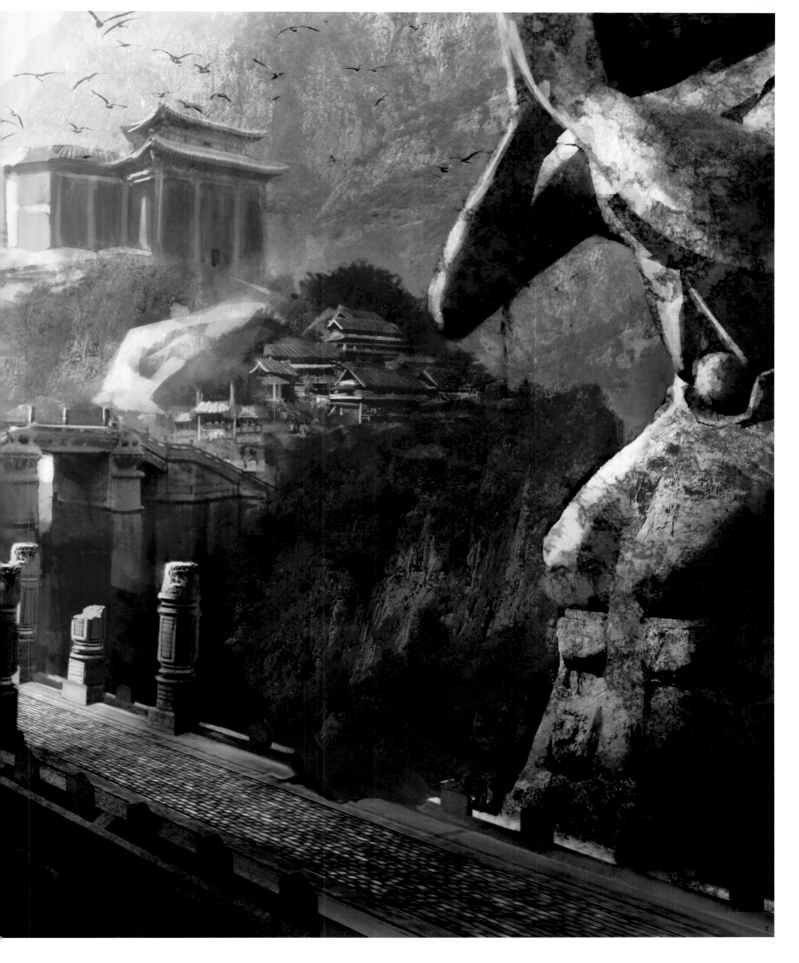

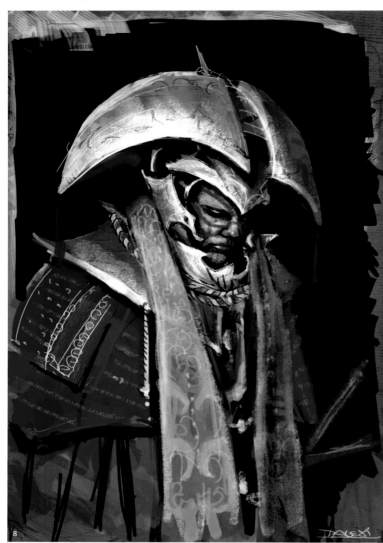

-- What do you think is the next step in digital art?

-- In the future, we will not be creating only fantasy, gamey, horror-fantastic subjects, but go further in giving meaning to what we are doing. A poetic, political, religious meaning, everything that an artist should do; there is much more than working only for a game or a movie. Artists should take consideration of poetic, political and religious meanings, which has more significance than just making a film or game.

8 King Face

9 Natural Bridge

10 Kink Andy

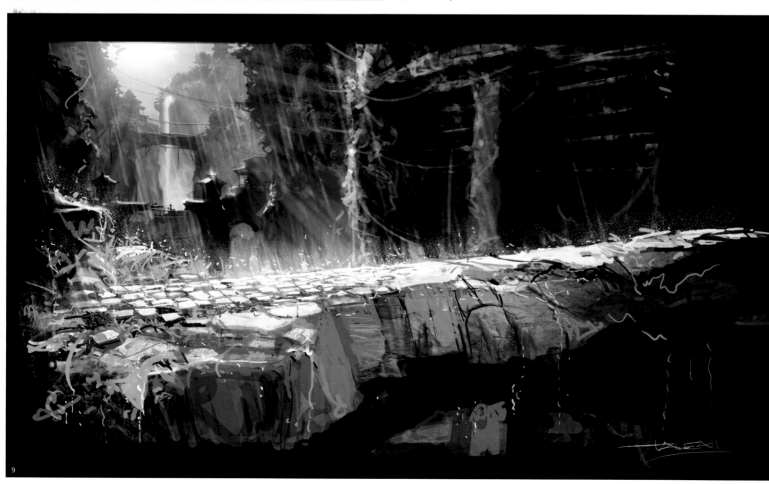

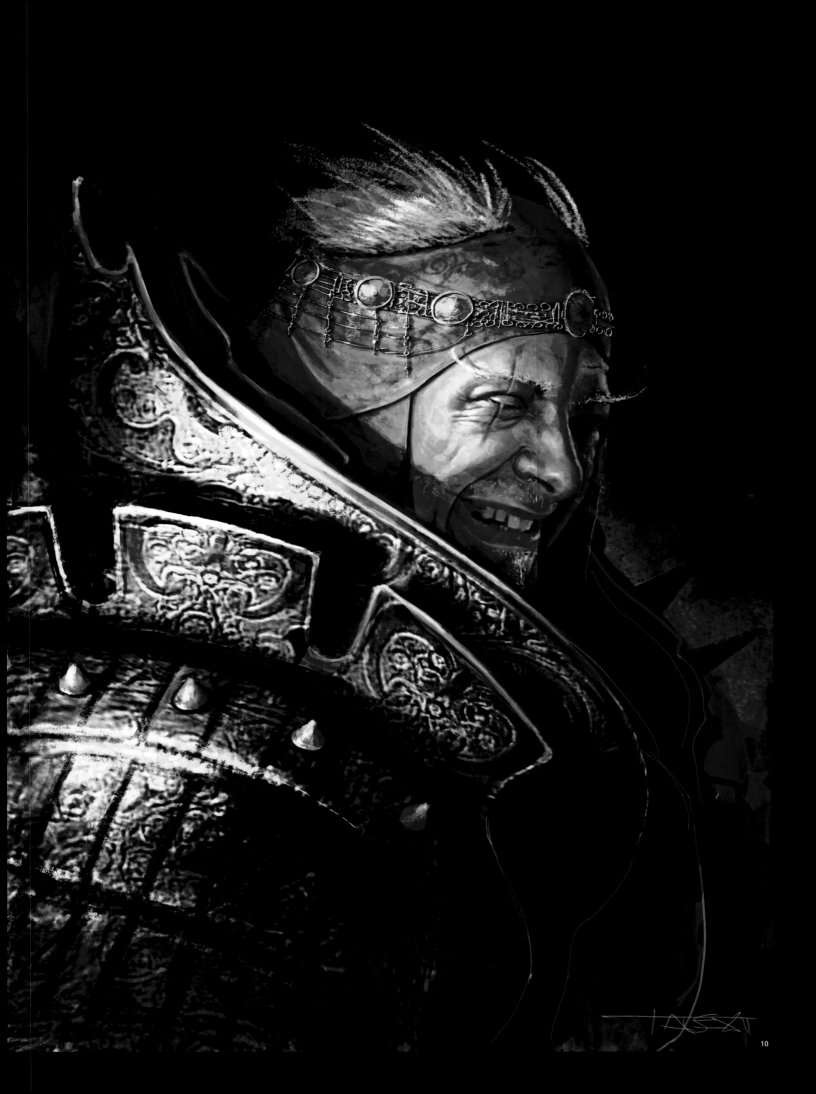

Name: Bobby Chiu
Occupation: Imaginism Studio
Homepage: www.imaginismstudios.com

Bobby Chiu

Without Limits
An Interview with U.S. Artist Bobby Chiu

This is the third time I have interviewed Bobby Chiu. Indeed, I don't think I have much to ask about him. But seeing his works always gives rise to my curiosity. I feel that there must be special interest stories behind every character and always wish to explore them. But limited by the length of the essay, I end up asking something about his recent conditions, just like an old friend, as well as his views on the subject matter of this interview.

There is no need to introduce the much-talked-about Imaginism Studio. In this era when vagaries are celebrated, fantasy arts reach there acme. Bobby used to tell me that exaggeration has its own rules, which you must follow to design characters that match with the actuality. But it now seems that there is no such a thing as "actuality" – What is flying? What is standing at the corner? What is running and roaring? You cannot tell what surprises and joy Bobby

and his peers will bring to the world. Anyway, there are no limits to their ideas, and the works from their gifted brushes are quite beyond other designers.

Now, possibly because their teaching videos online provide others with opportunities to imitate, more and more designers begin to try works of Imaginism Studio's style, making it demanding to differentiate himself. It is no problem. We never determine what he truly thinks.

Interview

-- There used to be so many distorted human images in your artwork, which are now making room for distorted animals. Which do you think intrigues more interest? And is there any different rule in designing them?
-- I don't feel there are rules in art, only guidelines. Lately I've drifted away from painting people because I've been working on a few movies where I was painting creatures all day so I think about creatures much more. Maybe in the future, my work will involve more human designs and I will start painting more people again.

-- How is your studio progressing? Who are your main clients?
-- Our studio is strong and good, thank you

for asking! Our main clients right now are Sony Imageworks and Harper Collins.

-- There are some great artists in your studio. How do you manage to bring them together? Do you have fun in your studio?
-- We were all friends first. Then we found that we shared similar views on how we wanted our lives to be as artists and we came together to help each other achieve our goals. Everyday is very interesting. We often discover new things on the internet and share it around the studio. Sometimes it's fun to call the fans that email us and talk to them on the phone.

-- You are always trying to provide CG courses for your fans. How much have your achieved?
-- I get my greatest sense of accomplishment from seeing the achievements of my students. Many of them are now professional artists working in games, movies and television. I think the pride of every teacher is his or her students.

-- Digital arts have allowed the artists to experiment with more styles and subjects. What do you think of that?
-- I think the more styles you learn, the better. The more information and techniques you have, the more tools you can use to create your art and the more powerful you will become as an artist.

❶ Big Bad Bunny Eater

2 Tree Monster **3** Whale Boy

❹ Twins ❺ Carrot Run ❻ Babylon ❼ Kanga Mole Bunny

8

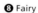

❽ Fairy

❾ Death of Teddy

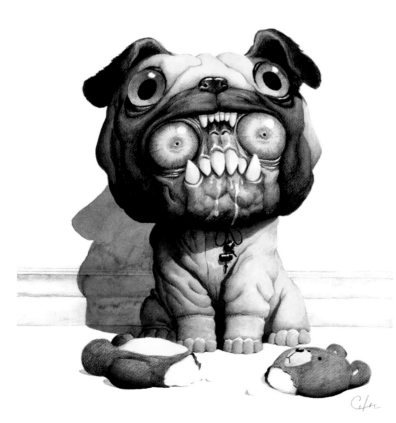

9

-- What do you think is the next step that digital arts will take?

-- I think the next step is to bring digital art into the fine art community.

-- What do you think is your largest accomplishment in the past two years?

-- I think the greatest progress is learning more and more about how life works and how we see the world around us. This is something that we never stop learning and working on.

-- Some students want to be a good CG artist as you. What do you think is the most important quality for a CG artist? Can you give them some suggestions?

-- I would strongly advise him or her to have a strategy about how they will improve and use their common sense. Write down schedules and goals and have a lot of passion when they work and talk about art. They will need to be intense and have a deep love for art in order to succeed.

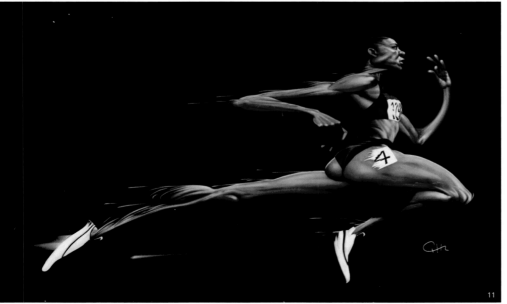

🔟 Mayan

⓫ Athlete

-- What are you planning to do at the moment?
-- To just keep learning new things and continue to build independence in my art and career.

-- Now more and more people are engaged in this digital industry. Do you think the traditional hand-painted art is still needed in this era?
-- Traditional art is such a wonderful thing and I think there will always be a place for it. Perhaps less and less for the entertainment industry but it's still very strong in the fine art industry.

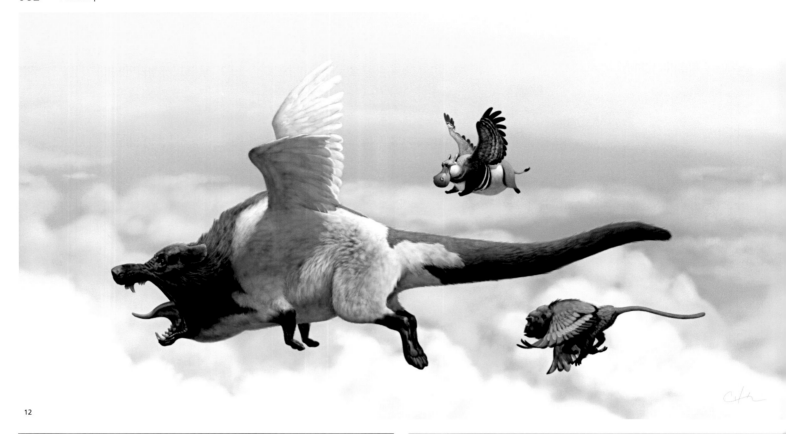

12

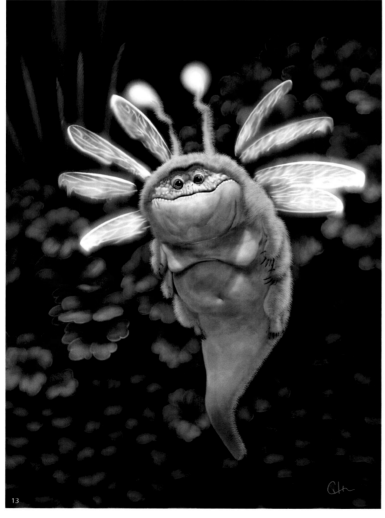

13

14

12 Flying High

13 Litebug

14 Bater

15 3 Samurais

Name: Christophe Vacher
Occupation: Designer, the Animation Design Department at Disney
Homepage: www.vacher.com

Christophe Vacher

The Back Side of the Poems
An Interview with U.S. Illustrator Christophe Vacher

I have read an interview with Christophe Vacher by a writer who called herself a famous poet in China. She seriously imposed poems upon the illustrator's works and its purpose was just to build a relationship of soul mates between the writer and the illustrator.

All right! Let's pretend that Mr. Vacher in-filtrated some poetry into those digital works that belong to pseudo-classic academism. You sense the light halo in the fog or the whisper of the wind and you become lost in it.

Now, please wake up and let's get to the back side of poems. Here, I introduce you to a professional digital artist, who has been working for Disney since 1989. From Paris to California, he participated in the concept design of many cartoons and films and occasionally holds some small exhibitions by himself. He has a pleasant personality and likes a free and healthy lifestyle, keen on martial art (*wushu*) and all kinds of sports.

Is he a poet? Stop messing with me! He is an actor.

Interview

-- Your artwork makes you look like a traditional artist, but your regular work is an animator. Why didn't you choose to be an illustrator?
-- Well, actually I am a little bit of everything. I developed my drawing skills first, and became a semi-pro illustrator / comic book artist. I was about to become a full time professional: I had an offer from a famous French comic book artist -Caza- who was one of the original artists who created "*Heavy Metal*" Magazine in the 70s. In 1992, he asked me if I'd like to start a comic book series with him. It was a fantasy story with a female heroine. But then, I entered Animation. It changed everything for me.

And I eventually moved to the U.S. Meanwhile, I was also doing book and CD covers and started to develop on the side my own paintings on canvas for Art galleries. So, now, I try to keep everything going at the same time.

-- Your illustration looks so classic, why do you choose this style? Which artists have influenced you most in your career?
-- Many artists influenced me. My actual style is influenced by old schools like the Great American Illustrators, the Hudson River school, the Romantics and the European Symbolists for their grandiose, theatrical scenery; my style has also been shaped by contemporary artists like Sandorfi, Beksinski, Ugarte and The Visionaries (Les Visionnaires) in France. All of these I credit for their striking visions.

-- I have noticed that some digital artists use Matte painting for background works. Are you one of them?
-- Yes, of course. Matte painting is just another way of painting for movies with Photoshop or an equivalent program. It uses both photographic montages and tricks, and traditional painting skills – although these days, many Matte painters of lower quality use only the photographic properties because they often don't really know how to paint.

❷ Vision at the Lake

❸ Expectations

❹ Claire Vallee

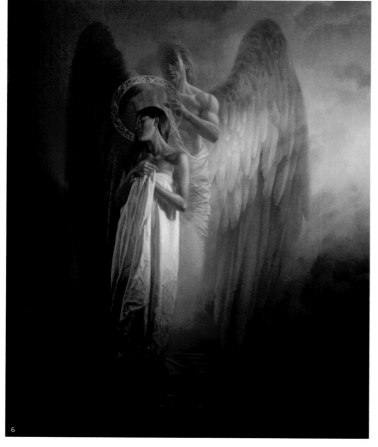

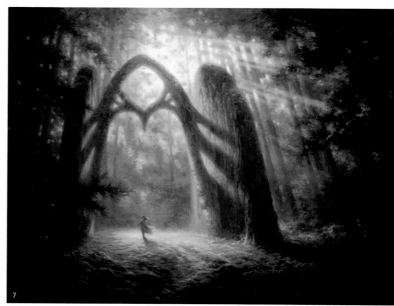

❺ Endless Dream

❻ Sacred Hour II

❼ The Gate

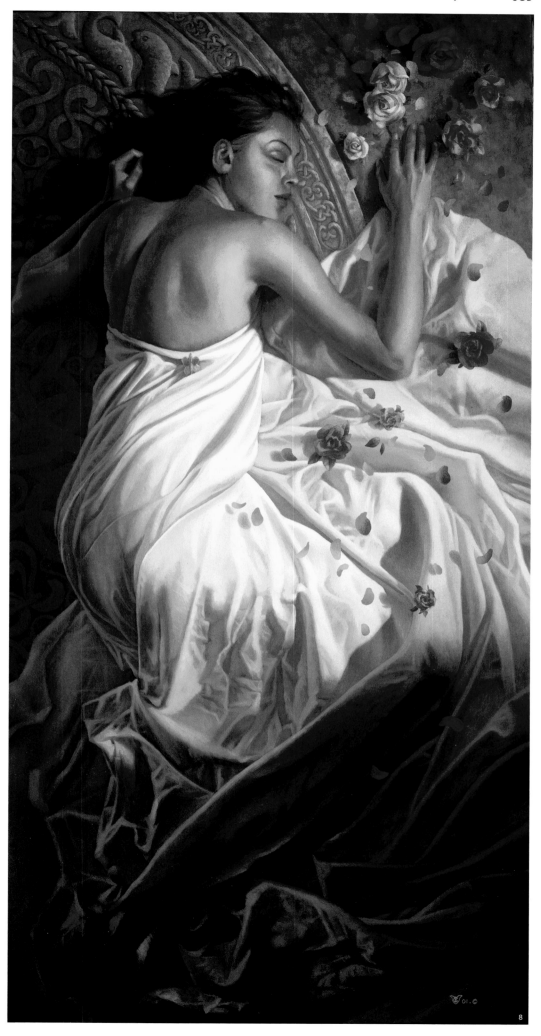

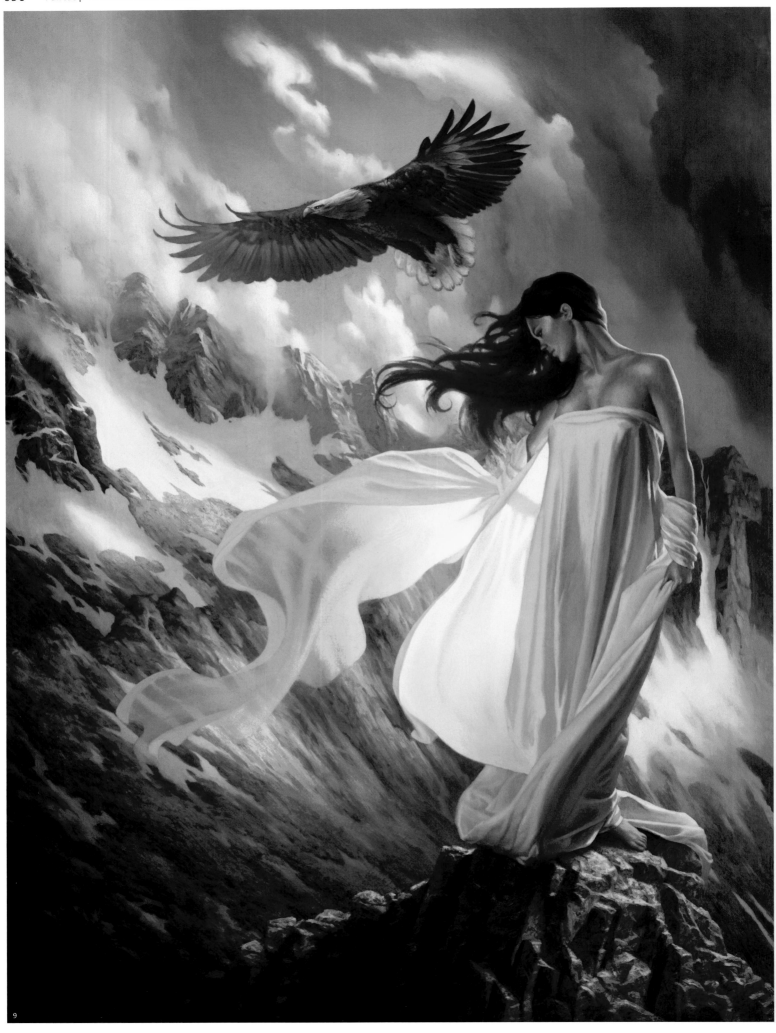

9

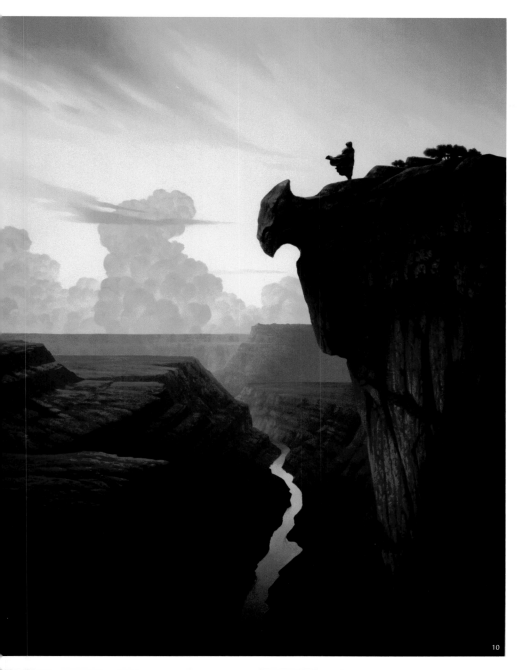

10

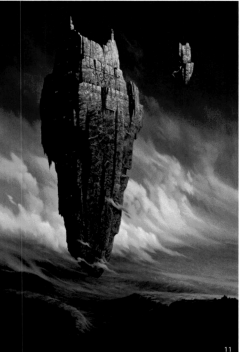

11

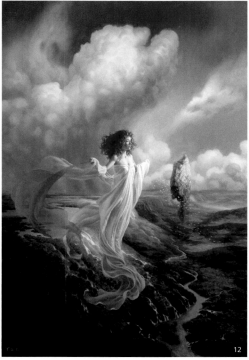

12

❾ Spirit Rising
❿ The Canyon
⓫ The Guardians
⓬ Mistress of the Winds

-- What's the focus of your work over the past 3 years? And what's the most important project (or the most memorable project) in the past 3 years?
-- I worked on quite a few projects in the past 3 years, but the 2 main ones I can talk about are Disney's "*Enchanted*", and the movie "*9*". I think my favorite is definitely "*9*", both because it was really cool to do the art direction on such a unique project, and because of the nice and professional people I worked with.

-- Digital arts have allowed the artists to experiment with more styles and subjects. What do you think of that?
-- I don't really think that the digital medium gives more styles or themes to the artist. It just gives the artist new tools and make things a little easier, like with the use of adjustment layers, cutting and pasting, deformations, etc....but these tools still require the same exploration as with traditional tools, the same skills as the foundation (solid drawing skills, understanding of proportions, volume, texture, light and color).

There are thousands of cartoony or realistic styles of all sorts. The digital doesn't create more styles; it just gives more tools to explore. As for themes, there are as many themes on the planet as there are books, songs and movies.

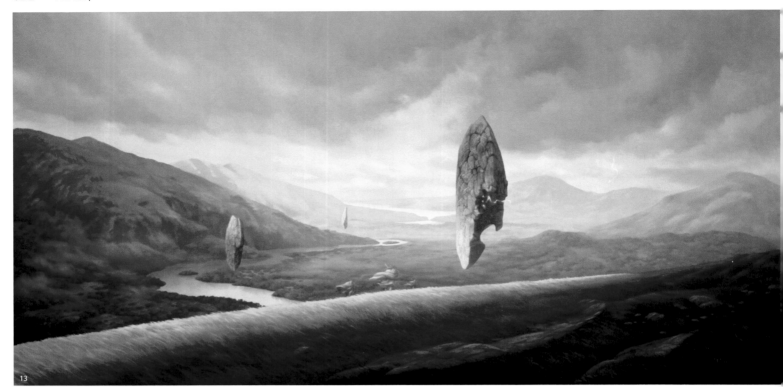

⓫ The Promise

⓮ The Messengers

15 ⑮ Storm Breakers

-- You have been engaged in digital artistic creation for many years. Would you share with us some practical experiences?
-- Everyone's practical experience is different, but I will say this: whether you use Photoshop, Painter, Maya, Zbrush, or any other digital package, you have to explore and know your tools well, and always go back to classical training. That is, drawing, painting, sculpting. This is the absolute foundation. If your drawing and perspective skills are bad, your paintings will be off. For sculpting, you might still do OK work, but good draftsman's skills will help you tremendously in improving your sculptures, no doubt about that.

If you're a painter, photographic experience can be a plus, or at least understand how warm and cool light reflects and bounces from one object to another, from light to shadow.

-- Now more and more people are engaged in this digital industry. Do you think the traditional hand painted art is still needed in this era?
-- Well, it connects very well to what I was just saying above: classical skills and training are still very much necessary. Whatever tools you prefer to use, traditional or digital, the foundation is still the same. A studio or a client doesn't really care what tools you use, as long

as you do a good job. The traditional tools are not really needed in the digital world anymore, but when an artist has a choice, he won't always go for the easiest solution. He might want to go for the most fun. And the most fun is not necessarily the digital solution. The feeling that real paint and a real brush gives to your senses is something the digital realm hasn't come close to, at least not yet. Some artists I know start their work with traditional tools and finish it with digital.

I think there will always be a place for traditional art tools, no matter what.

Name: Mike Daarken Lim
Occupation: Freelance Artist
Homepage: www.facebook.com/daarken

Mike Daarken Lim

The Big Player
An Interview with U.S. Artist Mike Daarken Lim

Daarken was a true player as a young child, when his biggest pleasure was the desktop and computer games which fascinate most children. When he grew up, Daarken spent most of his time out of school on games, which became an indispensable part in his life. He is still a player now, who has much to say about games. What is different about this player is that he designs games himself. Yes. From the self-made D&D maps to the conceptual design of various games, he always pays attention to the pictures of the classic games when he is playing. Then he creates works of his own style.

Even when he is not playing, Daarken always has a playful attitude. For him, drawing is something he loves. So he did not go job-hunting. But fate seems to favor the talented young man, and many clients come to him with commissions. And he gets the opportunity to enjoy playing the games he creates.

Interview

-- When did you start to be interested in art? Why did you decide to be an artist?
-- I think I have always been interested in art. When I was younger I collected comic books because of the art. In my free time I would try and copy the covers using pen and ink. I also used to play a lot of board games like *BattleTech* and *Dungeons & Dragons*. My friends and I would draw our own maps, weapons, and characters. At that time I knew that I wanted to create video games.

-- And what's the first video game you played? Why are you so obsessed with games?
-- Honestly I don't remember what the first video game was that I played. I know it was an old Texas Instruments console. I played a lot of games on that computer, but I really don't remember the names of any of them. What I like about video games is that for a short period of time you can be someone else.

You can venture into an unknown land and explore a fantastic place that doesn't exist anywhere else. It also allows me to do things that I would never do in my real life, like jump out of planes or kill zombies.

-- As you said, you spent a lot of time painting when you were in college, but after you graduated, you played games for 3 years. Why didn't you find a job in art?
-- Actually I got my first art job 3 months after I graduated. I started working for Fantasy Flight Games and Wizards of the Coast creating illustrations for their collectible card games. I think I got my first video game job about a year after I graduated. That was with Mind Control Software.

-- Why did WOTC call you and give you a job? It sounds so amazing!
-- You know, I am not really sure how they found out about me. I think they probably saw my website and decided to call me. I never actually sent out my portfolio to places or actively went looking for jobs. People always just seemed to come to me. I was really lucky.

-- Nowadays, digital arts are developing in such a vigorous way that a lot of people have thrown themselves into this industry. Thus, what is your trademark feature?
-- I think one of the things that set me apart is that my art is sort of a dark realistic approach. I feel that there are a lot of concept artists that all have a very similar style and technique. Even though I am aware of all the other styles out there, I try not to be too influenced by other people's work. Many artists also use a lot of shortcuts or photo overlays to create something, but I try to paint everything from scratch. I think my traditional training also helps me to create art that is more realistic.

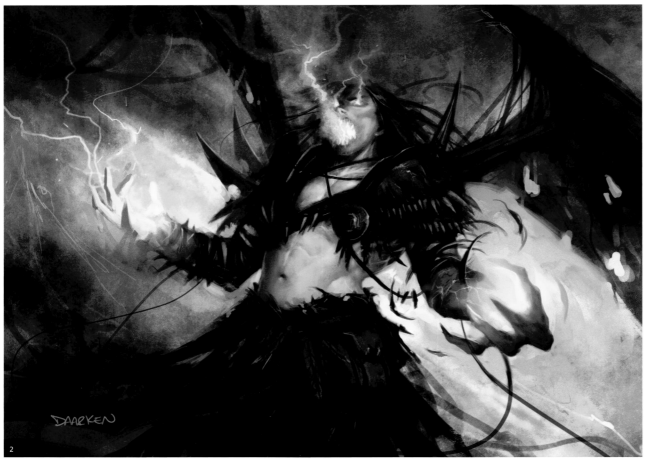

2 Form of the Dragon
3 Incurable Fireblood
4 Warcraft 1

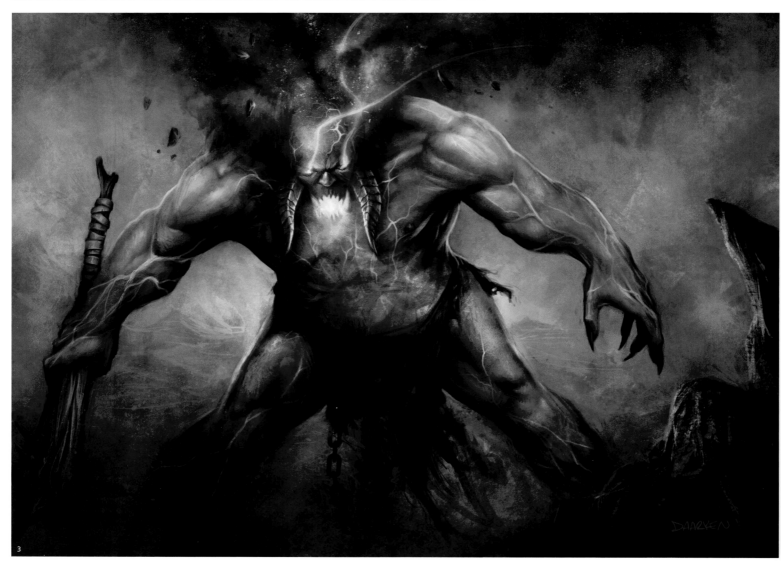

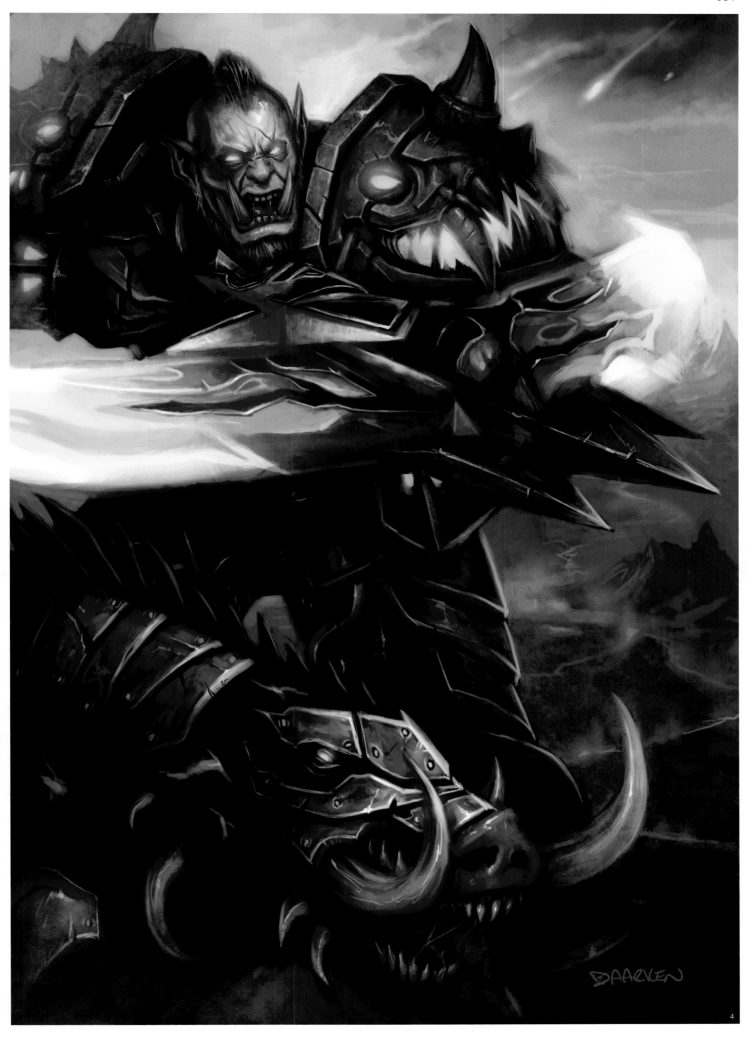

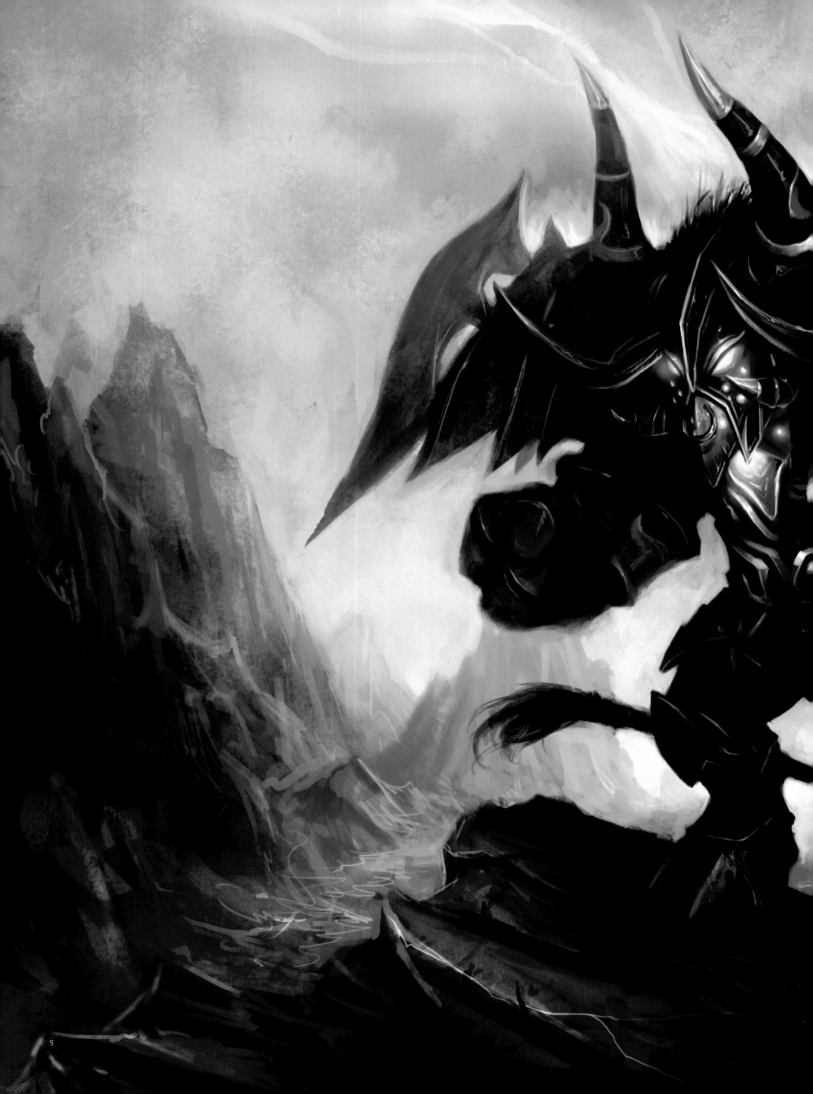

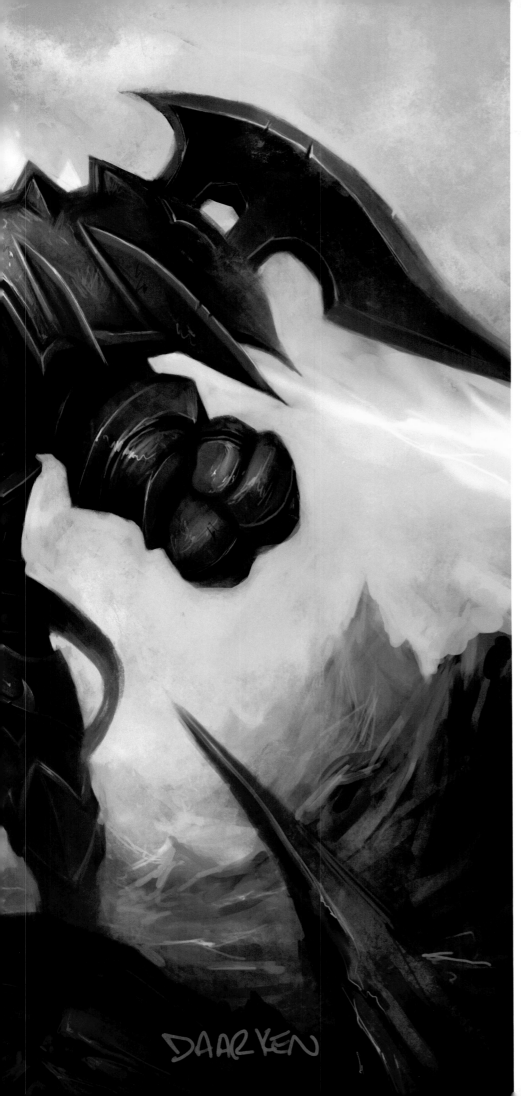

DAARKEN

-- Which artist has influenced you most in your art career?

-- There have been countless artists that have inspired or influenced me throughout my career. Some of the old masters that I look to are people like Sargent, Cornwell, Leyendecker, and Bouguereau. Some of the more contemporary artists include Aleksi Briclot, Daryl Mandryk, Brom, Craig Mullins, Paul Dainton, and Jon Foster.

-- Was there something interesting happening when you worked for WOTC and Mythic Entertainment?

-- One of the advantages with working for WOTC is that so often I get to attend the Grand Prix tournaments. Last year I got to go to Japan for a week. I hope that I get to travel again soon.

-- How much do you think playing game can help you in drawing? Did you play card games?

-- I think it helps a lot. If you are a player you know what the players are looking for, and that helps to influence my designs. I think it also helps to understand the world you are creating. Usually you can tell when someone doesn't actually play the game. I started playing *Magic: The Gathering* back in high school, so when it came time for me to start illustrating cards I already knew all about the world and game playing. I understood what a black card should look like, or what a blue card should look like. Even if you don't play the game it is still important to do some research about it.

-- Digital arts have allowed the artists to explore more styles and subjects. What do you think of that?

-- It really does. Having the ability to quickly change things allows me to try things that I normally wouldn't. I can be bolder in my approach and not have a fear of messing up. In terms of character creation I can try different silhouettes, or try different styles of armor, or different color schemes. When you work traditionally your process has to be very methodical. You have to do thumbnails, studies, color studies, clean line work, and then the final painting. You need to stick to your plan, because if you need to make changes it can be very difficult and time-consuming. Working digitally erases all of those boundaries.

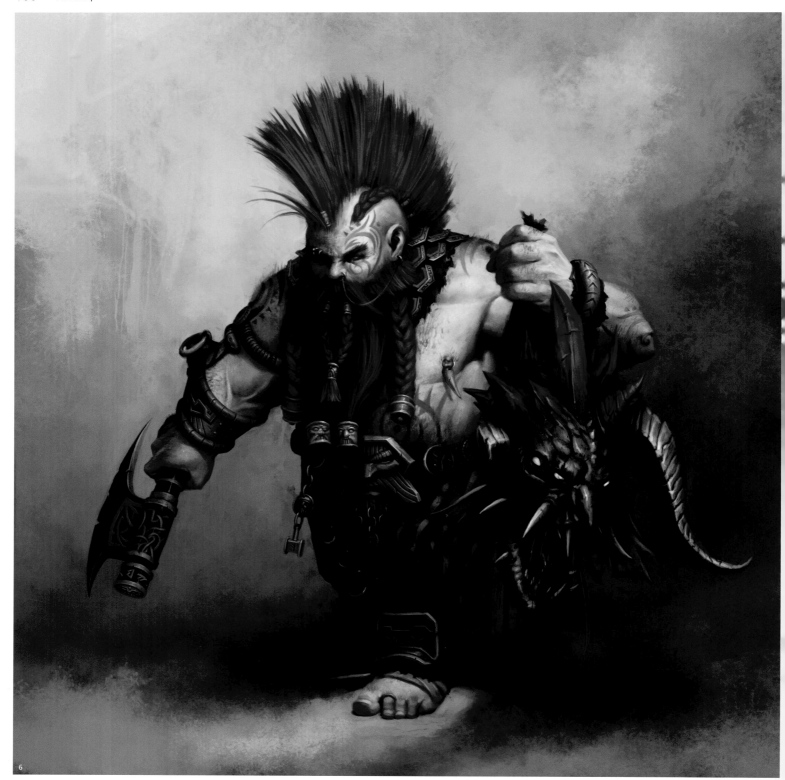

6

❻ Slayer

❼ Shar'Hetef

-- **What do you think is the next step that digital artists are going to take?**
-- Something that is already beginning to be explored is being able to draw something in 2D and have it rendered in 3D. I think this could help a 2D artist immensely in being able to visualize whatever he is working on. It could also save a lot of time in the production pipeline.

-- **Now more and more people are engaged in this digital industry. Do you think the traditional hand-painted art is still needed in this era?**
-- Traditional media is vital to the industry. People tend to think that with all these new digital programs anyone can be an artist. These programs are only a tool. You need to have the fundamentals first if you want to be

a great artist. The fundamentals you learn in life drawing, or oil painting, can all be used and applied to digital art. They are one and the same. I think there is also an awe factor with traditional media. When you look at an oil painting you get a certain feeling that you wouldn't get with a digital print. People still need that excitement.

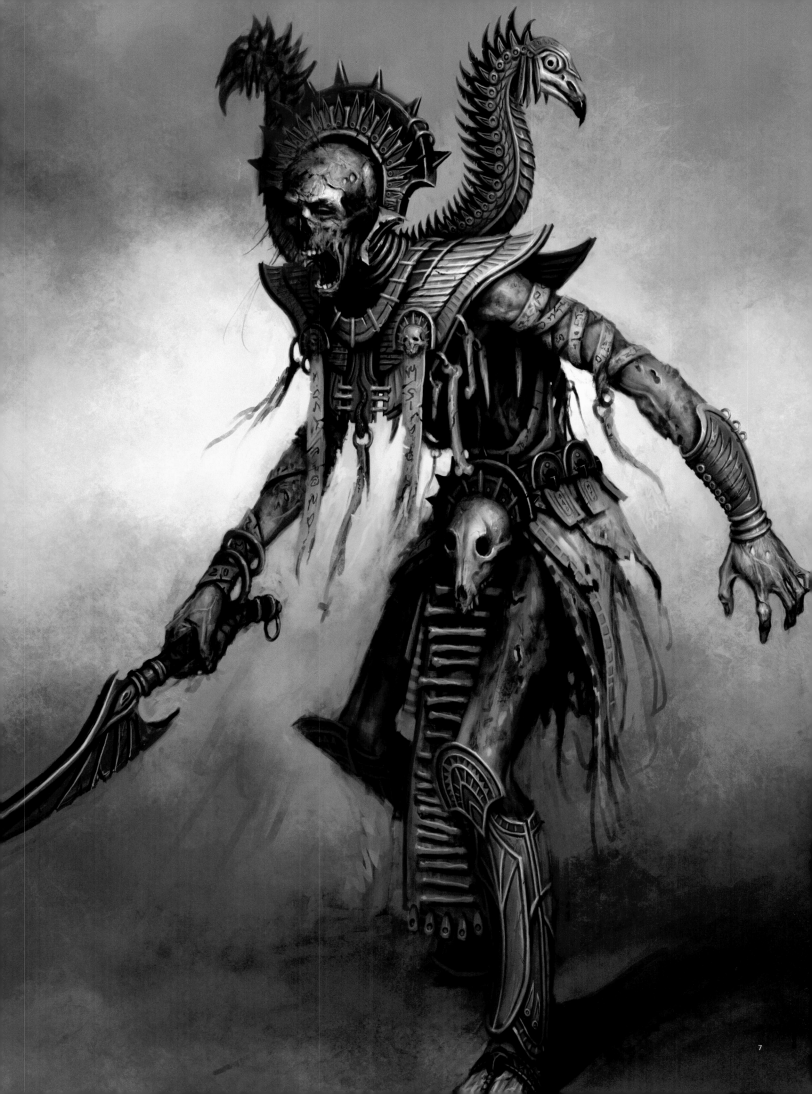

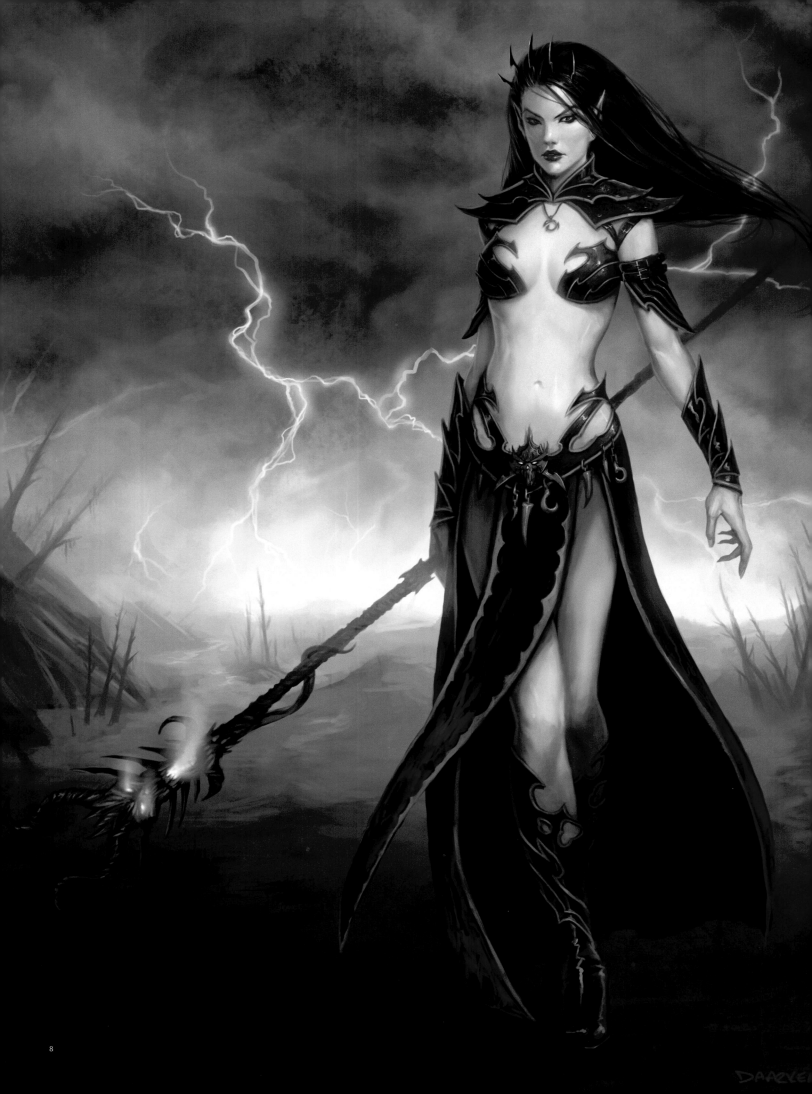

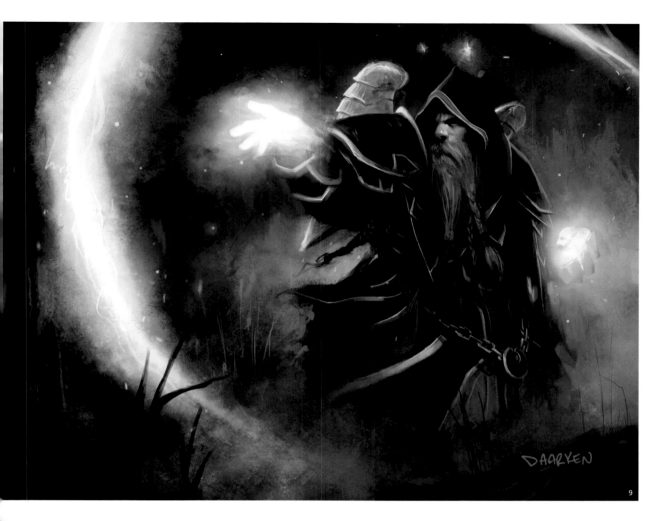

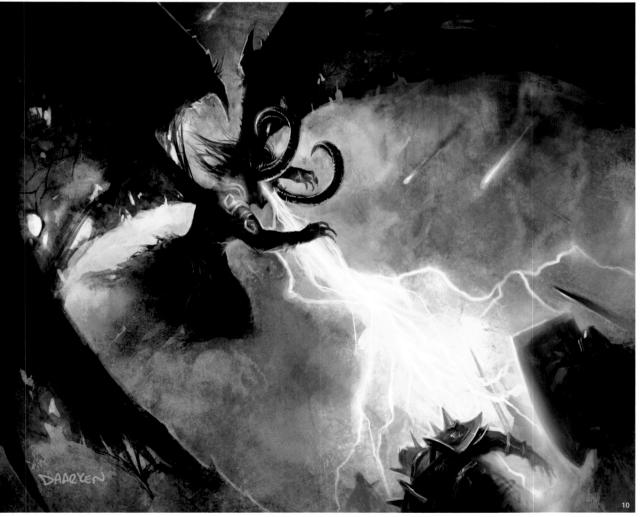

Edward Binkley

Name: Edward Binkley
Occupation: Digital Artist
Homepage: www.edwardbinkley.com

Edward Binkley

The Growth Rings
An Interview with U.S. Digital Artist Edward Binkley

Pristine styles do not mean anything is lagging behind our age. Instead, with the traditional characteristics, your digital work can look unique. The growth rings of culture leave their marks on our consciousness. Edward Binkley, professor and project director of the Computer Cartoon Depart- ment, University of Wisconsin Madison , is an anti-current pioneer. But he is at the same time a pioneer digital artist.

Obviously, you can find the marks of tradition from the fine, unique works. The 52-year-old Edward cherishes classic art and literature. For him, the classic composi- tions in the oil paintings are necessary elements for creation even now. He advocates pristine and basic ways of creation, though he has moved from paper to screen and teaches and works in the field of digital creation.

Interview

-- *You have a unique style of creation full of traditional flavors, something like a product from paper and pencil. But I know you draw with digital techniques. What's the secret about that?*
-- In my illustrations, I follow a simple prin- ciple based on basic drawing techniques and composition. They follow a traditional way to complete a work, from sketch to combination to the refinement. Now my work is entirely digital. I create every work through Photo- shop and Wacom. But before the computer production, I use paper and pencil as my base for creation, the way I used them for years. My works are mainly black-and-white. After I finish the creation of the basic tone, I add some color to it. Most of my drawings are divided into a number of layers, and then combined again. I try in my new ideas to give a sense of deepness to the presen- tation of the objects. To depict an object, I often begin with a black outline, and then add light to the form, to give it texture. I call it "heightened drawing" in my teach- ing. I believe the complete composition and inherent ways of drawing are fundamental principles for good illustrations. Unfortu- nately, many young artists just ignore them in their practice.

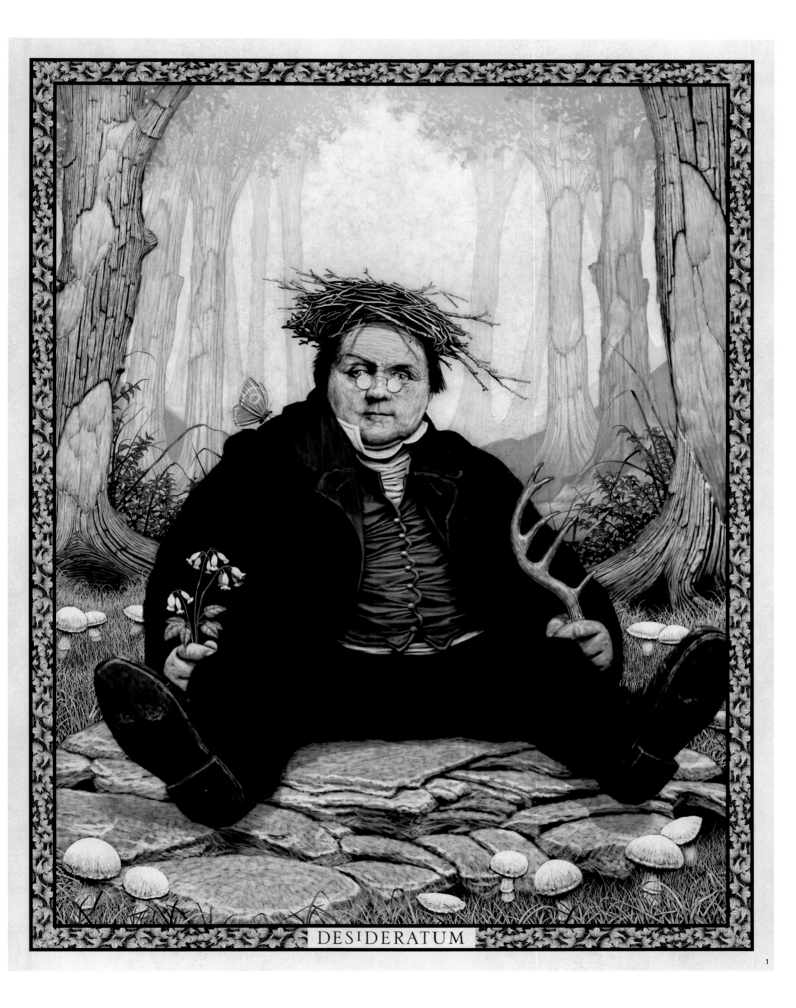

DESIDERATUM

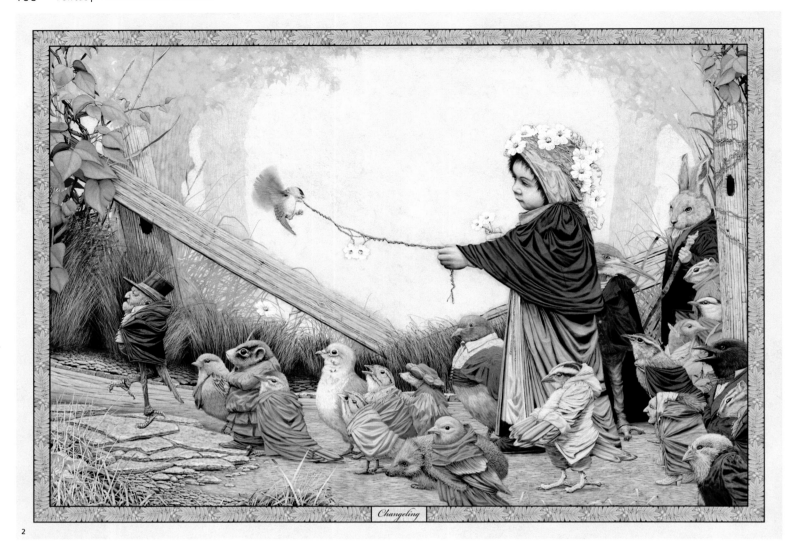

Changeling

2

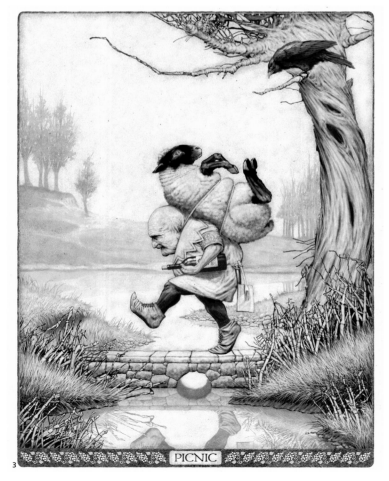

PICNIC

3

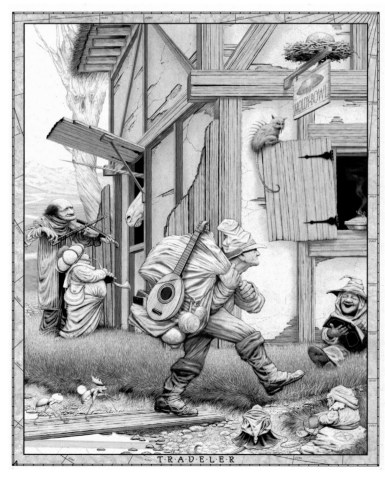

TRAVELER

4

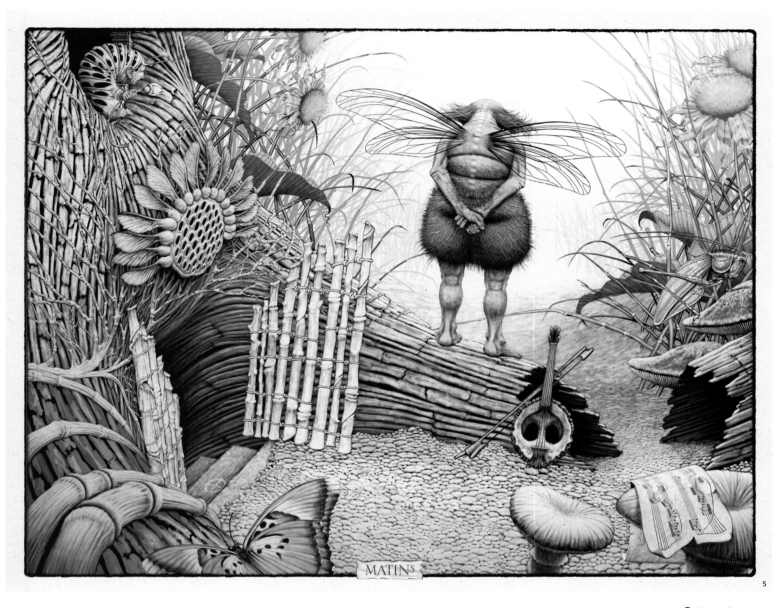

5

-- There are no drastic scenes in your works, which brings a sense of tales and legends. Which themes do you prefer? And where do you get your inspiration?

-- Oh, those works I show you now were all done recently. The creatures and fairies in the forest are stories and drawings I always wanted to create in the past, and I'm really fascinated with them. My official web page is www.edwardbinkley.com. But all the details in life and interesting things are at this site: www.edwardbinkley.com/alt. I'm still fond of creating images of little cowards. But drawing fairy images has been my first choice recently. My parents have been proud of my creations. However, they don't like demons (because they are Catholics). A lot of my works are included in *Spectrum* and you can also see these

there.

As to creative inspiration, in addition to some collections of normal materials, I can tell you some fresh ways. I don't know if you have ever heard about "Rorschach Test." When I want to create some new characters or themes, I will draw some drafts on papers with a pen and then try to refine one desired image from those abstract drafts to further process it. Though it doesn't work every time, it does sometimes. One hundred years ago, a psychologist named Rorschach put forward a test to analyze the personal characters through reactions to ink blot patterns. This is the "Rorschach Test." This theory always attracts me and now I use this way to create fairies, monsters, eidolons as well as their houses.

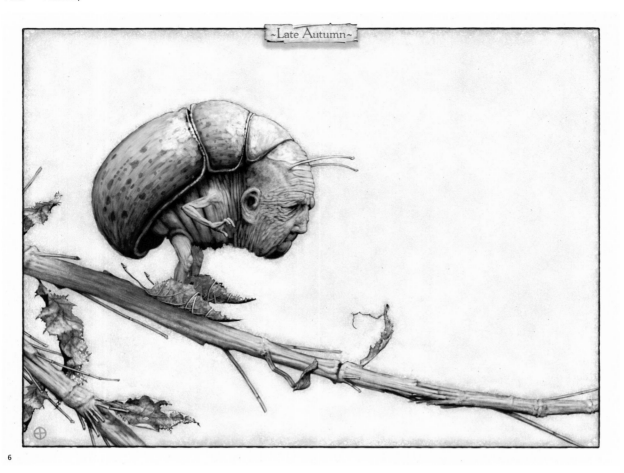

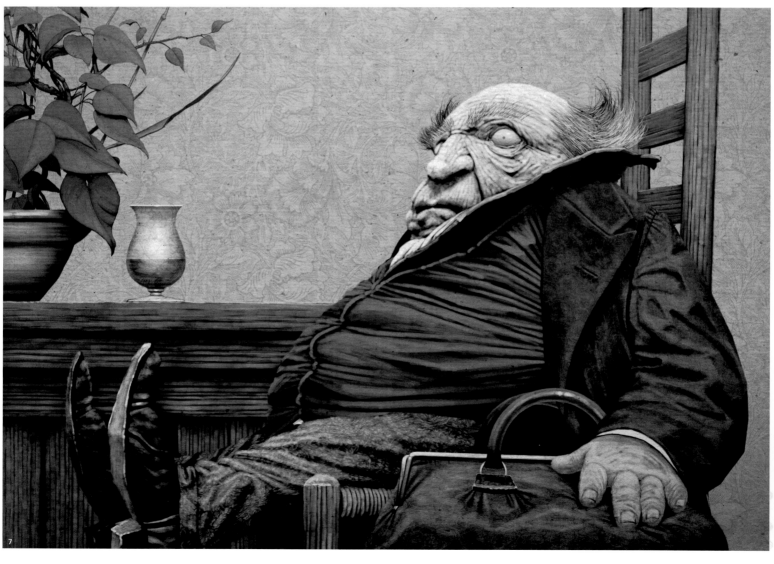

❻ Late Autumn
❼ Spriggin

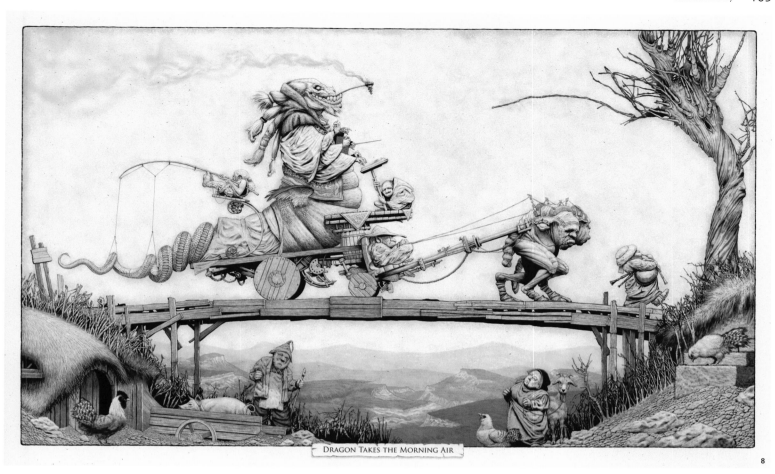

DRAGON TAKES THE MORNING AIR

8

9

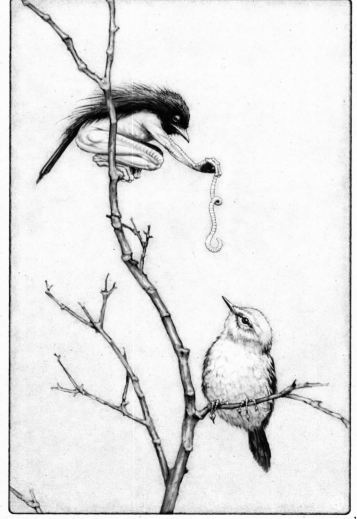

-- You are now teaching at the university. As an artist, how did you get there? What's your experience in arts?

-- I studied painting and publication at the university, and then continued my learning as a graduate student. I got a BFA and an MFA degree, but I learned a lot of skills by myself. I joined an awful department at the school, because I was too young to understand these things well. After graduating, I work for 17 years as an illustrator and designer. I drew covers for more than 30 books and magazines, and 20 covers for contents pages, but few of them were creative. Most of my creative works were completed after I began teaching. Being a teacher, I believe I can answer some of the questions that confused me before. The job helps me decide how to find the way to create artistic work that I like.

❽ Dragon Takes the Mor -ning Air

❾ Morning Glory

❿ Gift

10

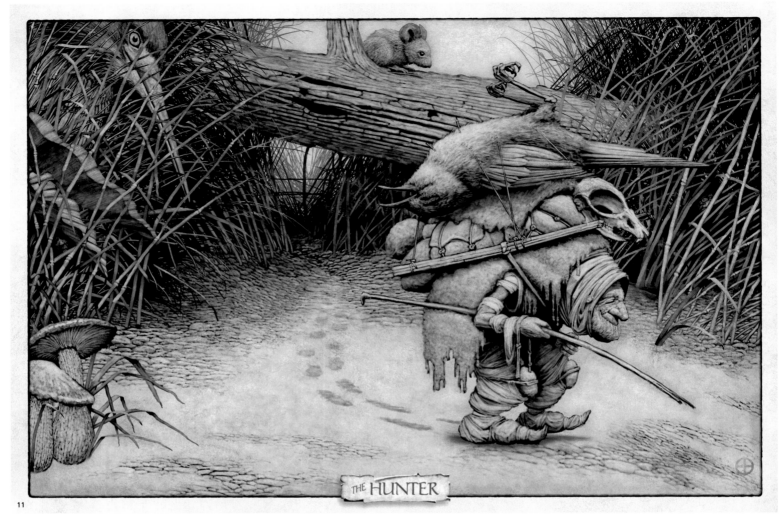

THE HUNTER

11

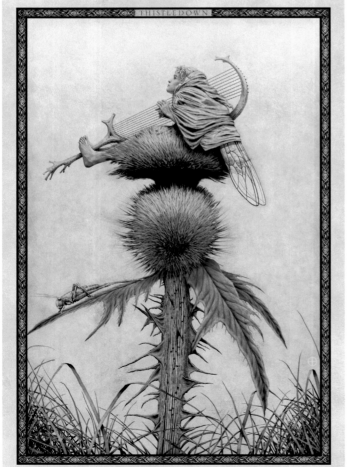

THISTLEDOWN

12

❶❶ The Hunter

❶❷ Thistle

❶❸ Hare

-- As a teacher, do you have any advice for the students?

-- I believe composition is an important skill for drawing. Regretfully, many art schools have stopped teaching traditional composition. All great artists in history were successful through their classic composition. Unfortunately, students today dispense with that key element in their creation. We always try to complete our works around a single image or a simple idea, by adding some details to a monotonous composition.

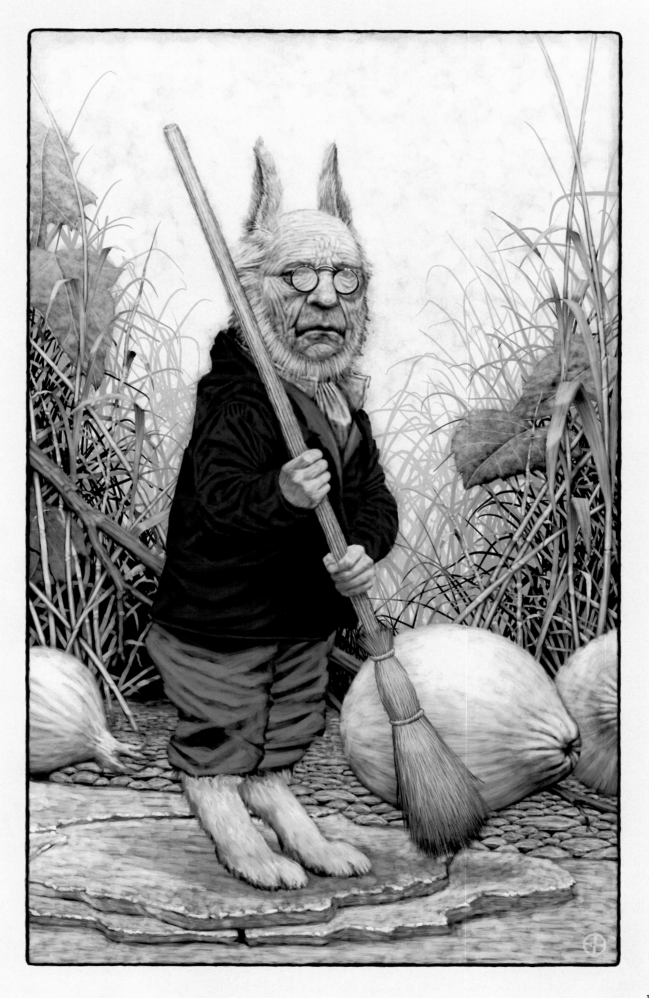

Eric Polak

Name: Eric Polak
Occupation: Freelance Artist
Homepage: www.ericpolak.com

Eric Polak

Gorgeous Adventure
An Interview with U.S. Conceptual Artist Eric Polak

Men are born with appetency for adventure. But later, we stop wandering about in bizarre clothing. We have to terminate our legend just as it starts its first step. We need to find a "secure" job, and tell a story we hear from others, to our friends or posterities.

Fortunately, we have card games, computer games and fantasy novels. And we can spend 2 hours in the cinema for a jaunt. Yes, the spirit of adventure is always there. However, there are always those few who never close their windows for fantasy and create maps of adventure for the rest of us.

From the fantasy illustration surge started by the Mesozoic commercial artists such as Todd Lockwood, to the vigorous development of the current digital age, more and more young men enter into the industry, and the prospect of the adventure becomes more and more gorgeous. As a Neozoic fantasy artist, Eric Polak has worked for 11 years. He loves the works of Todd, Brom and other artists, and provides his works for WOTC (D&D, MTG) Dragon magazine and other games. Currently, along the course of his predecessors, he is providing more colorful visual experiences for viewers yearning for adventure cultures.

Interview

-- When did you start to be interested in art? Why did you decide to be an artist?
-- I've been drawing ever since I can remember. Growing up, it's what defined me. I was always that "kid who can draw". As I got older it just made sense for me to try to do it for a living because it was something I liked doing and was pretty good at it.

-- How did you try to get job opportunities as a newly-graduated artist at the beginning of your career?
-- For me it basically came down to knowing someone. One of my first professional assignments was for "Legend of the Burning Sands," a CG by Alderac Entertainment Group. One of my very best friends, Michael Phillippi, who is also a very talented artist, got some work from them (also by knowing someone) and recommended me. I submitted a trial illustration and they liked it enough to throw some card art my way. I also made pamphlets showcasing my strongest work and sent them out to various companies. This was all before I had a computer at my disposal; nowadays it's all email and websites.

-- You have worked for fantasy and sci-fi illustrations for 11 years, how do you keep your own exuberant creativity?
-- Sometimes it's hard to keep the creative juices flowing. I tend to go through periods where I'm feeling very comfortable and it seems like I can draw anything and then I hit a brick wall and work becomes a struggle. When this happens I just buckle down and push my way through it. It's funny though because I seem to learn the most when I'm struggling. It forces me to think differently and I usually come up with something I normally wouldn't have.

Another way I try to keep things fresh and interesting is to try to find one specific aspect of the illustration and just focus on it for a while, like drawing a face or something, until I come up with something I really like. I find that after doing that I relax a bit because I like what I've just created and generally have an easier time completing the illustration.

-- Nowadays, the digital arts are developing in such a vigorous way that a lot of people have thrown themselves into this industry. Thus, what is your trademark feature?
-- I think I'm my own worst critic and it's hard for me to come up with one or two defining qualities about my artwork. I guess my work tends to be fairly detailed. I also take a fairly realistic approach and try not to overly exaggerate the figures and environment unless I feel it is necessary to the illustration or concept. That way when I do exaggerate something it has more of an impact.

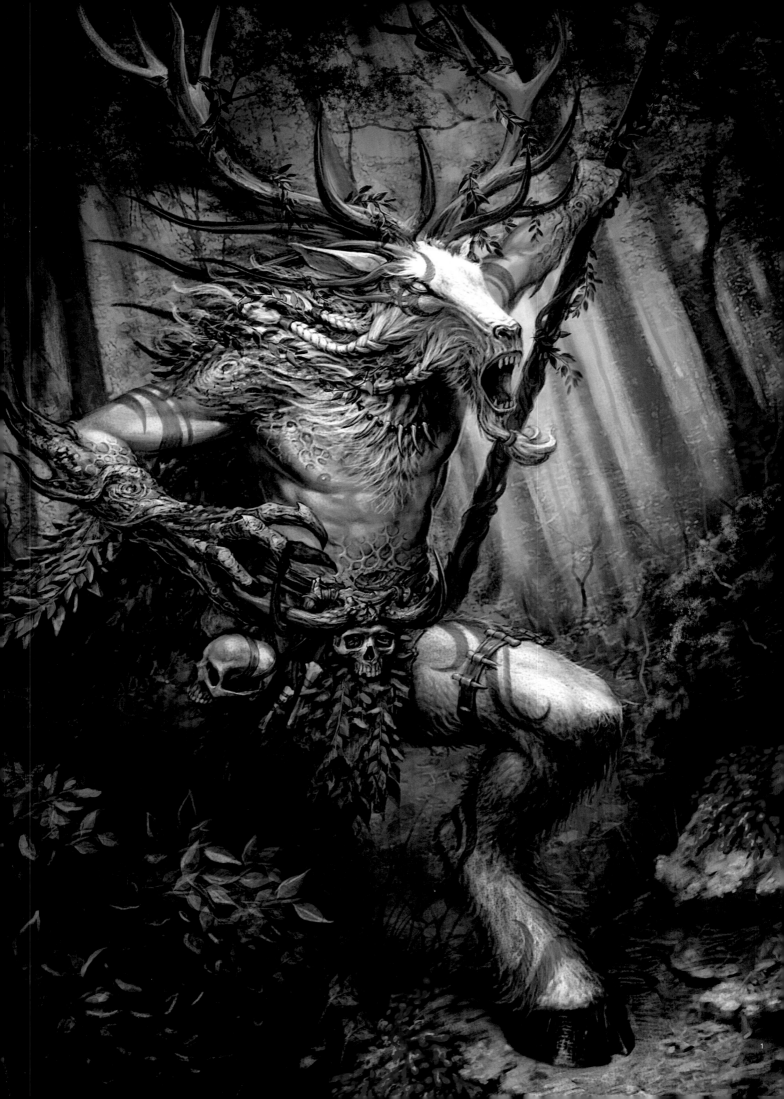

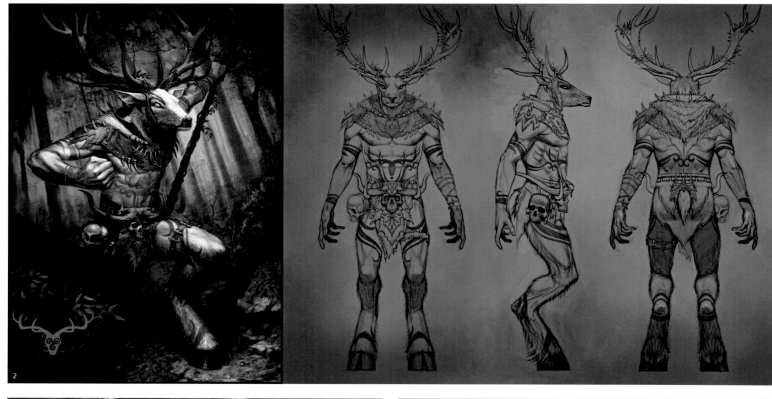

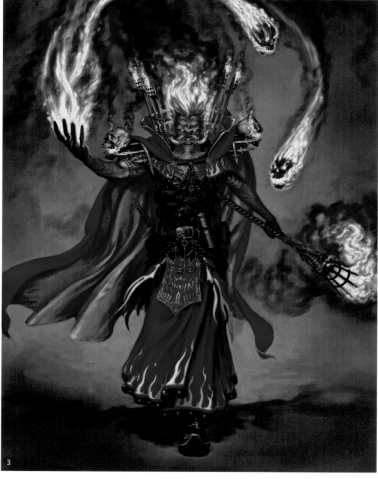

❷ Kurnous Turnarounds

❸ Thyrus Gormann

❹ Slayer

❺ OMB Kings

-- **Which artist has influenced you most in your art career?**

-- There are so many. Some of my favorite artists from my younger years include comic book artists Jim Lee, Gary Frank, and Travis Charest, fantasy / sci-fi artists Brom, Tim Bradstreet, Jeff Easley, and of course Larry Elmore. During my college years I discovered Todd Lockwood and his work has been a huge inspiration. A few of my contemporaries that inspire me every day include Michael Phillippi, Mike Lim (Daarken), and Jonathan Kirtz.

-- **Does something interesting happen when you work with different clients?**

-- There's always something interesting happening when you work with a new client. For me, one of the most interesting aspects is getting the art descriptions for my assignment. There are two ways this can go, either the descriptions will be good or they'll be bad. If they're bad, which usually means I think they're overly complicated, usually the batch of work will be a bit of a struggle. If they're good, however, my mind starts churning out a bunch of ideas. Hopefully one or two of these ideas gives me the inspiration I need to create an illustration worthy of the art description.

-- **What's your hobby when you have free time?**

-- I played the *MMO City of Heroes* for a long time, but recently gave it up. Currently I'm playing *Street Fighter 4*. Performing "links" in that game is difficult for me so I've been practicing that a lot.

-- **Digital arts have allowed the artists to explore more styles and subjects. What do you think of that?**

-- One of my favorite aspects of digital art is the ability to use "layers." This allows me to try something I might not do if I was working traditionally because I know I can always just delete the layer and still have my previous work untouched. I do find that this is a double-edged sword, however, because sometimes I keep trying something new and the next thing you know half the day is gone and I hardly have anything to show for it. The different adjustment layers available also allow a lot of flexibility and variety with just a click of the mouse; I particularly enjoy using the "overlay" adjustment.

6 **❻ Altdorf Gate**

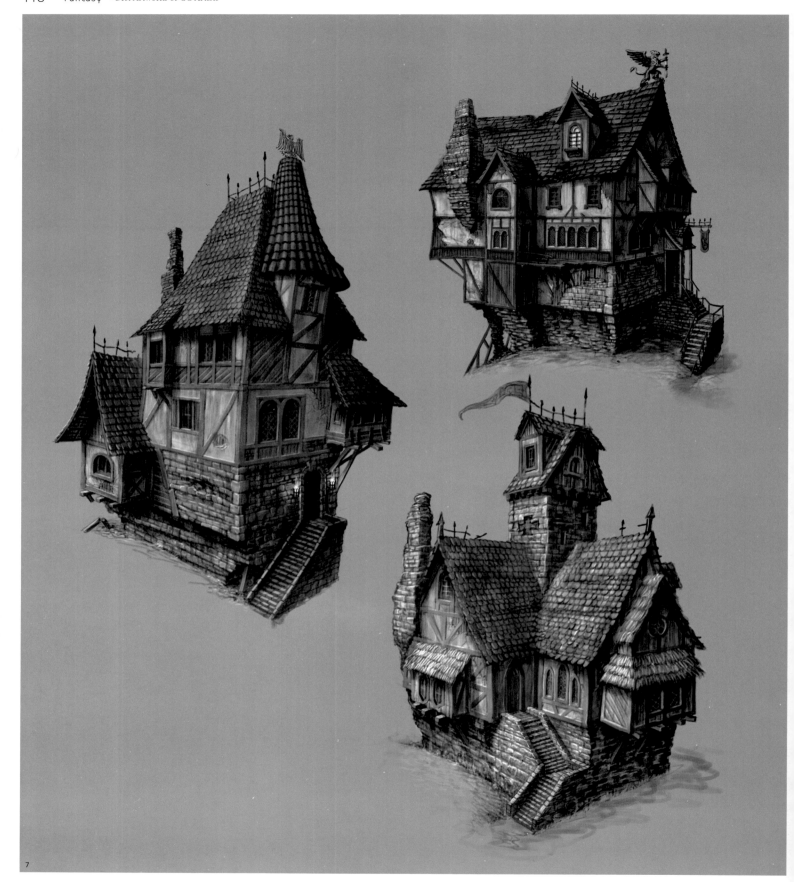

7

❼ Empire Architecture

❽ Empire Observatory

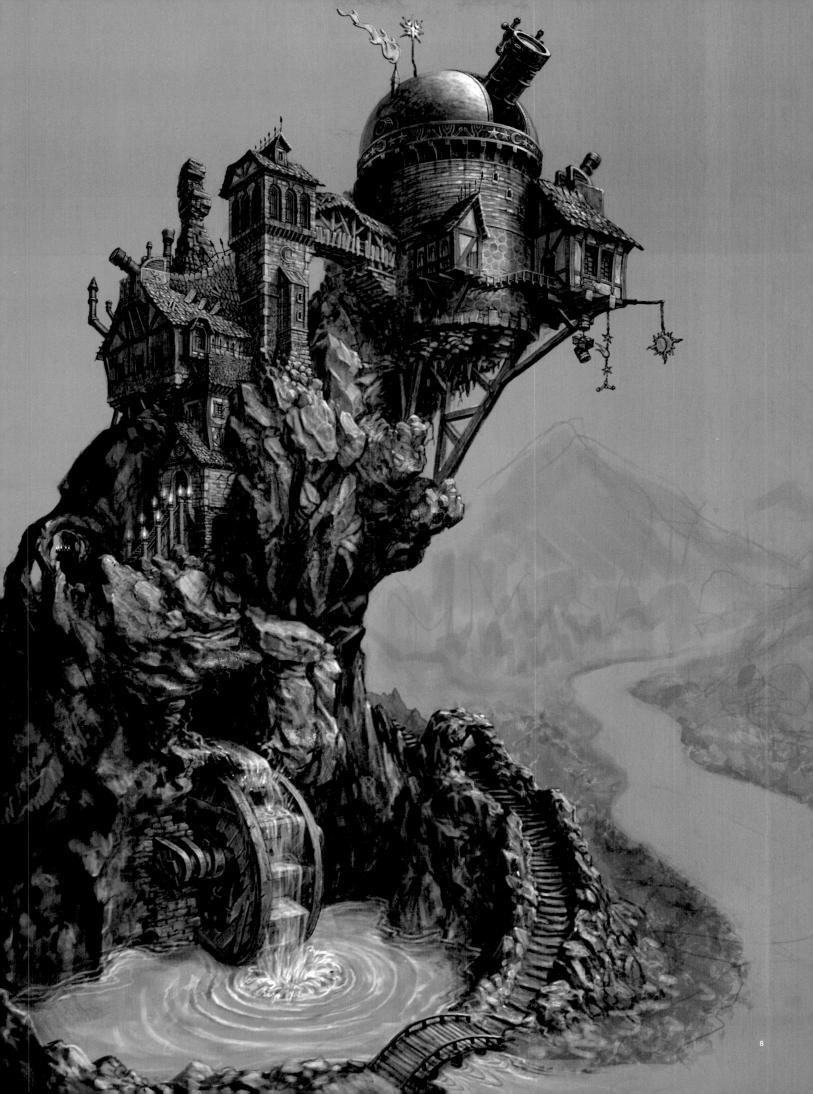

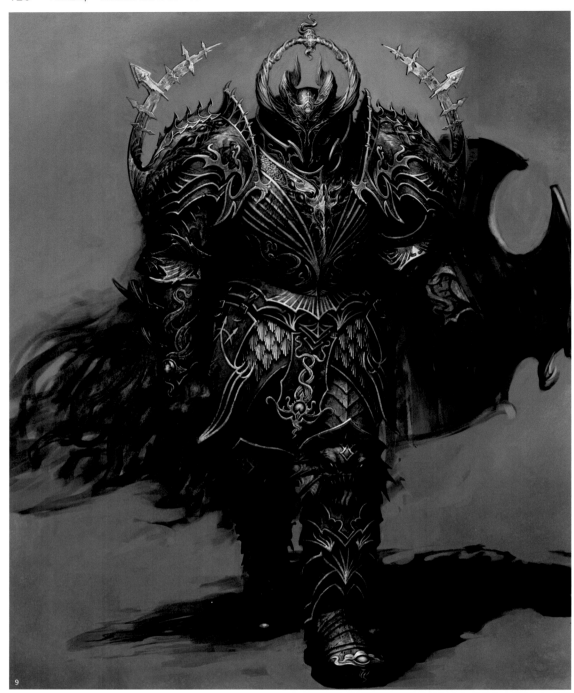

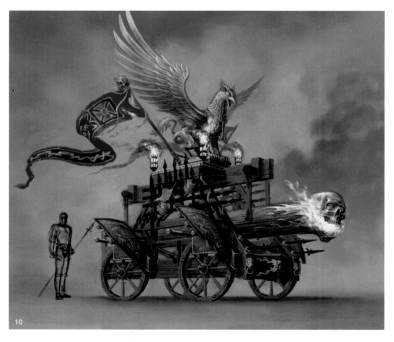

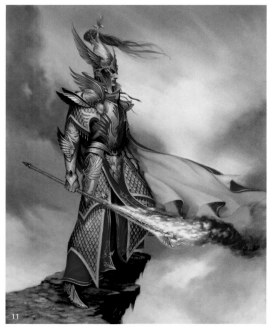

9 Epic Chosen

10 Empire Battering Ram

11 Finubar

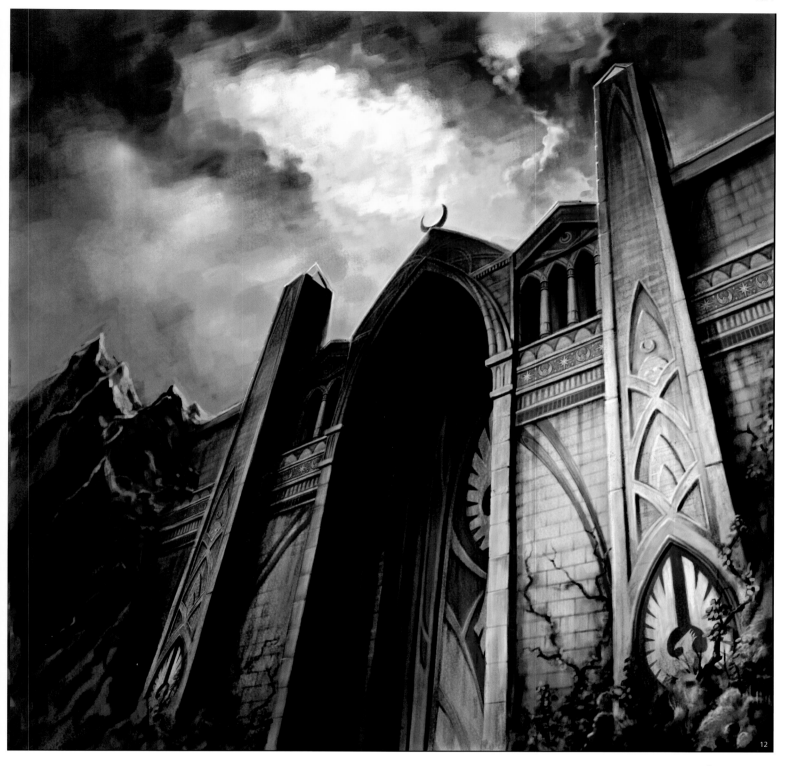

⑫ Phoenix Gate

-- *What do you think is the next step that digital artists will take?*

-- I don't think I really have an answer to this question. As a digital artist, I kind of feel like I pretty much have the necessary tools and technology I need to create artwork. My personal exploration lies in learning and absorbing as much as I can, to later utilize in my work so that it continues to improve.

-- *Now more and more people are engaged in this digital industry. Do you think the traditional hand-painted art is still needed in this era?*

-- I don't think traditional art is really need-ed, but I don't think it's going to disappear either. I think certain aspects of the illustration industry are generally better suited for digital artists and others are better suited for traditional artists. If for example your profession is at a game studio working as a concept artist, then I believe digital art is the superior medium because of the speed and flexibility a computer allows an artist to have at their disposal. However if you're a freelancer illustrator working on book / magazine covers, RPG art, etc. then I think traditional illustration is a very valid medi-um. The traditional artist might have a lon-ger turnaround time in creating the artwork; however they'll have an actual physical illus-tration at the end of the process which they can sell. There is a large collectors market for selling original illustrations and if you make a name in the industry those originals will fetch a hefty price. A traditional artist also doesn't have an "undo" button so they have to get it right the first time, which I think makes them a stronger artist in the long run.

Jason Stokes

Name: Jason Stokes
Occupation: Conceptual Artist, Arena Net
Homepage: www.jasonstokes.net

Jason Stokes

Evolution of the Dreams
An Interview with U.S. Digital Artist Jason Stokes

We have various dreams when we are young. Most of them disappear as our characters and interests change. Maybe one of your dreams comes round someday when you are established. But at the end, it has to be realized in the unknown future.

Now, let's talk about the dreams of artists, such as Jason Stokes who began drawing at the age of 3. At the golden age of cartoons in the U.S., he wanted to be a cartoonist because of MAD magazine, and dreamed to be a caricaturist because of Jim Lee and Todd McFarlane. With these dreams in his heart, he went to Seattle to study art after graduating from high school. Besides sketch and illustration, he learned digital art and 3D courses for the first time. His classmates all pursued digital arts in the end. Jason Stokes also finds his way of achieving his dream in his work, not as a cartoonist or caricaturist, but as a game designer. Although his role has changed, his exploration of art has not.

Interview

-- What do you think is the acquisition you received from your early work in Hulabee when working for Disney?
-- Working on the Disney games was a great first job for me. I was exposed to many aspects of game creation and it helped me realize the direction I wanted to go in my career.

-- You said you wanted to be a comic artist when you were a child. Do you still want to become a comic artist one day?
-- I'm more interested in game development than comic books these days. I feel like my intentions for being a comic artist were not in the right place. I was more dazzled by the potential fame and recognition that my favorite artists had and I thought that's what I wanted. Now that I'm older I enjoy being part of a larger team working together to deliver a grand vision. I might do a comic later on in

life when I have some more free time.

-- Nowadays, digital arts are developing in such a vigorous way that a lot of people have thrown themselves into this industry. Thus, what is your trademark feature?
-- My artwork lately has been focused on environments because I want my concepts to be beneficial for the work I do on *Guild Wars*.

-- Which artist has influenced you the most in your art career?
-- As a kid I really enjoyed MAD magazine and I would try and copy my favorite cartoons from it. My Dad was also a big artistic inspiration for me. I remember going through all his old sketches and being blown away by the art he created. In the early 90s I became really interested in comic books after seeing the artwork from image comics. At the time Jim

Lee and Todd McFarlane were my favorite artists and they inspired me to try and draw comics for a living. Once I started at Arena Net I was exposed to some great digital artists and was inspired to learn from them. Some of my favorites are Craig Mullens, Daniel Docui, Jamie Jones, Kekai Kotaki, Nicolas Bouvier and Octo Stash.

-- Was there something interesting happening when you worked for Arena Net?
-- Before the original *Guild Wars* came out we would all play to test it during lunch. My friend and fellow artist Kekai Kotaki was trying to save up his *Guild Wars* gold so he could get a better set of armor. Another friend of mine told Kekai they would give him 100 *Guild Wars* gold if he drank a full bottle of honey. We all watched him drink it in a matter of seconds and Kekai was moaning for the rest of the day. It was pretty gross!

❶ Temple Pit

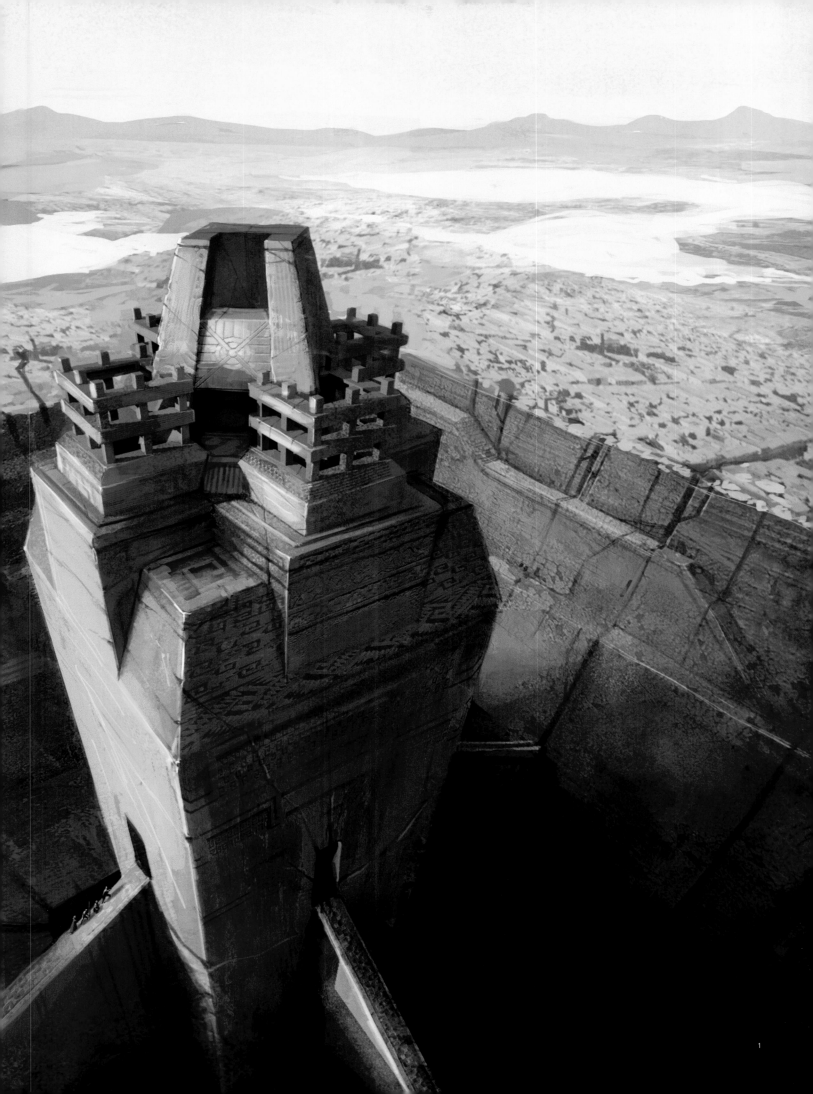

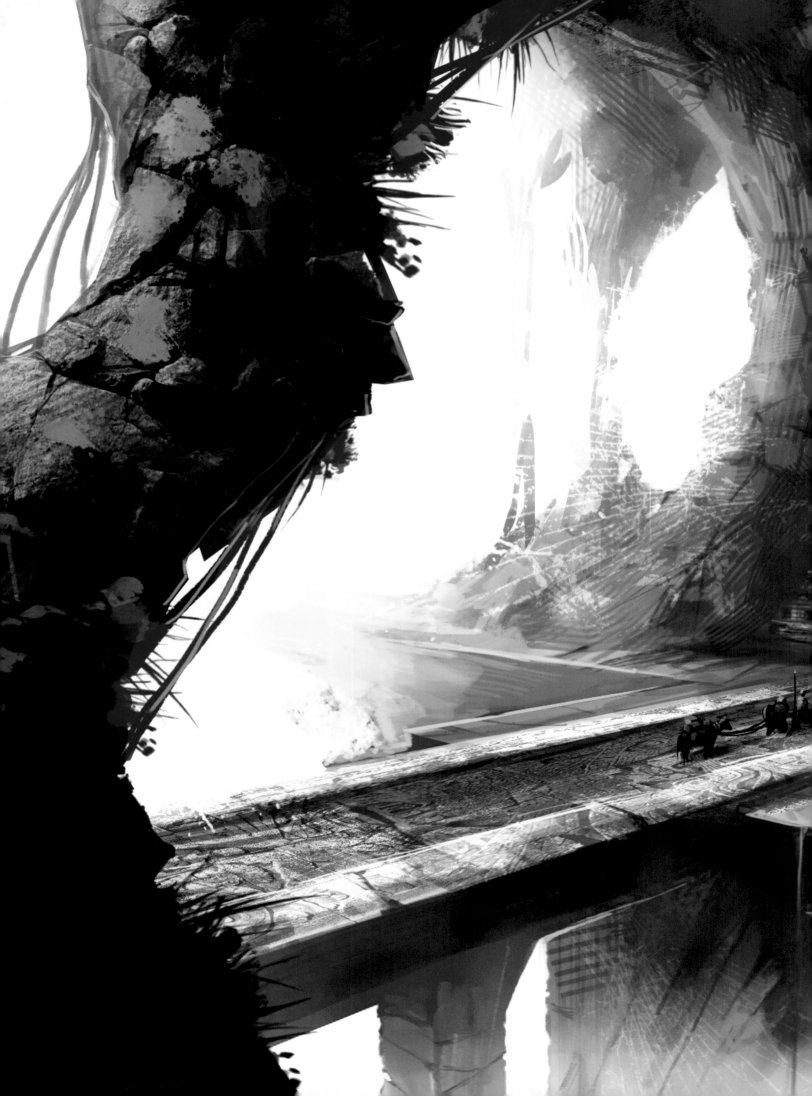

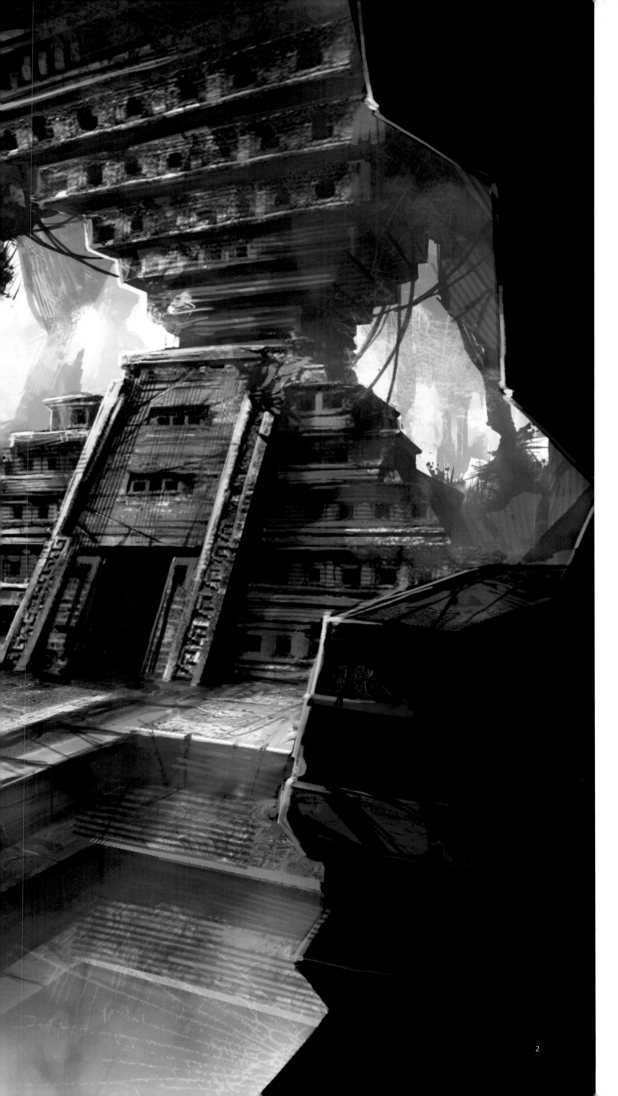

2

2 Cave Ruins

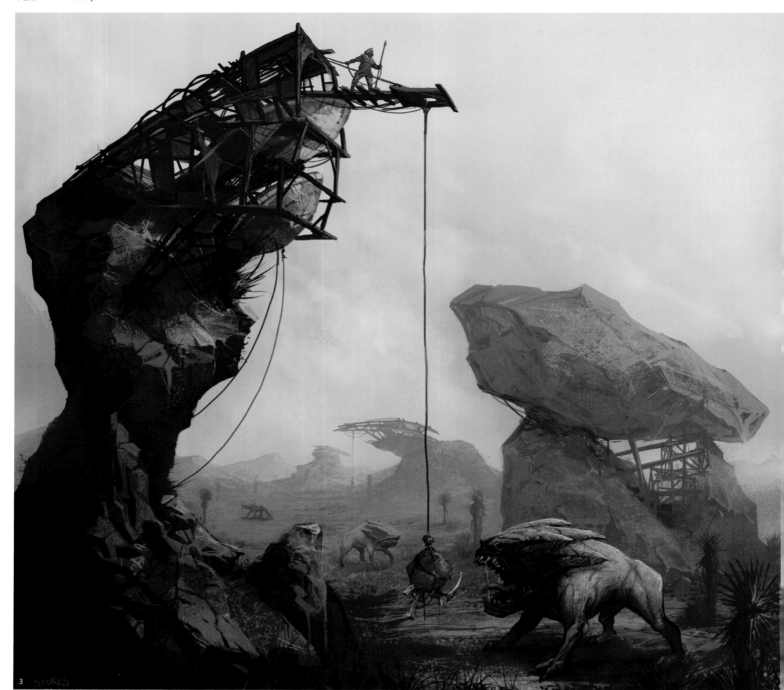

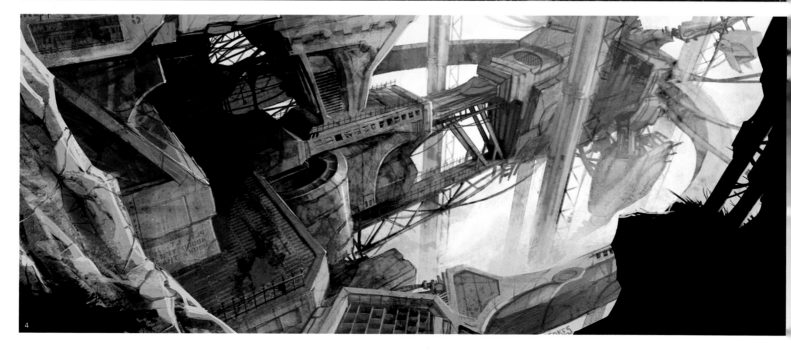

-- Which do you like better, 2D or 3D?
-- I enjoy 2D more since I spend a majority of my time making 3D assets during the day. I do like to block out illustrations in 3D to save time on perspective problems.

-- As an artist working for a game company, how do you keep your own exuberant creativity?
-- It can be tough because after sitting at the computer all day the last thing I want to do is go home and sit at the computer. Lately my favorite thing to do is just to hang out in down town Seattle and draw people as they walk by. It's very tricky to capture someone's attitude and style in such a brief moment but it's a good exercise.

-- Digital arts have allowed the artists to explore more styles and subjects. What do you think of that?
-- As I mentioned before, blocking in some compositions with 3D and playing around with interesting shape interactions is a fun way to start a painting. It's also cool to overlay interesting photos and textures on to your illustration to see if anything unexpected pops out.

❸ Land Fishing
❹ Under Ground
❺ Bridge Castle
❻ Beneath It All

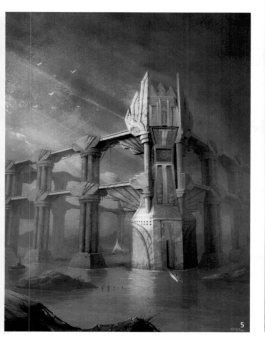

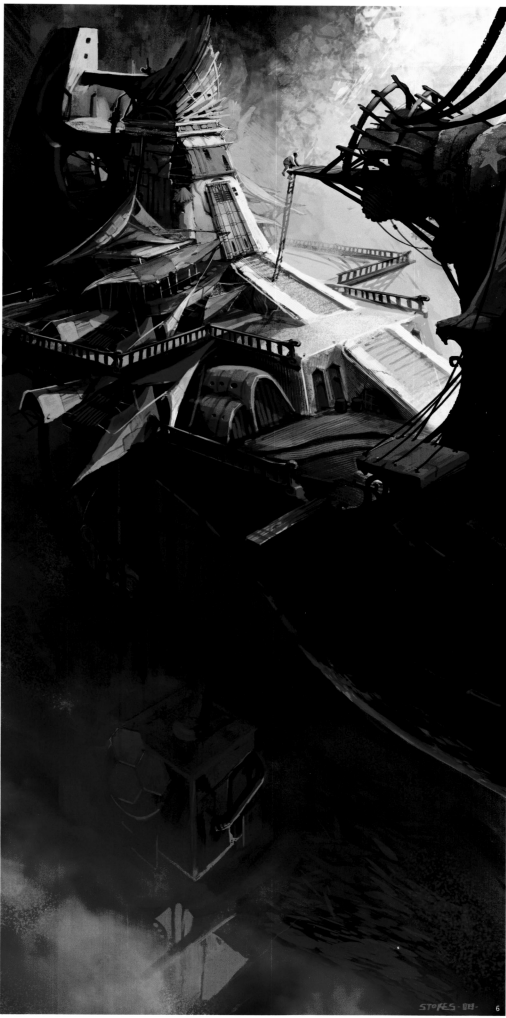

STOKES06

❼ Aztec Warrior

❽ Stair Room

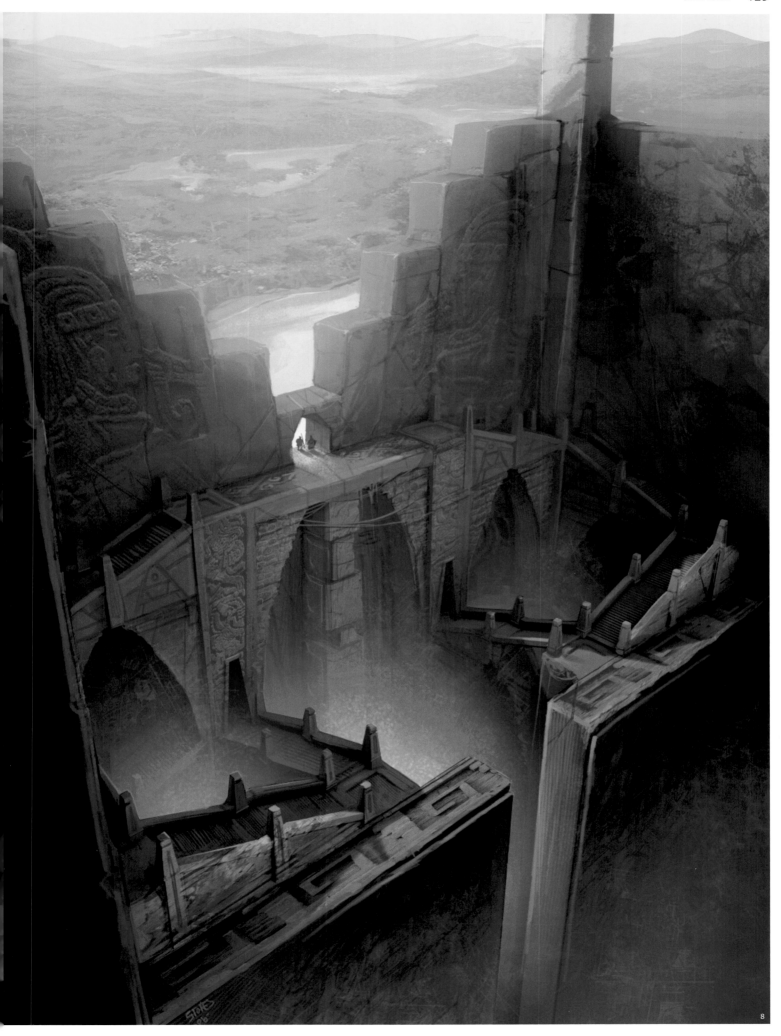

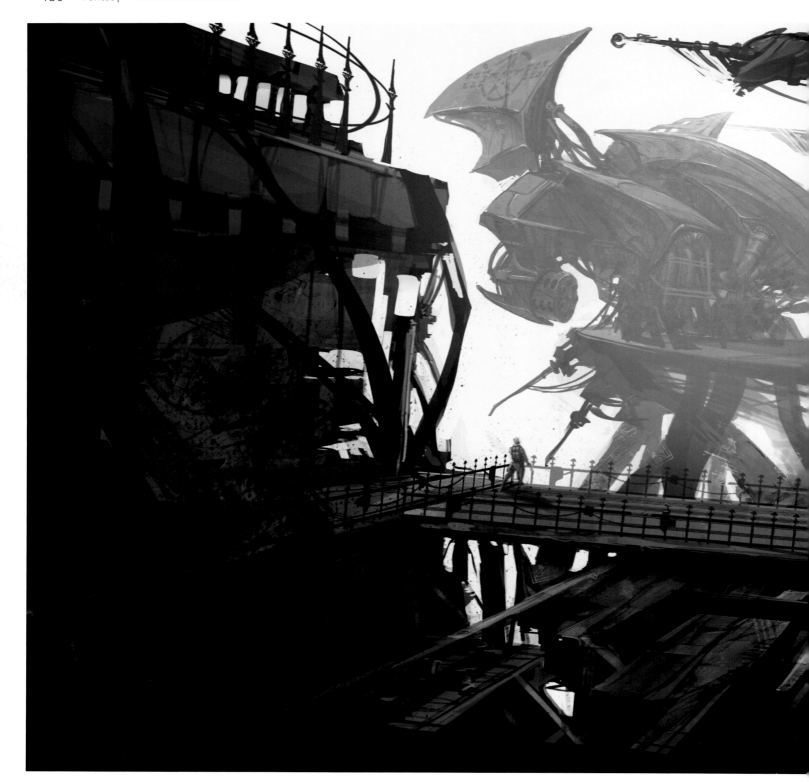

-- What do you think is the next step that digital artists are going to take?
-- I think video games and concept art will slowly start merging together. Currently video games look too clean and crisp and they could benefit from some of the looser concept styles that have become popular.

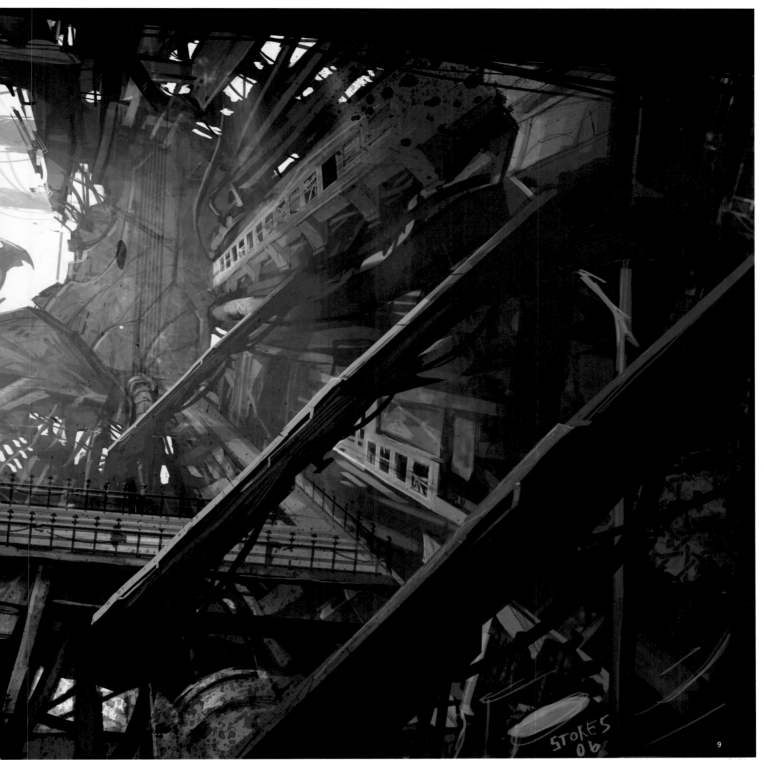

❾ Ship Yard

Name: Justin Gerard
Occupation: Freelance Artist
Homepage: www.justingerard.com

Justin Gerard

Bayeux Tapestry
An Interview with U.S. Illustrator Justin Gerard

To date, how the 70-meter-long Bayeux Tapestry was weaved is still a mystery. And more and more people are interested in the mysterious animals, the Vikings, the Normandy and the Saxon cavalry. The spirit for adventure within the Tapestry and the top achievement of handcraft it represents makes it enduring in Art history. Justin Gerard is one of those fascinated by its charm.

According to Justin, he began to create his own Bayeux Tapestry at the age of 4. And it was at that time when he began to get indulged in various colorful classic legends.

Justin loves adventure from his heart. He managed to sell his works when he was 18, and began his travel with the money he got. He currently lives in the forest of suburb Greenville, South Carolina, living a Spartan life. He continues his creation through travel, seeking, recording and making his own legends and footprints. He is weaving his own Bayeux Tapestry, with CG and traditional drawing skills as his crochet needles.

Interview

-- Your artwork looks like fairy tales. Is that your special style?
-- I have always been very interested in classic stories. I read a lot, (or listen to stories on audio book anyway) and inevitably while I am reading I will begin to form pictures in my head of what the characters or worlds look like. A lot of times I end up doodling and sketching these ideas out. A lot of my illustrations are formed by stories.

-- I saw from your artworks that you like using digital skill to produce classic feelings? Why do you have this predilection?
-- Digital offers some really wonderful tools that allow you to achieve really great effects in a fraction of the time it takes in traditional media. There are many great effects that I wanted to recreate in my work, effects that I had seen in photography and film and in other artists' works. There was a mood I was after, a feeling within the pieces themselves.

I always tried to recreate these effects traditionally but never could. When I picked up digital I found that I was suddenly able to begin to achieve many of them. I have been studying for the past years to try and learn how to create them traditionally as well. I still have a lot to learn about lighting.

-- Nowadays, digital arts are developing in such a vigorous way that a lot of people have thrown themselves into this industry. Thus, what is your trademark feature?
-- Digital artwork allows for a great range of techniques and effects to be added to a piece. It also allows the artist to work, and rework very quickly without many of the hassles that accompany traditional media. It is a wonderful tool that certainly has changed the industry. But in the end, it is just a tool, and no tool can replace the basic drawing, which is the intellectual soul of an illustration.

I think digital art is great for a number of reasons; one in particular is that it allows many people to paint who otherwise would not be able to. It affords them a chance at this form of expression and helps them further their skills. It offers quick results and non-threatening work experience (as opposed to oils, which can be terrifying to those who haven't used them). With this new ease of use has come a glut of capable artists on the market which indeed may threaten to oversaturate the industry, driving down rates and making it harder to make a living as an illustrator. I hope that by continuing to learn and push my abilities I will be able to stay ahead of the curve. But if it becomes impossible, and the industry becomes flooded and the work begins to thin out, that is fine; I will take work doing something else. But I will always be drawing and painting my own ideas, with or without pay. It is, of course, nice to get paid for it, but this is what I do, and I will continue doing it either way.

❶ To Chain the Beast

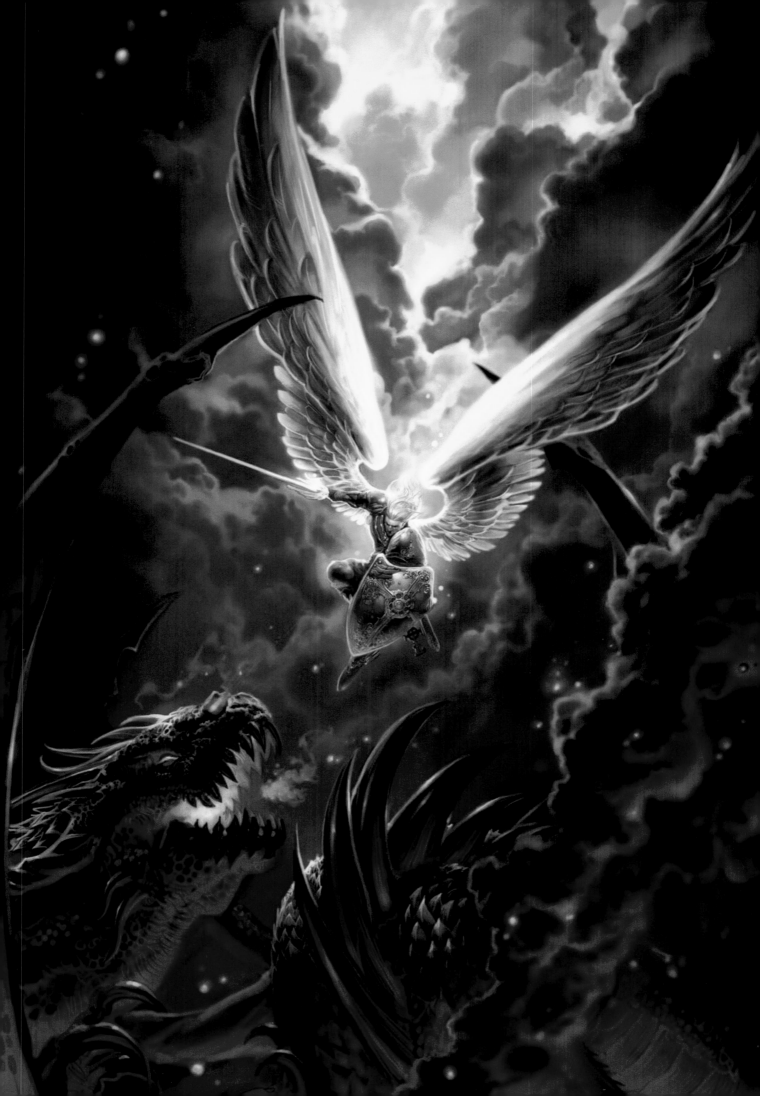

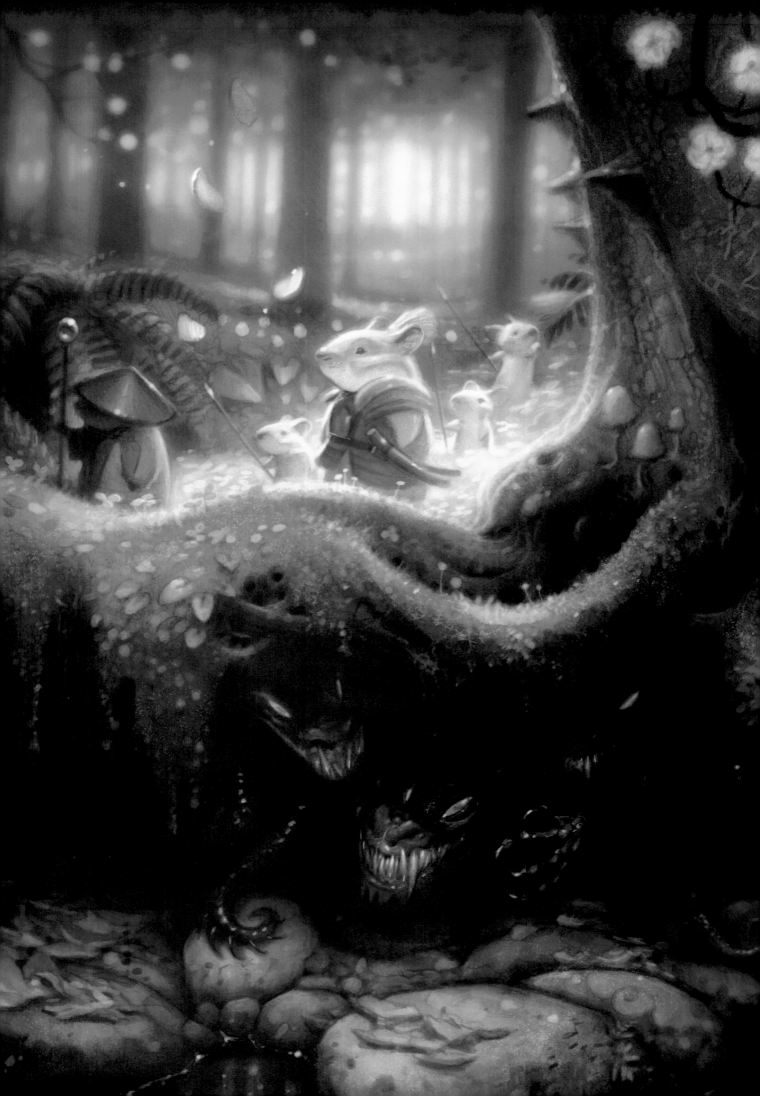

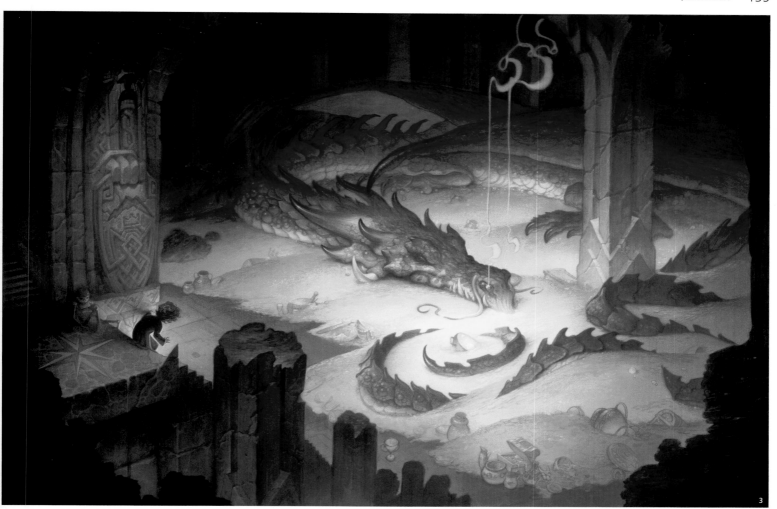

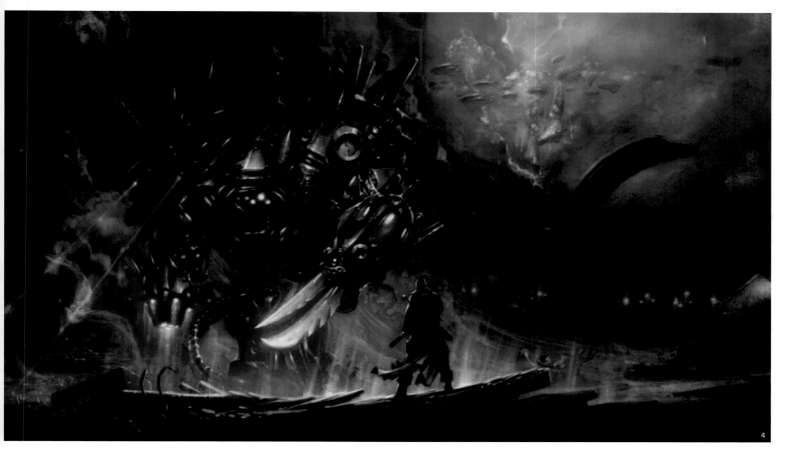

2 Samurai Hamster

3 There He Lay

4 The World Devastators

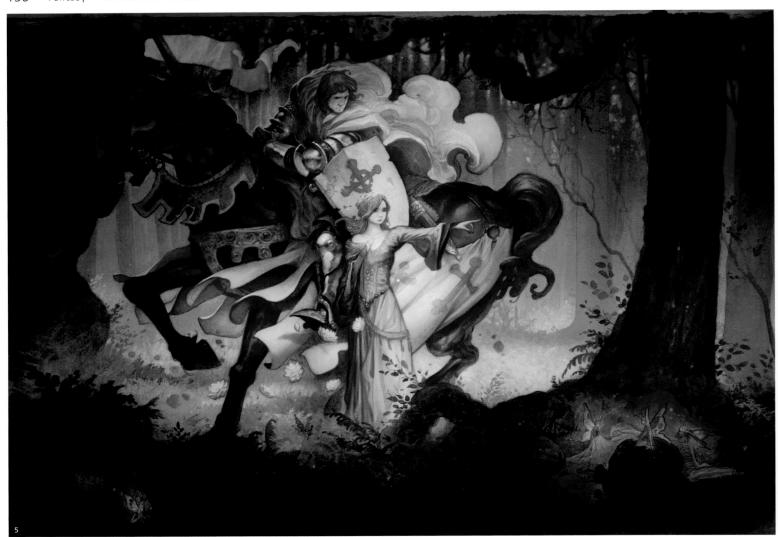

5

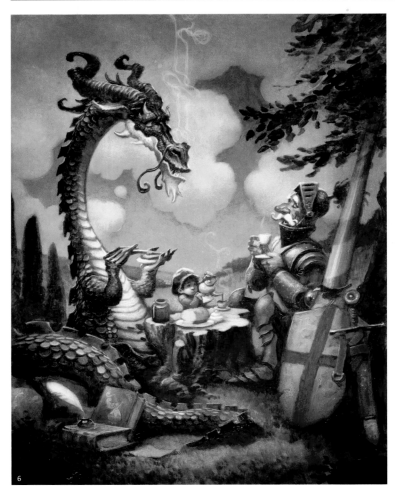

6

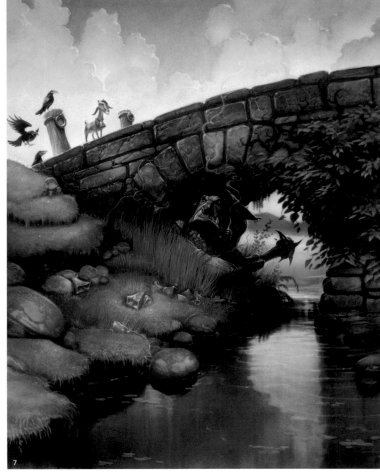

7

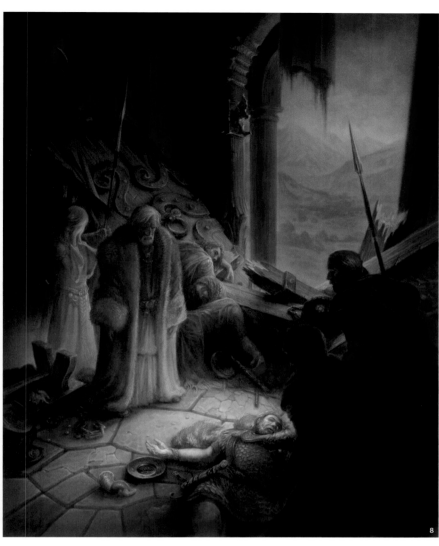

-- What's the focus of your work over the past 3 years? And what's the most important project (or the most memorable project) in the past 3 years?

-- My focus in the past 3 years has been to uncover and learn many of the techniques of past (and current) masters. I have felt like there were many gaps in my education that I needed (and still need) to fill. To this end I started many projects, both to help me pursue excellence in art, and work on classic stories (which I also love). The first of these was an illustrated version of *Beowulf*, of which a book has now been released. This I did primarily in digital, using Photoshop CS2 and a wacom tablet. The second, and possibly my favorite, was a series I did on JRR Tolkien's, *The Hobbit*. This I did with watercolor and CS3. This was a great chance for me to walk around in the world and to put down my own ideas about it on paper.

I feel like I learned a great deal from both these projects, and I plan to undertake several more like these in the coming years.

❺ Lancelot du Lac

❻ Reluctant Dragon

❼ Little Goat

❽ Beowulf-Hrothgar's Defeat

❾ Abandoned by the Sea

10

❿ The Battle of Five Armies

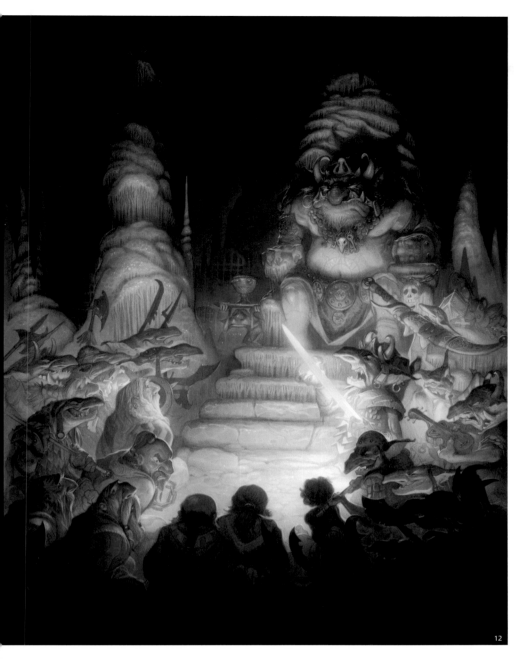

12

⓫ Beowulf-The Battle with Grendel

⓬ The Great Goblin

-- Digital arts have allowed the artists to explore more styles and subjects. What do you think of that?

-- I think it is great that digital art affords such an opportunity for people wanting to experiment and learn more about art. While nothing can replace solid drawing courses in an artist's education, digital art does offer a great way to try out many methods of working without the necessary drawbacks of traditional media: drying times, costs of materials, cleaning materials and difficulties in reworking mistakes. It is an almost indispensable tool in the professional illustration world now.

-- What do you think is the next step that digital art is going to take?

-- I would like to see a 4-foot-tall wacom tablet that you can digitally paint on as though it were an actual canvas, with a brush made of synthetic fibers, that transferred all the information from each bristle to the computer in real-time.

But I fear it will be less like traditional paint-ing and more like filters and 3D work painted over with digital. This is distressing to me because it will mean that people will draw less and less, which is a shame. Drawing, especially drawing from one's memory, gives such depth and personality to the subject. It imprints much of the artists own spirit onto the drawing. The more and more that digital artists begin to rely on tricks like filters and 3D maquettes in their work, the less and less soul digital art will have.

-- You have been engaged in digital artistic creation for many years. Would you share with us some practical experiences?

-- Every few months or so, you should put away your digital materials for a few weeks and work in traditional media, even if it is very hard to do. Do a few illustrations in watercolor, or oil, or acrylic. Then go back and work in digital again and repeat this process as often as you can. I found that by doing this, the work I was doing digitally was being informed by my practice in traditional paint-ing and that my traditional painting was being informed by my digital work. It helped me see the errors and crutches that I had in both media and it helped me to correct them. I also found that I have known more clearly how to arrange my layers digitally, because I began to treat the digital canvas the same as a traditional canvas. I found the results to be much more pleasing. I recommend to every digital artist, that the best way to do excellent digital art is to draw with pencil and paper from life as often as possible, and to learn how to paint traditionally and to practice it. It will help your work when you are using digital tools tremendously.

-- What's your hobby when you have free time?

-- I read a lot and I travel as often as I can. I feel like there are still so many places on earth left to see. The things I see and the people I have met when I have traveled always have a huge influence on my art.

Name: Kei Acedera
Occupation: Art Director, Imaginism Studio
Homepage: keiacedera.blogspot.com/

Kei Acedera

Behind the Smile
An Interview with Canadian Artist Kei Acedera

While sadness gives us a straightforward shock, a smile has its aftertaste. Anyway, we prefer the pleasant playful works.

What is Kei Acedera like? Before the interview, I just knew that she and Bobby Chiu are both from Imaginism studio. It can be said that the studio has become a well-known brand in the field of conceptual design because of their efforts. Kei Acedera's works are interesting and humorous, just like those of Bobby Chiu. What's more, you can find the romance of a girl in her works. And you can see smiles from her subject, be it a character, an animal, an elf or a monster. It gives rise to a curiosity to know the famous new woman artist. Now, I can see a Kei Acedera who is liberal and courageous, earnest and romantic, and loves life. Behind her smiling works is her bright smile.

Interview

-- When did you start to be interested in art? Why did you decide to be an artist?
-- I have been interested in art for as long as I can remember! When I was a little girl, my mother would always make sure I had a pad and pencils or crayons to draw with no matter where we went. The support of my family was very important in maintaining my interest in the arts. And because I have always been supported in my art from an early age, I have never considered doing anything else for a living! If I didn't do art now, I have no idea what kind of job I would have!

-- How did you get your first job at the age of 16 and how did you start your career? Was it an interesting experience?
-- My first art-related job was helping to paint huge murals in private homes and casinos. I had been doing art my whole life, so this job didn't seem very unusual to me at the time. I was having too much fun to think about my career. It wasn't until a few years later that I reflected on how lucky I was to have had the opportunity to do such a job before I even entered college. The work was interesting and fulfilling on an artistic level because it allowed me to paint. But more than that, it showed me that there was a big career market out there for all kinds of art.

-- Why did you leave college without finishing your studies? Was it for a good chance or self-confidence?
-- I interned at Imaginism Studios while I was in college and worked part-time there once school started again. At Imaginism Studios, I collaborated with Bobby Chiu on designing our own TV show, as well as contributed to our "*Sketches*" series of art books. After a while, I realized I could not dedicate enough time to both Imaginism Studios AND college, so I had to choose one. I decided that college was meant to prepare me for a career in art, which I was starting at Imaginism so I chose to focus on the studio. I thought, once the studio work slows down, I can go back to school, but it never did! I became the art director at Imaginism Studios and work has kept coming in, so I never returned to school. I think art school is a good idea for most people, but when opportunity knocks, you have to open the door. That was what I did and I'm thankful that everything has worked out well so far.

-- Nowadays, digital arts are developing in such a vigorous way that a lot of people have thrown themselves into this industry. Thus, what is your trademark feature?
-- I don't consciously try to develop my art with a specific set of features in mind. I just draw and paint what I like, so I think the features of my artwork is me. I try my best to put my own feeling into my art and create images that would be attractive to me if I saw it in a gallery. I'm often told that my art connects to people because I paint with the eyes of an art fan, not as an artist. I'm not sure if that is necessarily true, but as long as it works, I'm happy.

❶ *Unexpected Visitor*

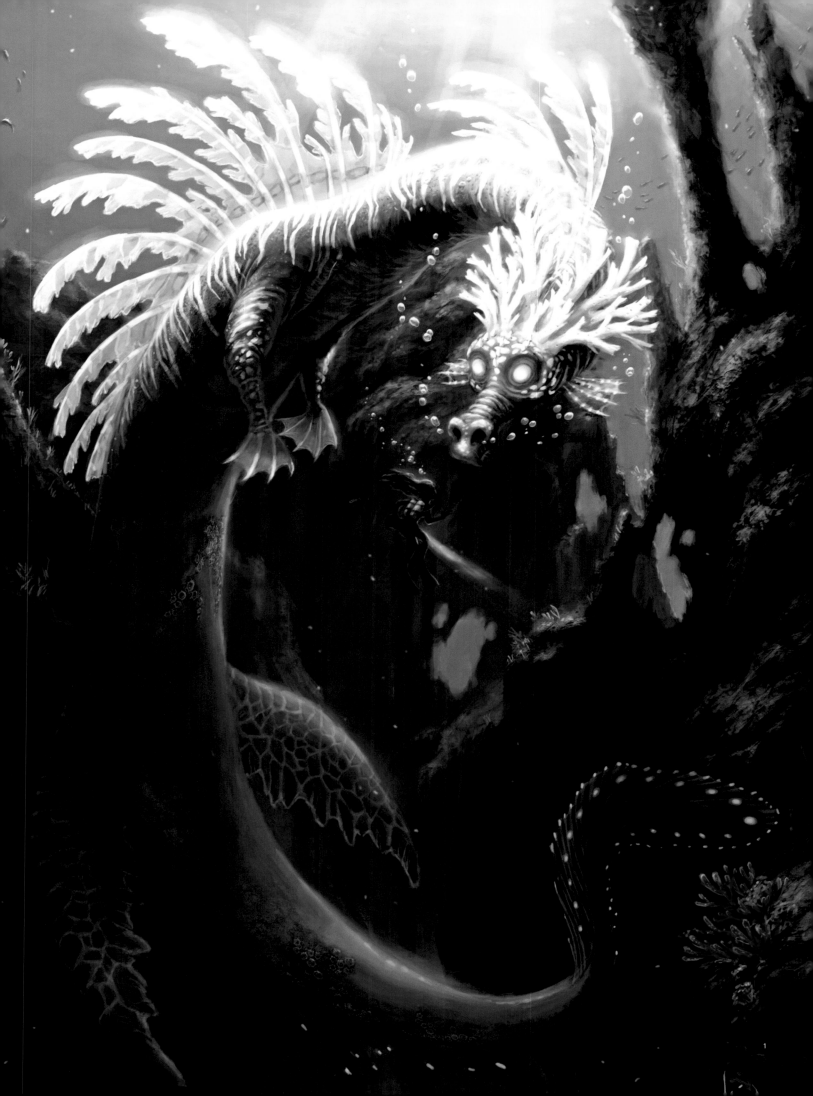

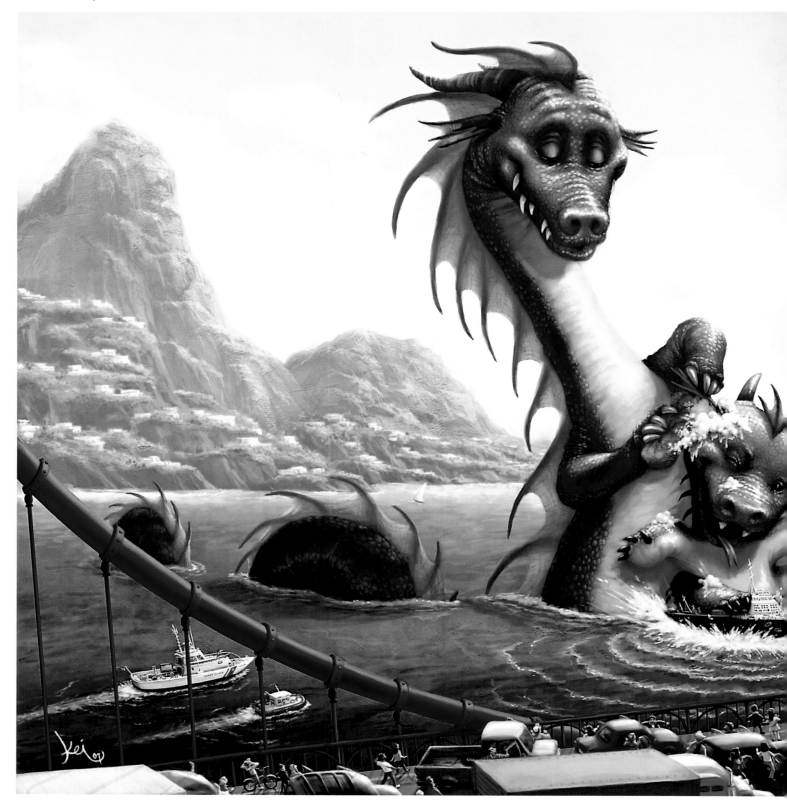

-- I have noticed that all of your figures are smiling, whether it is a human, an animal or spirit. Can you tell us why?
-- That's an interesting question, which I have never considered before! I think my characters are usually smiling and having fun because that is how I am as a person: I am generally happy and love to have fun. I guess as artists, we inevitably always put a bit of ourselves into our work.

-- How do you keep your light-hearted attitude or childlike innocence during your work

and in your daily life?
-- Ha-ha, I don't think I have an answer for this question! I enjoy my work and my life, so nothing really gets me down. I think positivity is easy if I surround myself with positive things and positive people.

-- Which artist has influenced you most in your art career?
-- There's so much amazing work being produced these days, and it's hard to narrow down a list, but some of my favorite artists who have influenced me include Erich Sokol,

Sargent, Henrich Kley, Gustav Klimt, Kiraz, Bill Peet, Milt Kahl, Lou Romano, Tadahiro Uesugi, Peter de Seve, Carter Goodrich, Nicholas Marlet, Chris Sanders, Ben Balistreri, Bill Presing, Stephen Silver and Bobby Chiu!

-- Why are you still using hand-painting in your work while incorporating digital skills? What do conventional techniques mean to you?
-- I think traditional techniques remain very important. Digital technology is only a tool, it is not a magical shortcut to great art; I do not

❷ Bath Time

think computer technology will ever be able to replace conventional skills. My digital works always use and build upon the conventional skills that I have learned and practice regularly.

-- What's been the focus of your work over the past 3 years?
-- This is a tough one! So many fun and exciting projects have come across my desk in the past few years, and it's hard to name the most important one! I did the character designs for Tim Burton's *Alice in Wonderland* with Bobby Chiu, which will be out March 2010. To

work with Tim Burton is a dream coming true; he's one of my animation heroes. I designed a kids' TV show for Disney last year. Perhaps my highest profile job was illustrating a series of children's books called *"How to talk to...."* The first book, *"How to Talk to Girls,"* became a New York Times best seller! I'm very proud of that! The book is very cleverly written and very charming.

-- *You have been engaged in digital artistic creation for many years. Could you share with us some practical experiences?*

-- I think my best practical experiences in my growth as a digital painter is collaborating with Bobby Chiu, learning his techniques, then meeting other artists I admire and learning their techniques as well. The most practical experience anyone can have in anything is to listen and learn all the time. And BOOKS, I read and look at a lot of books (The old ones are the best kind).

-- *What's your hobby when you have free time?*

-- In my free time, I like to travel, do photography, and watch movies. I enjoy everything that can show me new wonders that I have never seen, give me new ideas, and just allow me to see the world in a different way. I also love to dance!

❸ Crabby Chat

❹ Jelly Fish

❺ Enoki Forest

Name: Kekai Kotaki
Occupation: Digital Artist
Homepage: www.kekaiart.com

Kekai Kotaki

His Bearings
An interview with U.S. Digital Artist Kekai Kotaki

The picture Kekai Kotaki sent me attests to his pedigree. You know, pedigree can always present itself in form of details, despite generations of heritage or immigration. From this picture, you can see the bearings of Ronins from the Meiji period, or of artistic directors who worship their national culture. And his works bear the style of occidental fantasy arts.

Kekai Kotaki was born and grew up in Hawaii. He moved to Seattle to pursue art and his career. He joined Arena Net, a famous international game company, in 2003. He is now chief conceptual artist of the team. The games they produced include *Guild Wars 2*, *Guild Wars Nightfall* etc.

If you play games from Arena Net, you will see the characteristic style of Kekai Kotaki's works. Maybe you will see similarity between him and Justin Sweet or Vance Kovacs in conceptual design of the characters. But if you just view his illustrations, you will feel the bookish styles that belong to the Orient. And that is where our interview begins.

Interview

-- When did you start to be interested in art? Why did you decide to be an artist?
-- I have been interested in art my whole life. I still remember winning an art contest when I was in kindergarten. I got my very first dinosaur book from it. I continued to do art throughout my school years, and getting a job doing art seemed to be the logical next step in my life. I am glad I did. I enjoy doing art every day at work. I can't think of any other thing I would rather be doing.

-- Why did you decide to move to Seattle for further studies in art? Did you receive any special accomplishment there?
-- I decided to move to Seattle for schooling because I heard good things about the city. I really didn't know much about the school I was going to except that an artist friend of

mine whom I went to high school with was going there also. It wasn't until after I got into school that I found out that Seattle was one of the hot spots for the gaming industry. I have greatly enjoyed my time here in Seattle and I am always glad I made the move.

-- Nowadays, digital arts are developing in such a vigorous way that a lot of people have thrown themselves into this industry. Thus, what is your trademark feature?
-- Right now, I would consider myself an epic fantasy artist. I work on a fantasy game, *Guild Wars 2*, and most of my inspiration comes from the fantasy genre. I try to use strong compositions combined with a painterly technique to convey emotion of what's going on in a piece of art. I also make an effort to

achieve a level of implied detail in my works.

-- Does having a Japanese background relate to your special style? Do you like Eastern culture?
-- Yes I would say so. I am heavily influenced by western fantasy painters. However, I try to look at all art no matter what it is. I feel that everything has something that can be learned from. And I love Eastern culture.

-- What's been the focus of your work over the past 3 years? And what's the most important project (or the most memorable project) in the past 3 years?
-- The focus has been my work at Arena Net working on the *Guild Wars* franchise. My most important project in this time period is my work on *Guild Wars 2*.

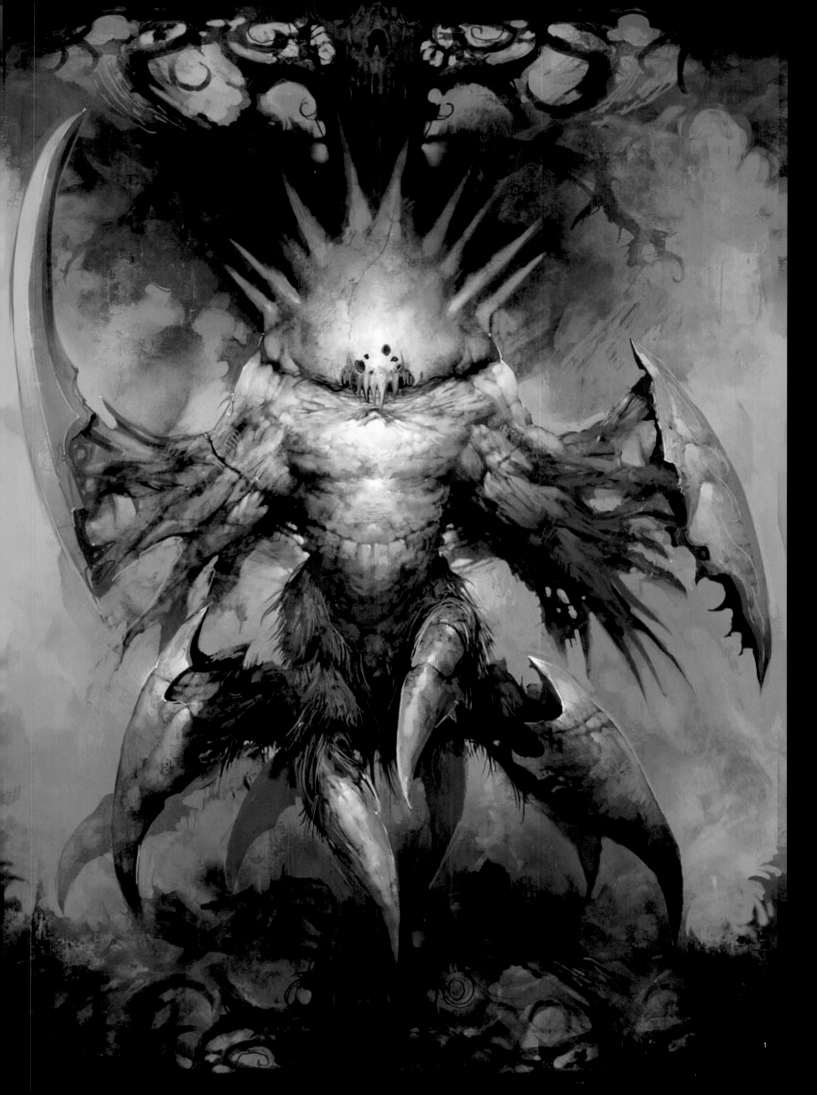

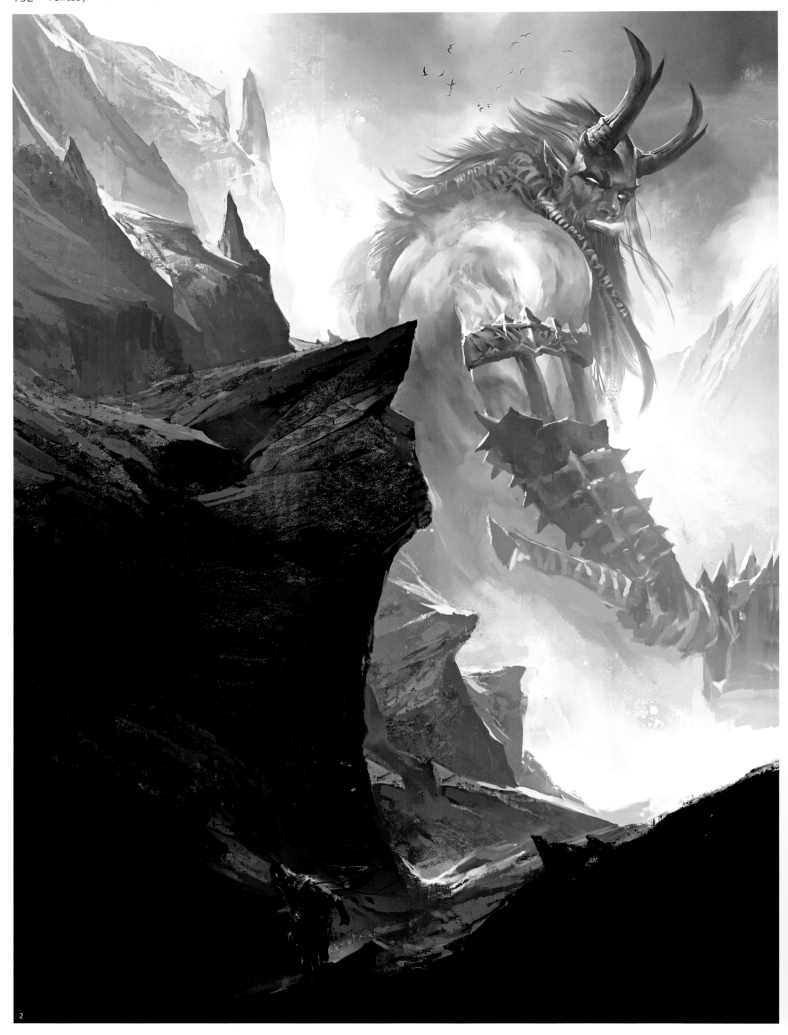

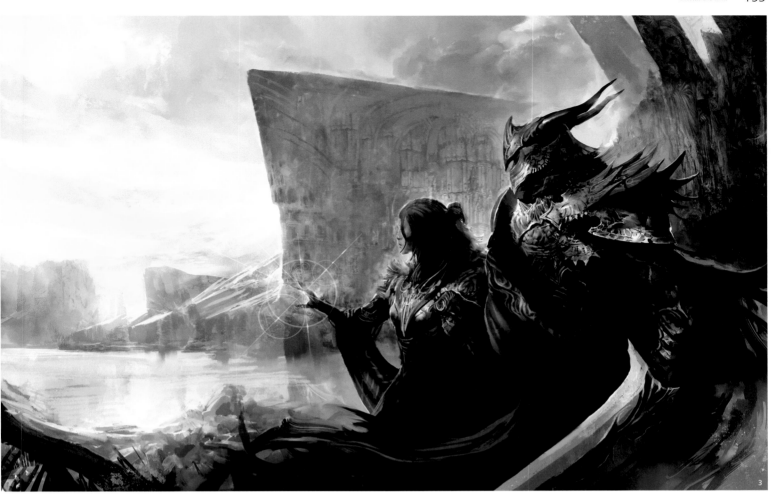

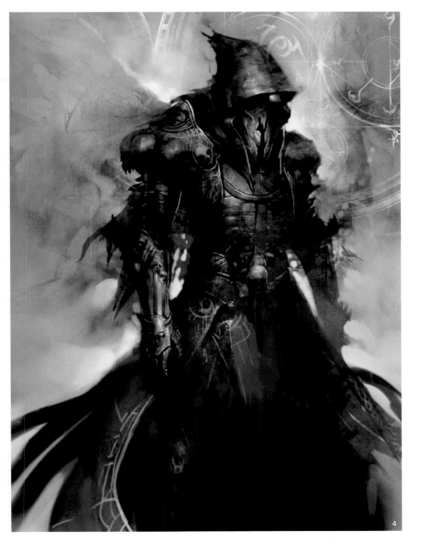

❷ The Frost Giant

❸ Seashore

❹ Grenth

-- *Digital arts have allowed the artists to experiment with more styles and subjects. What do you think of that?*
-- I have done some exploration. Not as much as other people. I feel that I am still crafting my voice in art. Any practice or exploration pieces that I do are usually done to help me build the greater whole of my technique.

-- *What do you think is the next step that digital art is going to take?*
-- I really can't answer that. I believe every artist's path is his, or her, own. But I believe that every artist is trying to improve their art.

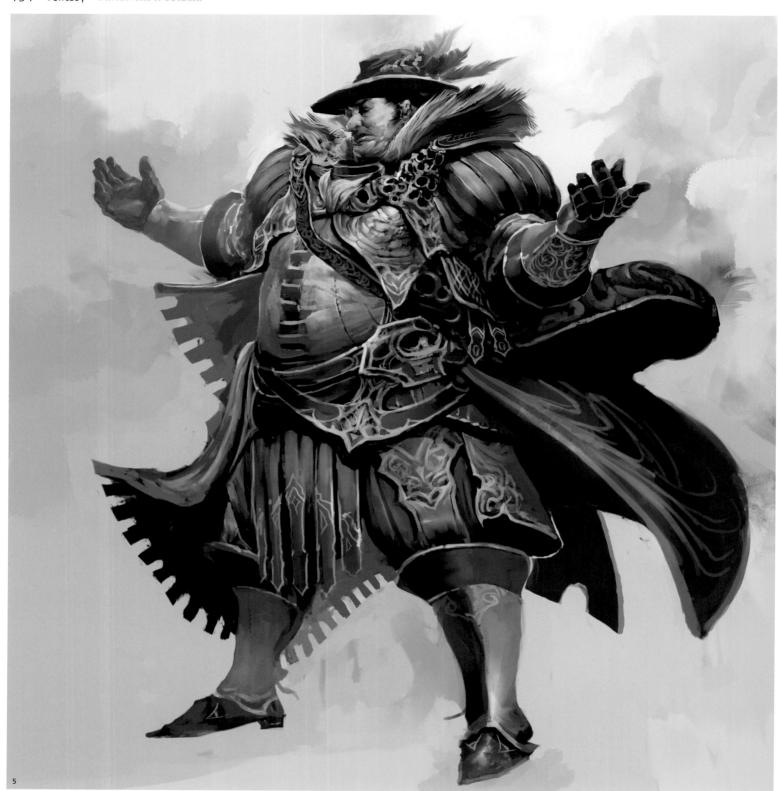

5

❺ Jolly

❻ Knight

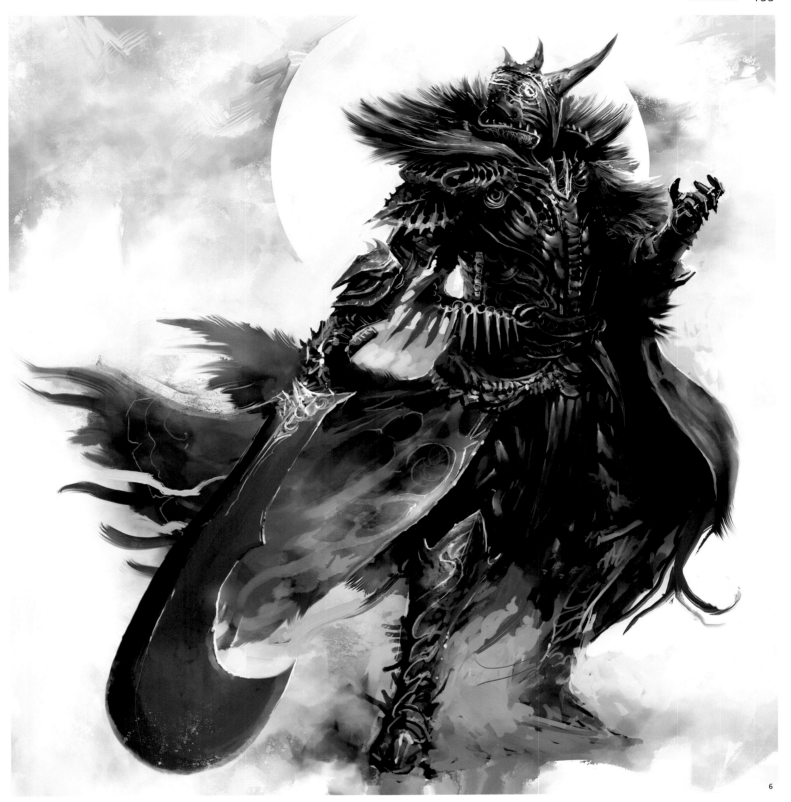

6

-- *You have been engaged in digital artistic creation for many years. Would you share with us some practical experiences?*
-- Get to know your setup when you work. Being comfortable while doing art is a great benefit. Have fun when you do art. Find out what subject interests you and then use that for motivation. Doing art on

a subject that you like will make that art much better.

-- *What's your hobby when you have free time?*
-- I like to read books and watch movies.

-- *Now more and more people are engaged*

in this digital industry. Do you think the traditional hand-painted art is still needed in this era?
-- There is always a need for traditional art. Art is too big to just limit it to digital. A computer is no different than a brush in a painter's hand. It is just a tool. A big fancy tool, but it's only a tool still the same.

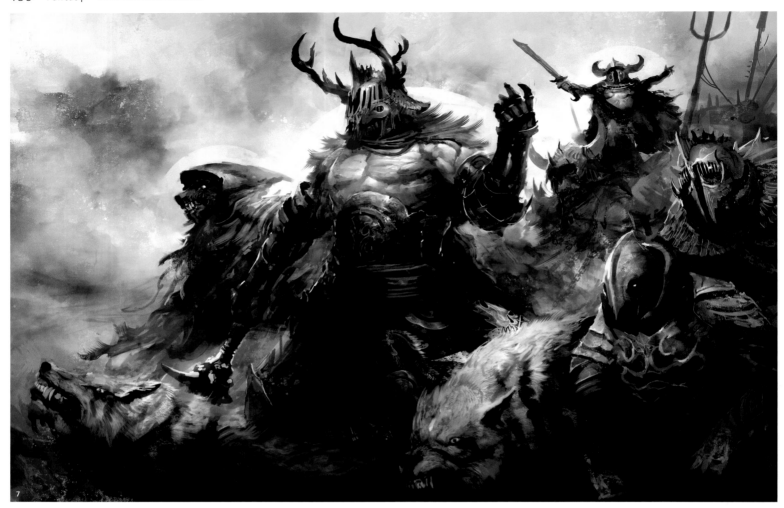

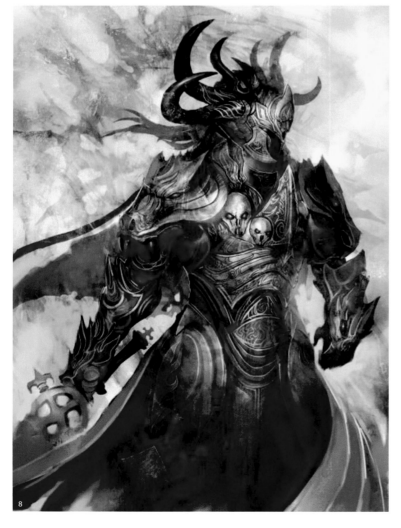

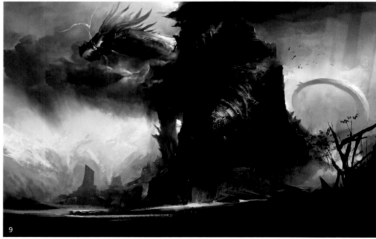

❼ Warband

❽ Balthazar

❾ The Storm Lord

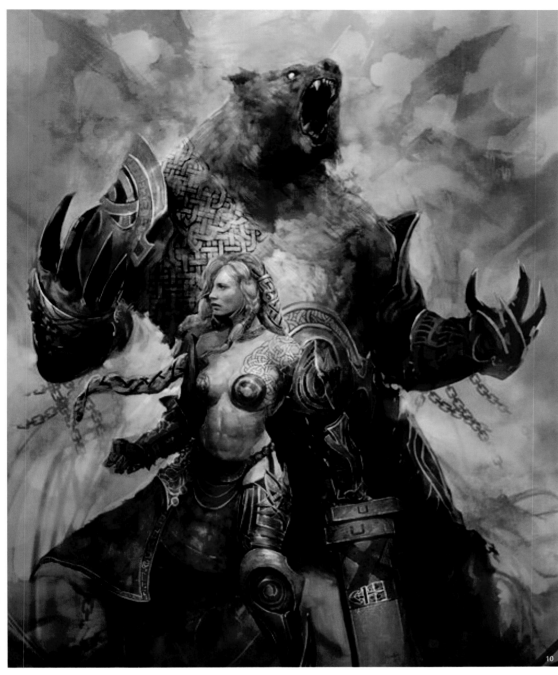

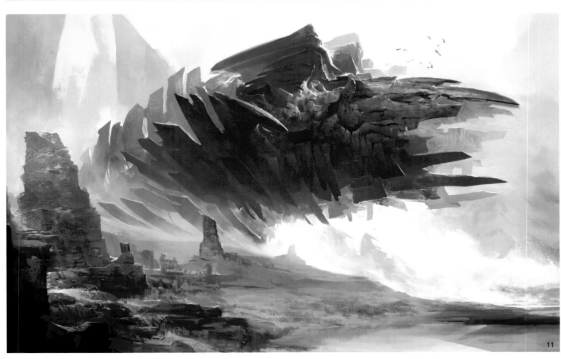

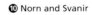 Norn and Svanir

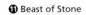 Beast of Stone

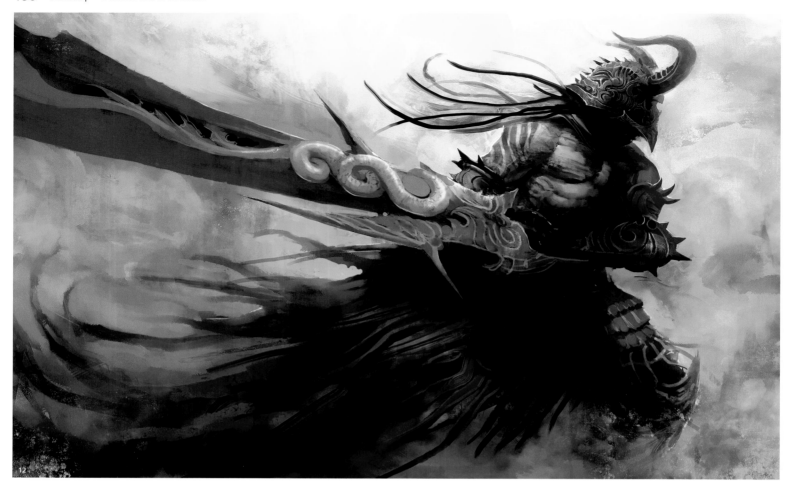

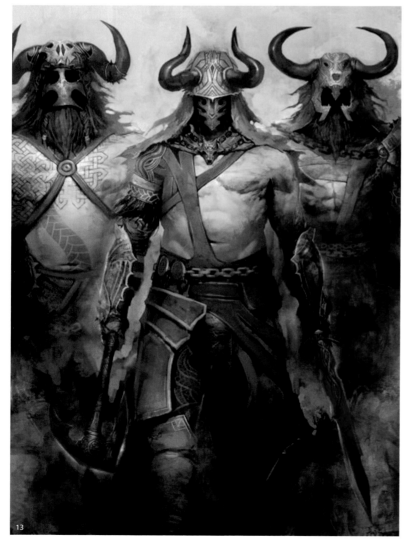

⓬ Great Sword Warrior

⓭ Norns

⓮ Slayer

⓯ Barbarian

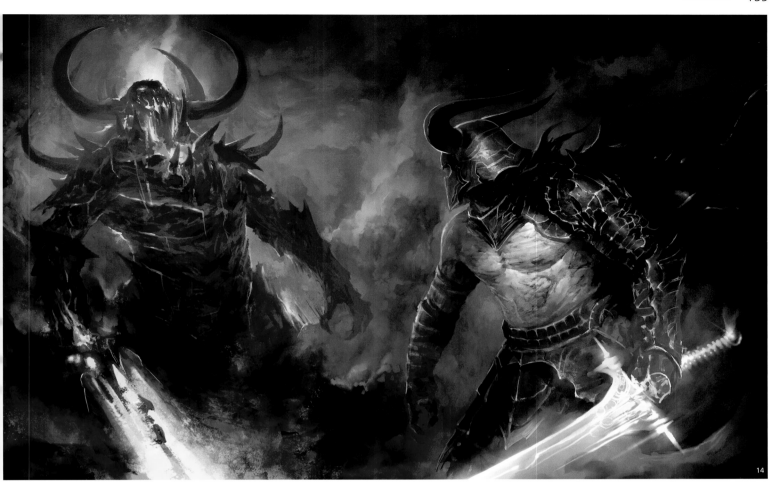

14

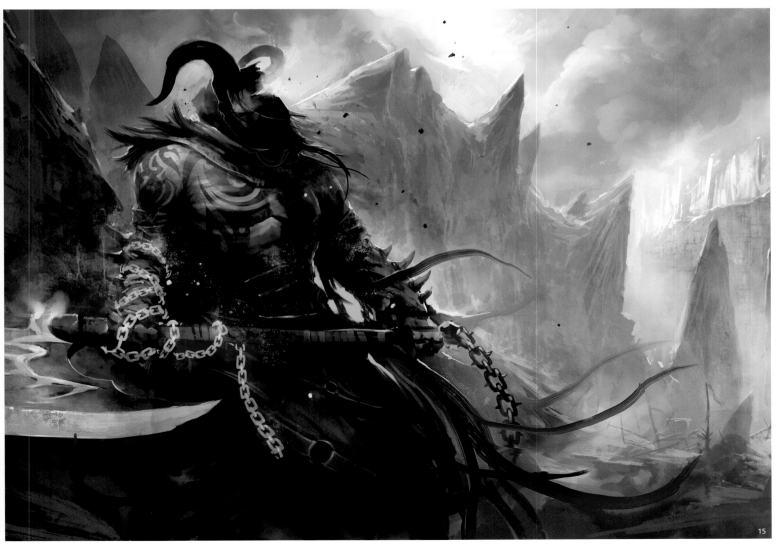

15

Ken Wong

Name: Ken Wong
Occupation: Design Director, Spicy Horse Games
Homepage: www.kenart.net

Ken Wong

The Honest Inspiration
An Interview with Australian Artist Ken Wong

When I visited Spicy Horse Games last year, a friend told me that Ken Wong was design director there. I had met with the young artist before but did not interview him. His works are mysterious and cranky, but simple and playful. My first response was: "he really goes well with the style of Spicy Horse."

A number of people have asked Ken Wong why he creates works with such a style. For him, what is important for illustration and conceptual design is not to meet some requirements or make some stunts; what are considered "personalities" or gim- micks. What he does is to observe from different perspectives and draw what he envisions honestly. "The so-called inspiration is what I have in my heart, just natural ideas." So there is no mystification in his works. You will love them if you view them quietly and feel the honest inspiration.

Interview

-- When did you start to be interested in art? Why did you decide to be an artist?
-- I was always drawing when I was young. I didn't really decide to make a living in art....work found me instead. I do it now because it's rewarding—it gives me freedom, and it's always exciting and new.

-- How much did you know about China before you came to this country?
-- My family is Chinese but I was born in Australia. I grew up learning about some Chinese customs and culture, but I did not really know much until I moved to Hong Kong in 2004.

-- How is your life in Shanghai? Are you accustomed to the life here?
-- I've been in Shanghai two and a half years.

I'm fairly accustomed to it. It's a very convenient place to live, and very exciting right now.

-- Why did you decide to change from freelance to full-time, and move from your homeland to a strange country?
-- Freelance is tough and you can only rely on yourself. Doing full-time work now allows me to work with and learn from others, with a steady income. Moving from my homeland was not a trouble for me, I like to have adventures, and challenge myself.

-- What do you do in Spicy Horse?
-- I am an art director at Spicy Horse. My role is to develop the visual quality and artistry of our products, and manage the art team.

-- Nowadays, digital arts are developing in such a vigorous way that a lot of people have thrown themselves into this industry. Thus, what is your trademark feature?
-- I'm not looking for a gimmick for my work to stand out. I strive to be honest in my art, to put my personal heart and ideas into it, and in that way, I hope my art will stand on its own.

-- You like to use single lines to draw your characters? Why did you choose this style?
-- It's not something I chose. It's just my natural style. But there are some ideas I feel are expressed better with simplicity, some with complexity.

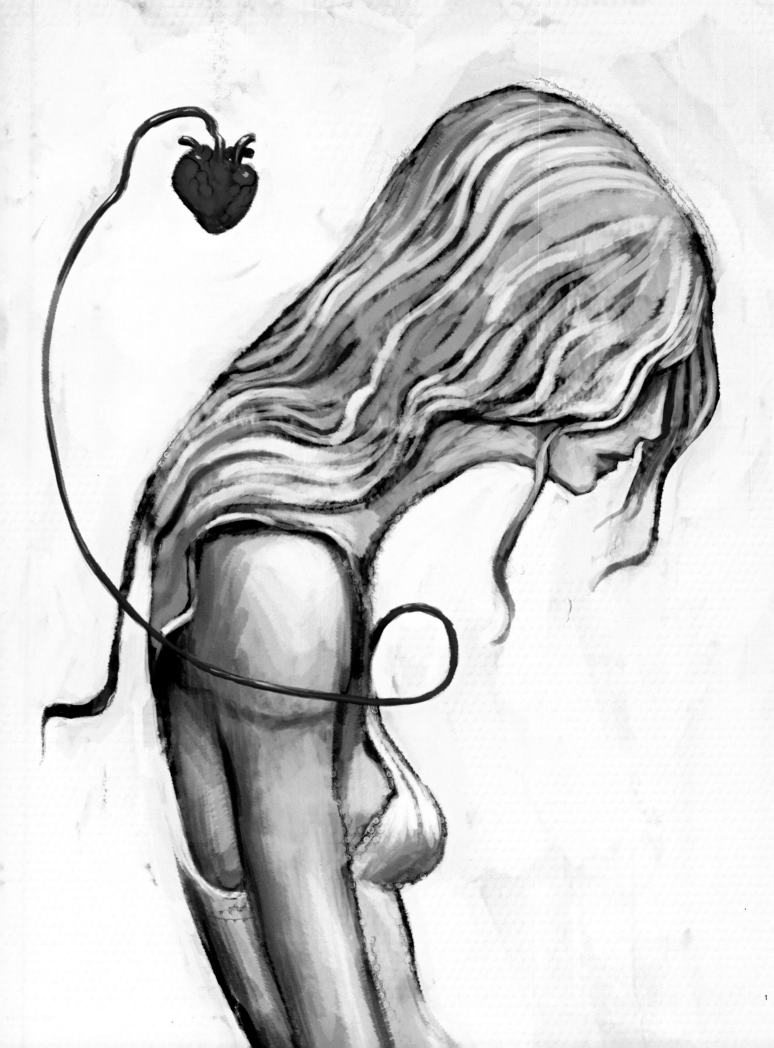

3

❹ Fly by Night
❺ Sanctuary
❻ Blue New

-- *There are always some funny ideas in your picture. How did you get them?*
-- The concepts in my art usually come from looking at something in a different way or contrasting two things that normally aren't found together. It's just the way my mind works. I like to see how ordinary things can be used in interesting ways, combining the mundane and the fantastical.

-- *What do you think is the most important thing to an illustrator, color, line, shapes or originality?*
-- There is no one correct way to think of illustration and no one element is the most important consideration.

-- *Digital arts have allowed artists to explore more styles and subjects. What do you think of that?*
-- I like to combine different techniques together to achieve results that could not be found by using other media. For example, combining photographic textures and color adjustments with digital painting and scanned pencil lines.

7

-- What do you think is the next step that digital art is going to take?
-- What excites me is seeing more creative uses of these tools, using them to express ideas and movement and form in new ways. There won't be a big next step.... but gradually we'll see graphic design, CG animation, photo manipulation, computer games, and digital painting combine and mutate with each other and with traditional art forms and ideas, in exciting new ways.

-- Now more and more people are engaged in this digital industry. Do you think that traditional hand-painted art is still needed in this era?
-- There is a beauty and brilliance that comes from the texture and fibre of natural media that is still unmatched by digital emulation. Digital is best at being digital. When you want something to look painted, traditional paint will always look more natural, more expressive. However, digital can be faster and manipulated more easily, making it increasingly attractive for commercial art.

Luis Melo

Name: Luis Melo
Occupation: Conceptual Artist, Spicy Horse Games
Homepage: www.luismelo.net

Luis Melo

The Journey to the East
An Interview with Portugal Digital Artist Luis Melo

It is wonderful that a foreign artist you phoned for an interview comes to work in your country. Maybe he felt curious and excited the first time he met with Easterners. But now, he is living in the large country, working and enjoying the life here, and getting to know new yellow-skinned friends.

Luis Melo is the first Portugal artist I interviewed during the several years of work. Most of the questions I asked were about his background and the local culture. What impressed others were his expressive posters, with a sense of lightheartedness. Two years later, he came to China and worked by the side of one of my friends. To describe our meeting again, we can say the world is really small.

Interview

-- *How much did you know about China before you came to the country?*
-- Before I came here I was quite fascinated with the Far East, although I didn't know all that much about China. I knew it was a fast-growing and changing country nowadays, and I think that's what I came to find.

-- *How is your life in Shanghai? Are you accustomed to the life here?*
-- When I arrived in Shanghai something about the city felt more familiar than I expected. I really like it and I think I'm accustomed. I live by myself and I have my daily routine now, nothing really feels strange or out of place in my everyday life. Language is still the biggest barrier I have to overcome to really feel at home, but I'm slowly learning.

-- *What has changed in your life since you moved from Lisbon?*
-- Well, lots of small things are different just for the fact I moved to a gigantic busy city, although, as I said, not as much as I had imag-

ined. I keep doing the same activities I did in my country - drawing, playing music, going out with friends.... the biggest difference is maybe how surrounded I am by this urban environment, while in Lisbon I was just a short drive away from the ocean or forest.

Also, not speaking much Chinese limits my interaction with people, but not enough to make me isolated, since I met many people at the company and also some Chinese who speak good English.

-- *Why did you decide to change from freelance to full-time, and leave your homeland for a strange country?*
-- It's a chance I couldn't let go by. I was looking for jobs out of my country because I felt it was the right moment in my life to try and live different things, and maybe the more different and far away the better. In a few years, maybe I would have created too many roots in my country or in Europe, to try something like this. I also wanted a different work experience, and having spent a really good year

and a half working as a freelancer I thought it would be interesting to get some more "inside the industry" experience. I was lucky to find this position at Spicy Horse, because besides providing me what I just mentioned, I got the chance to work on some really exciting projects.

-- *What do you like most about China? Can you speak some Chinese after staying here for months?*
-- It's hard to pick the best thing about China. I love the food; the people are really friendly, and I've been to many beautiful places. Maybe I'd say my favourite surprise here was to be surrounded with life on the streets everywhere and at any time. Although Shanghai can sometimes feel heavy and urban, it's uplifting to see how the street life goes and how much animation there is.

I'm learning Chinese and I can say some things, but when it comes to understanding other people it's still quite hard to catch up. My ear is not fluent with it yet. But I'm far from giving up!

❶ Dream Final

❷ Blue Singer Hires

❸ Like Summer

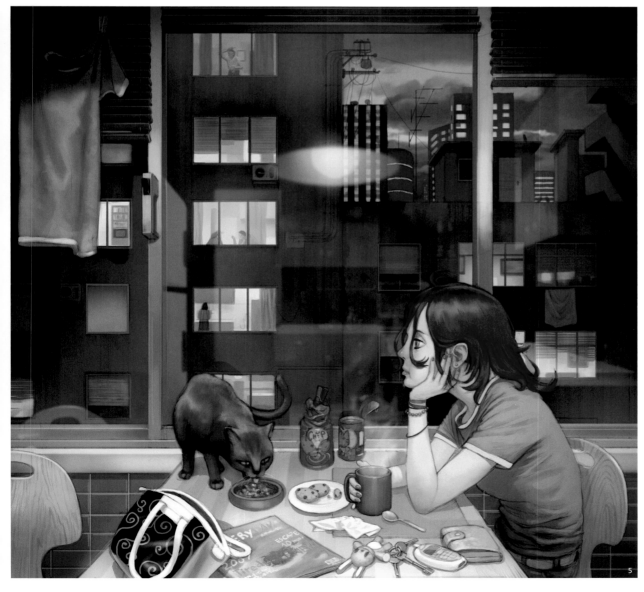

4 Forest Cats
5 Routine Flat

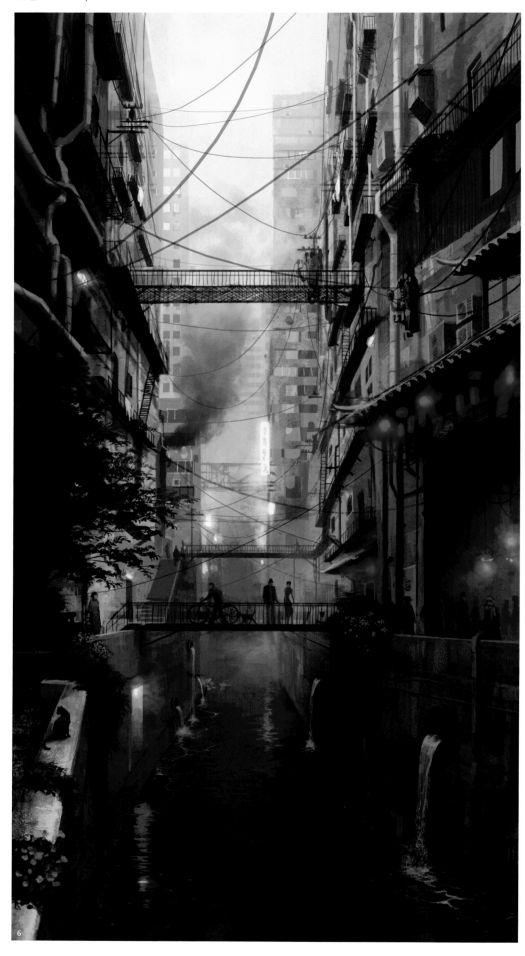

❻ Canal

❼ River

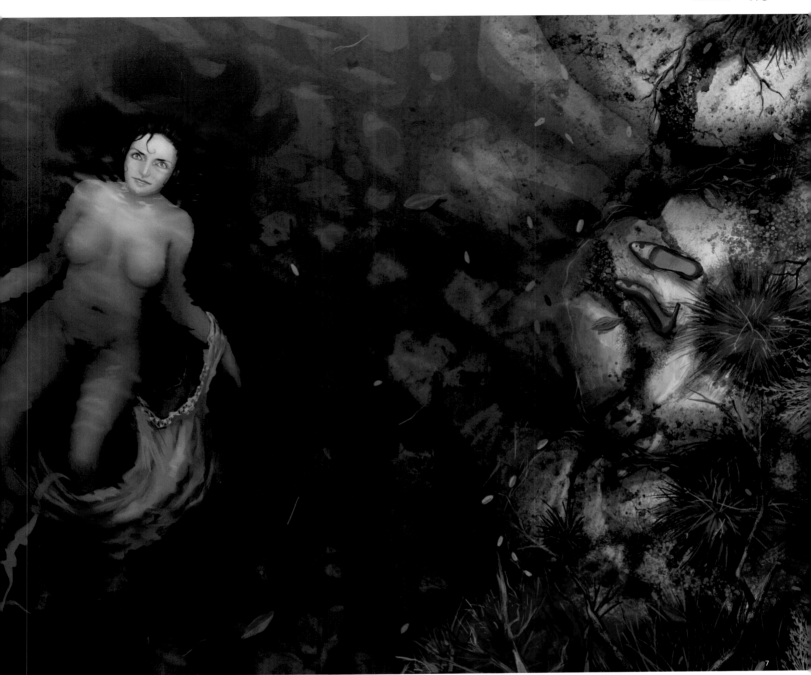

-- Now what do you do in Spicy Horse?
-- I'm a concept artist. I make digital paintings of characters, environments and assets for the company's current projects.

-- Nowadays, digital arts are developing in such a vigorous way that a lot of people have thrown themselves into this industry. Thus, what is your trademark feature?
-- Digital art is indeed in fast development, and lots and lots of amazingly talented people are emerging. Sometimes I feel outdated and technically limited when I see the skills of other people working out there. I try to follow a personal look on things. I try to draw what I really like and from my most personal references and feelings. And then I hope the final result is strong and unique enough to make people interested.

I think this field requires a balance of skills, taste, style and ideas. Some things you learn from studying, teachers and practice and oth-

er things you bring from within yourself. The more of yourself you put into your work, the less you have to worry about too many people doing the same as you. But you shouldn't use that as an excuse to be lazy. You have to keep that balance to make people (and employers) interested, and you should know where you fit and what your art is best suited for, if you don't want to be misunderstood.

-- Digital arts have allowed the artists to experiment with more styles and subjects. What do you think of that?
-- Yes, it's true; the digital medium makes it easy for artists to go in any direction at any time. Sometimes I feel like trying something unexpected, or different from what I'm used to, so I just try.

Some artists prefer to work in a single style and refine it as their trademark, others like to show versatility. I think both approaches are valid for a successful career. It's easy to get lost

in the amount of digital options at first, and if you don't focus on one thing, it's hard to specialize. But if there's something you fancy trying, why not? Personally, I don't even think about that, I just draw however my impulse for a picture orders me.

-- What do you think is the next step that digital art is going to take?
-- I don't really know.... there are too many options! Some digital artists break the boundaries of 2D art by exploring 3D, video, animation or even programming in really creative ways. I think those kinds of ventures will result in the most groundbreaking stuff. But speaking for myself, I find it hard to keep up with novelty, especially on the technical side of things. However, even digital painting and concept art itself has a lot of room to innovate, as other media it's normally associated with (like games, cinema and animation) are taking on different visual styles all the time.

-- Now more and more people are engaged in this digital industry. Do you think the traditional hand-painted art is still needed in this era?

-- Depends on what you mean by "traditional hand-painted." I think painting will always be there as a fine art, as long as people want to look at pictures on the wall, whether with a contemporary or traditional approach.

If you mean whether there's a need for natural media illustration, I think it will also still have its place. Although the digital medium brings so much convenience to the painting process and its integration in a project, convenience is not the sole objective of art, and there are many other qualities about natural medium illustration which will always be appreciated. I think that as projects broaden their visual scope, they will integrate more and more kinds of art, including natural media. It all depends on what you can do with it.

Of course, if you're thinking of becoming a concept artist or such, if you can't use a computer, you're seriously limiting your employment options, unless you can do something really outstanding and have an amazing workflow with natural media.

❽ Burning

❾ Waterfall City

❿ Praiasdesertas

-- *You have two sorts of artwork: illustration and posters. There were also two styles. How did you do them in such a different way? And which sort do you prefer?*
-- My major at university was graphic design, not really illustration. I eventually discovered I liked illustration more, but I finished graphic design and it taught me many important things and made me more comfortable with composition and using type. I did a lot of posters for my bands' concerts and other events, and some of my personal work is also in poster form. It's a really fun thing to do, posters have that in-your-face impact, and they have to sum up all you want to convey in a powerful way.

I can't say if I prefer doing posters or normal paintings, they communicate differently, and they're both things I wouldn't want to stop doing. But I haven't had much chance of doing posters lately....

-- *What are your achievements and progress in the new team?*
-- In this team, I think the biggest achievement for me and the other artists here, was to tune in to one very challenging creative vision. It's been great to witness that happening and I'm glad that artists at Spicy Horse are encouraged to bring so much of their own into the project, instead of just being briefed exactly what to do.

Also, all of my colleagues work in totally distinct styles and methods, so I'm really learning a lot from each of them. Besides this, it's pushing me a lot more, to be so closely directed and in contact with the team and project creators. I feel I give more to the project and also try harder to do better work.

Paul Sullivan

Name: Paul Sullivan
Occupation: Freelance Artist
Homepage: www.paulsconcepts.com

Paul Sullivan

A Knife to Break down Everything
An Interview with U.S. Digital Artist Paul Sullivan

How do we break things down? With eyes or logic, or with a brush or a knife?

Human beings always break down things in nature for their end. For Paul Sullivan, everything in the world can be broken and used in his creation.

After graduating from the art and de- sign school of Rocky Mountain University in Denver, Paul began his journey of free creation passionately. For him, what matters is not the living and pay, but the sense of being an artist. He often walks on the sands outside his house, and draws an afterglow or wave in the sunset. He breaks down the elements of art the nature brings him, and refines them into experience in drawing.

Paul is now working for game companies. After his great success in the adaptation of *Tomb Raider*, he adapted the *Afro Samurai* into grandeur game. Everyone who has played the game will find it exciting.

Interview

-- When did you start to be interested in art? Why did you decided as an artist?
-- I have had an interest in drawing since I was a child, which continued into my adult life. I used to enjoy watching my mother draw and try to learn from her as she is a very artistic person. Because of this lifelong passion, I decided that the only thing that I could do with my career was to pursue an artistic position.

-- Nowadays, digital arts are developing in such a vigorous way that a lot of people have thrown themselves into this industry. So what's the feature of your artwork?
-- There are a lot of extremely talented people out there with a strong voice. Everyone makes their mark their way and makes design choices and compositional choices independently. I would hope that through enough practice, I would begin to make my own distinct mark instinctively as well.

-- What's been the focus of your work over the past 3 years? And what's your most important project (or the most memorable project) in the past 3 years?
-- Over the past three years, the focus of my artwork has been to try and get myself onto projects that I feel are more in line with the type of art that I would like to be doing. With an emphasis on personal artistic growth and experience, I enjoy pushing designs, shapes and compositions and finessing the fine line between not enough and too much, this is the art in concept design for me.

-- I have always wanted to know who designed the character Afro Samurai in the very beginning. How did you follow the path to paint a new character belonging to your style?
-- I would say that the most important and memorable project for me has been the *Afro Samurai* project so far. It is a really great concept filled with inspiration and fun ideas! I had the great opportunity to work with some extremely talented people and great friends at Namco. The core art team was small and efficient, Bryan Johnston (art director), Josh Tiefer (lead character artist), myself and a few others. The character Afro Samurai was originally developed by Takeshi Okazaki who created the graphic novel. He has brought a really rich and exciting feel to the book. I tried to do his art justice while also putting as much of myself into it as possible.

❶ Afro Droid Air Battle

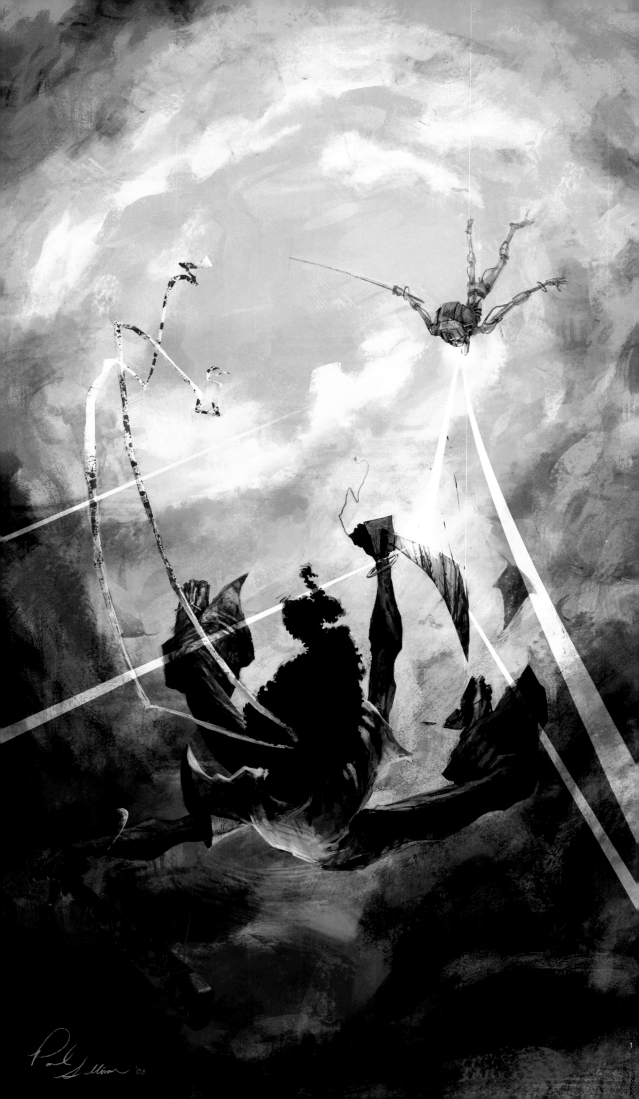

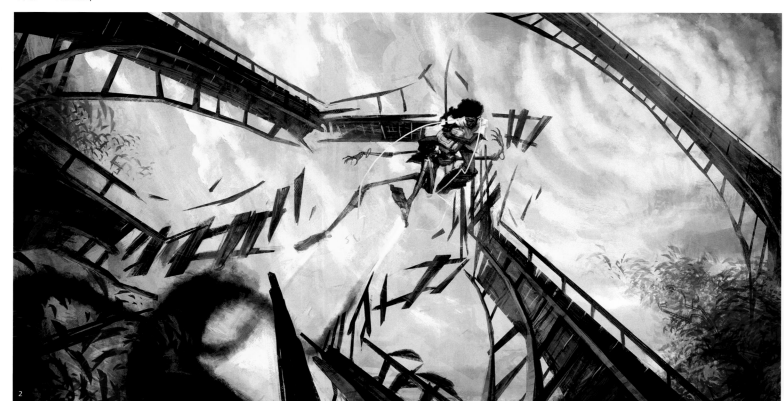

❷ Afro Droid Battle Bridges

❸ Hero

❹ Hive Progress

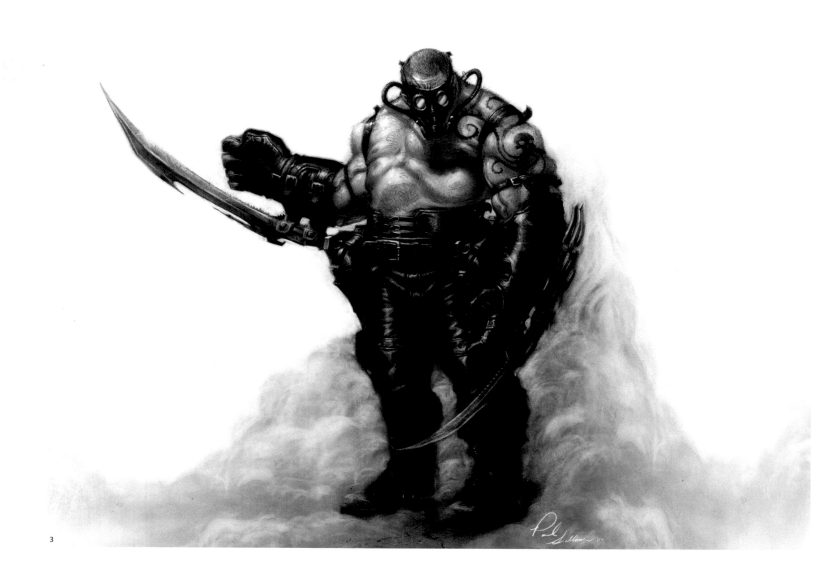

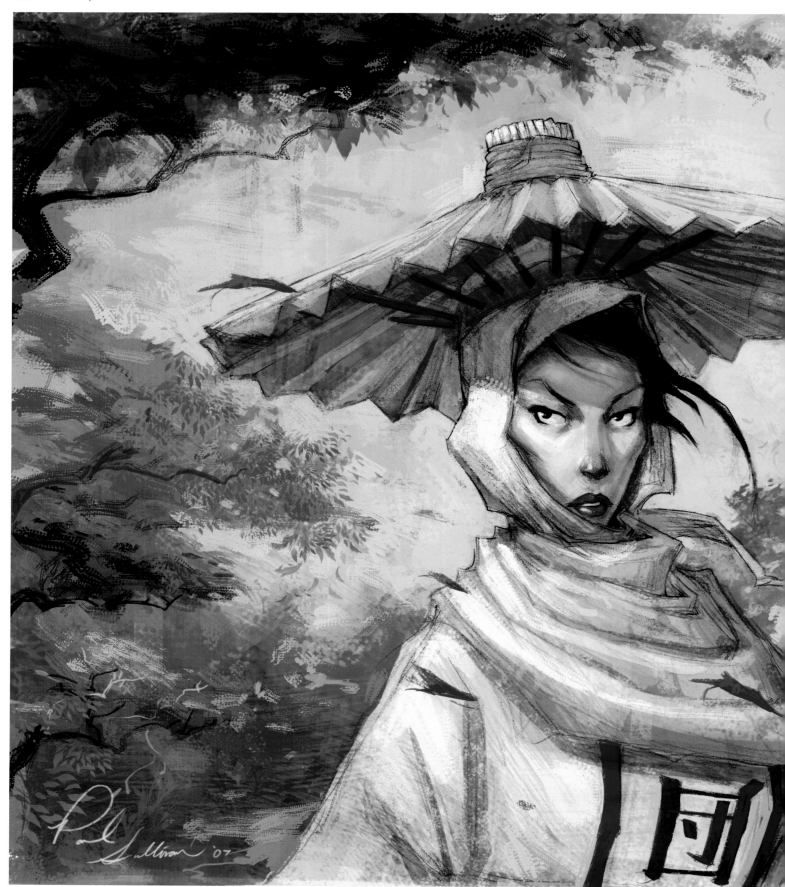

❺ Musician

-- Do you like Eastern cultures when you take part in this project?

-- I did a lot of research for the *Afro Samurai* project including old school Kurosawa films, Manga, a lot of Eastern artists were referenced and used as inspiration as well as Western artists. Because the project is kind of a mix between East and West, with no specific time period.

-- Digital art provides a convenient condition that seems to allow the artist the opportunity to try more styles and themes. What do you do of this aspect?

-- I have always enjoyed changing my style and medium. I feel that it keeps things exciting for me and definitely helps achieve different looks, with the digital medium however, it is possible to achieve a wide variety of looks with the same medium, I have a bit of a range of styles from realistic to stylized that I hope to expand on and add to more in the future.

-- What do you think will be digital artists' next step of exploration in this field?

-- Tough question, it seems like the most successful pieces done digitally have a hand-done traditional feel to them. I think artists will continue to master this look and maybe create a new one that is widely appreciated. For now, I feel that the human touch is what makes art most interesting and intriguing.

-- You have been engaged in digital artistic creation for many years. Would you share with us some practical experiences?

-- I learned to paint traditionally first and learned about digital programs later. It was when I started working as a professional that I combined the two and tried to apply my traditional knowledge to the digital medium. This has actually involved a lot of trials, which ended up in either success or failure. I have just tried to rationalize what is done traditionally in a digital medium.

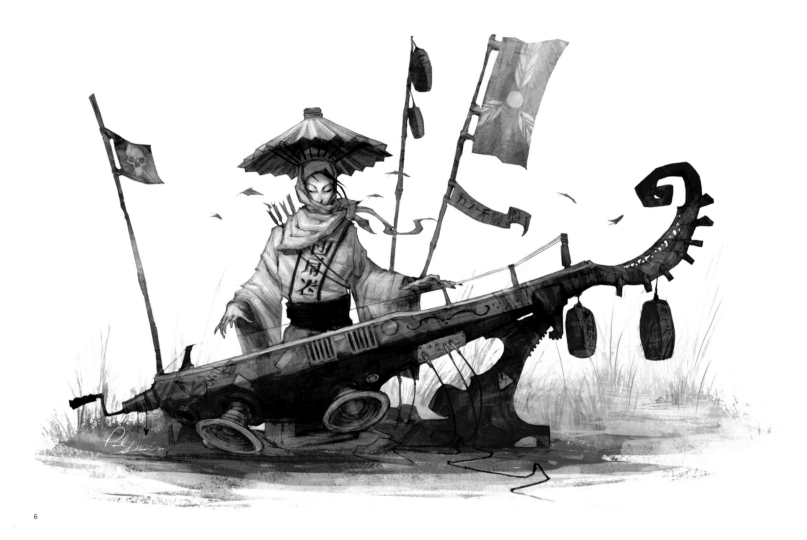

6

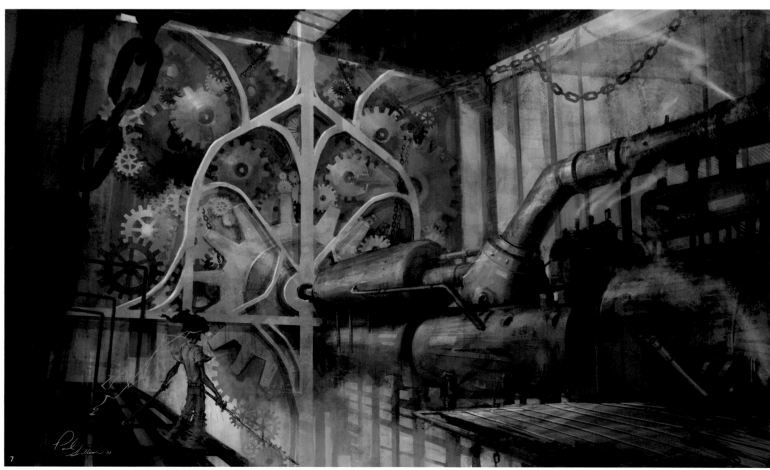

7

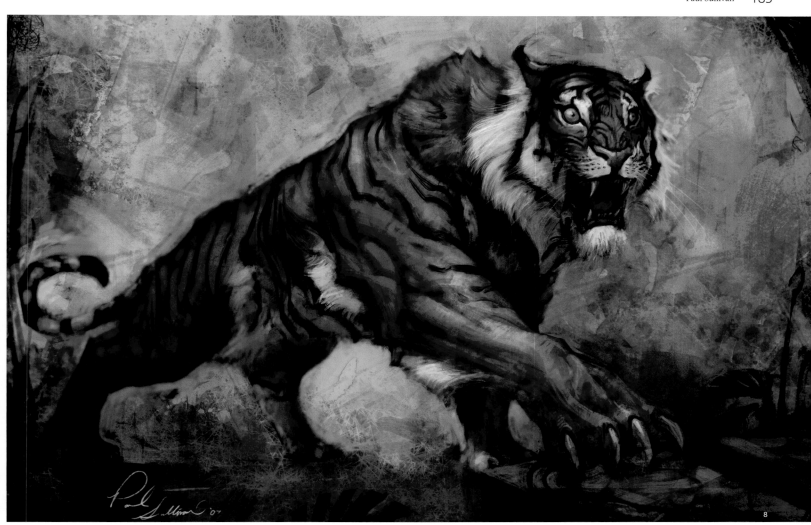

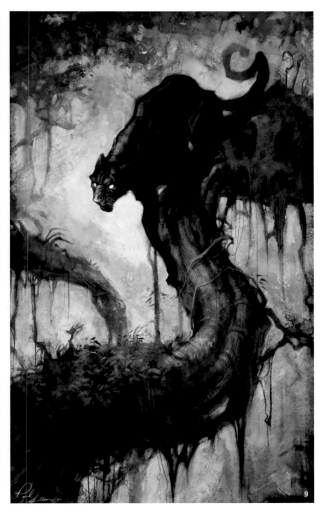

6 Musician Instrument

7 Clock Gear Room Final

8 Johns Tiger

9 Panther Pounce

-- What's your hobby when you have free time?
-- I love doing art. It occupies my mind. In my free time I look for inspiration everywhere—film, photography, sketching etc.... I also enjoy reading, martial arts and sports, which will hopefully always be a part of my life as well.

-- Now more and more people are engaged in this digital industry. Do you think the traditional hand-painted art is still needed in this era?
-- As I mentioned before, I think that anything by-hand has a particular charm that cannot be created by modern equipment. However, the digital medium is taking over because it's faster, more efficient and allows for quicker changes and tweaks. Traditional and digital skills go hand in hand and they're both just media. However, in the competition between traditional skills and modern techniques, the former seems to lose ground little by little.

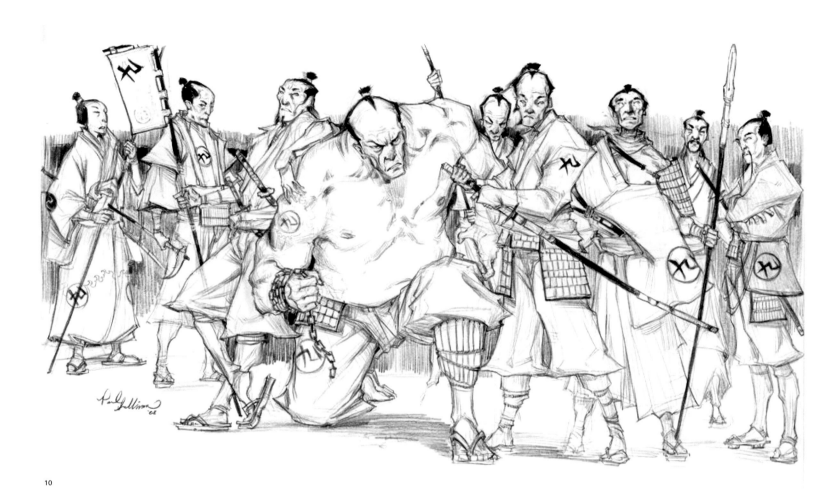

10

11

Name: Marc Craste
Occupation: Freelance Artist
Homepage: www.studioaka.co.uk

Marc Craste

The Dolls
An Interview with U.K. Digital Artist Marc Craste

Marc Craste is one of the cartoonists I got to know in recent years. He works in London, first as a print illustrator and now an animation director. Digital arts are vital in his life and work. With these digital skills, he produces a number of award-winning animations for several companies. Besides the work he is commissioned, he tries his own production with limited resources. Marc is a man with the heart of a child, who considers his works as dolls for children. So the characters in his animations are like dolls too, which become the key to his success. His *JOJO IN THE STARS* and *VARMINTS* won BAFTA in 2004 and 2008 respectively.

I decided to interview the digital artist who produces animations. The digital art in his eyes is full of sounds and actions, which provide a way to create living characters.

Interview

-- When did you become interested in art? Why did you decide to be an artist?
-- I always drew as a kid. I would sit for hours happily drawing. My interest in animation started with seeing Disney animated features. I enjoyed them as films, but more importantly I was aware there was enormous artistry involved. I didn't then know how they made these films, but I could see there was a lot of beautiful work involved.

-- How do you define yourself? An animator or an illustrator?
-- Most definitely an animator. I've always been attracted to cinematic images and even when I do illustrations they tend to look like stills from a film. With animation I like the combination of design and movement and sound. It is a unique way to tell stories, and its emotional impact is different to any other medium.

-- How do you design a new animation character, like JoJo and the others? And how to plan out a new story? Tell us some of your experience.
-- Very often the design process consists of sketching and just seeing what might come out. For commercial jobs this process is very often quick - perhaps a design will need developing in a 24-hour period. And of course you have to be aware of the clients' needs.

For my own projects I can have more freedom. But often there are pragmatic considerations. For example - with JoJo there was a very limited budget. So although the simplicity of design appeals to me, those characters were designed primarily in order to be inexpensive to build and animate.

With the Varmint character the idea was to make it appealing to children, so we moved away from the simple textures and gave him fur to make him almost toy-like.

I always try to strike a balance between simplicity of design, and having enough in that design to make the characters warm and engaging.

With commercials I am given a script from the advertising agency. From there it is up to me to find an interesting way to bring it to the screen. I usually do this by roughing out storyboards, which is where most of the ideas suggest themselves.

-- Nowadays, digital arts are developing in such a vigorous way that a lot of people have thrown themselves into this industry. Thus, what is your trademark feature?
-- There are so many people now doing brilliant things. At this stage of my career I suppose I've reached the point where I no longer feel able to compete or keep up with the latest trends. For me the important things have always been appealing characters, and a self-contained environment for them to inhabit.

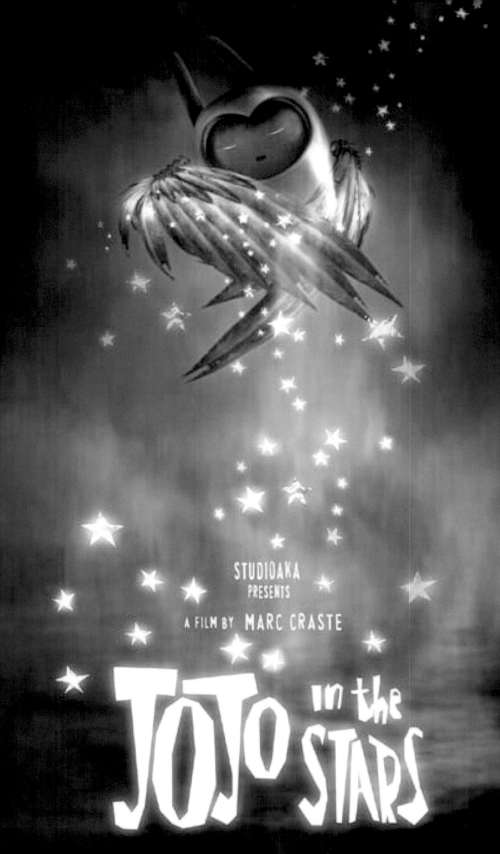

STUDIOAKA
PRESENTS

A FILM BY MARC CRASTE

JOJO in the STARS

STUDIOAKA PRESENTS A FILM BY MARC CRASTE JO JO in the STARS MUSIC BY DIE KNODEL DUMB TYPE SAMUEL BARBER SOUND DESIGNER HILARY WYATT
FEATURING THE VOICE OF OLIVER MICELI AS MDME PICA CG ARTISTS FABRICE ALTMAN DUNCAN BURCH JAMES GAILLARD
DOMINIC GRIFFITHS TALIA HILL BORIS KOSSMEHL FABIENNE RIVORY JAMES ROGERS ANDY STAVELEY BRAM TTWHEAM
EDITED BY WILLIAM EAGAR PRODUCTION ASSISTANTS LINDSEY FRAINE REN PESCI TRACEY ASHFORD EXECUTIVE PRODUCERS PAM DENNIS SUE GOFFE PHILIP HUNT

DOLBY DIGITAL
IN SELECTED THEATRES

PRODUCED BY SUE GOFFE WRITTEN DESIGNED AND DIRECTED BY MARC CRASTE

❷ JOJO_01
❸ JOJO_02
❹ Guinness

-- What's the focus of your work over the past 3 years? And what's the most important project (or the most memorable project) in the past 3 years?
-- *Varmints* (the film) took over two years to make. Although I was busy with commercial work during the production, the film was my main passion. I'm very interested in pursuing longer format projects, and quite enjoy projects that take months or years to reach their conclusion. That sort of time frame allows you to really immerse yourself in the world you're creating. *Varmints* was a wonderful experience, not least because of the people I got to work with. Along with a talented crew I was lucky to work with Johann Johannsson, an Icelandic composer who wrote the music. We recorded the score in Prague with the Prague Philharmonic (an orchestra that has recorded soundtracks for David Lynch and Roman Polanski). That was definitely a highlight of the production.

-- Which animation do you like best?
-- Right now I'm thrilled with the success my friend David O'Reilly is having with his film *"Please Say Something."* It's among the most interesting work I've seen. I'm also very much looking forward to seeing Coralline which opens here in the UK in a few days. And we always watch a Miyazaki film every Friday night in our house.

❼ Varmints 6

❽ Varmints 4

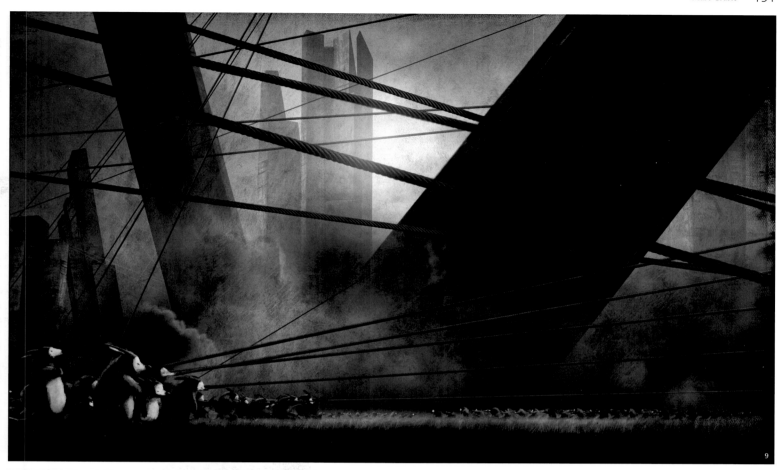

9

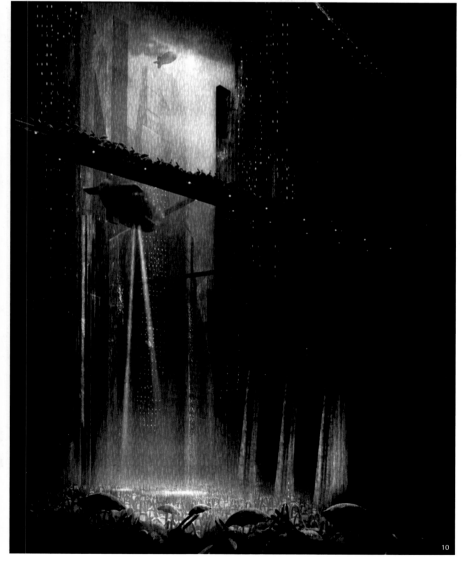

10

-- Digital arts have allowed the artists to have explore more styles and subjects. What do you think of that?

-- I think this is very much the case. Digital tools allow you many opportunities. But...for most of us the tools themselves will be liberating only to a degree. Our work, regardless of how we do it, will still look like "our" work. I find I now use Photoshop in exactly the same way I used a paintbrush ten years ago.

-- What do you think is the next step that digital art is going to take?

-- In CG, I suspect only the surface has been scratched. It is understandable I think that initially the drive should be towards photorealism, realistic appearance and realistic movement. But far more interesting is when the tools developed to create these effects become more inexpensive and easier to use, and people take them and subvert them to their own use. Then some surprising and exciting things start to happen.

-- You have been engaged in digital artistic creation for many years. Would you share with us some practical experiences?

-- Digital tools have of course revolutionized the way we work. Things are faster and far more flexible. The down-side of all this flexibility is that often everyone wants to have a say in how the image is realized. For the most part I still start with a drawing on paper. I have been with the same team for many years now, and we have developed a way of working where my sketches are faithfully translated into CG with remarkable efficiency.

9 Varmints 3

10 Metropolis

Fantasy⁺ -Best Artworks of CG Artists

Author: Vincent Zhao
Project Editor: Yvonne Zhao
Assistant Editor: Fiona Wang
Translator: Gexian Xie
Copy Editor: Joseph Augustus Bosco
Book Designer: Jing Yu, Shanna Mu

©2010 by China Youth Press, Roaring Lion Media Ltd. and
CYP International Ltd.
China Youth Press, Roaring Lion Media Ltd. and CYP
International Ltd. have all rights which have been granted to
CYP International Ltd. to publish and distribute the English
edition globally.

First published in the United Kingdom in 2010 by CYPI PRESS

Add: 79 College Road, Harrow Middlesex, HA1 1BD, UK
Tel: +44 (0) 20 3178 7279
Fax: +44 (0) 20 3006 8787
E-mail: sales@cypi.net editor@cypi.net
Website: www.cypi.co.uk
ISBN: 978-0-9562880-0-4

Printed in China